IMAGES
of America

STOKES COUNTY

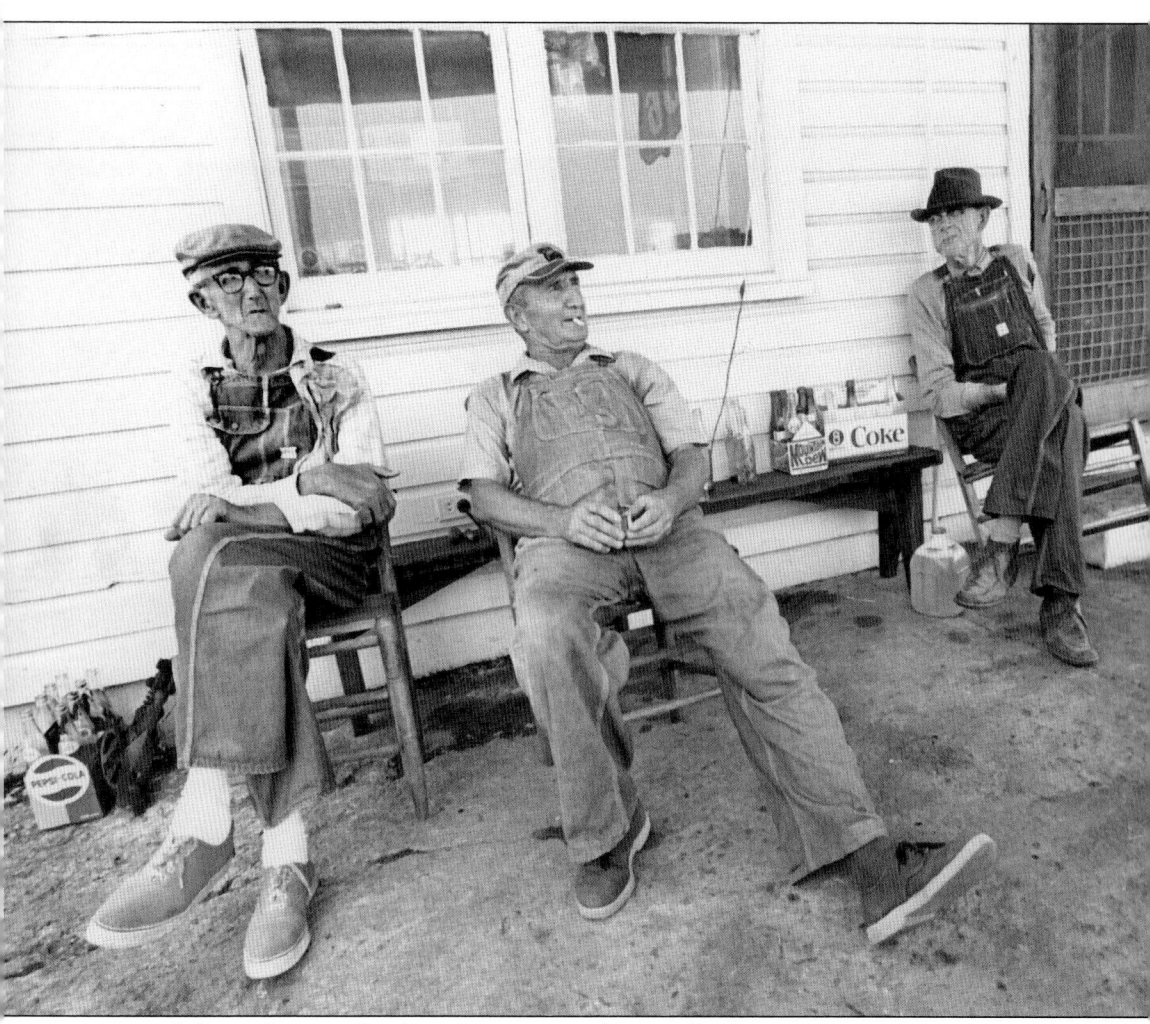

From left to right are Gib White, D.P. Kiger, and Lee Calloway at Kirby's Grocery in King, 1970. (Courtesy the Forsyth County Public Library Photograph Collection.)

IMAGES of America

STOKES COUNTY

Chad Tucker

ARCADIA
PUBLISHING

Copyright © 2004 by Chad Tucker
ISBN 978-0-7385-1656-1

Published by Arcadia Publishing
Charleston, South Carolina

Printed in the United States of America

Library of Congress Catalog Card Number: 2004103642

For all general information contact Arcadia Publishing at:
Telephone 843-853-2070
Fax 843-853-0044
E-mail sales@arcadiapublishing.com
For customer service and orders:
Toll-Free 1-888-313-2665

Visit us on the Internet at www.arcadiapublishing.com

For Mom,
who taught me to respect history and inspired me with her inner strength
and
in memory of my Grandfather,
who shared with me his unwavering faith, warm wit, and quiet courage.

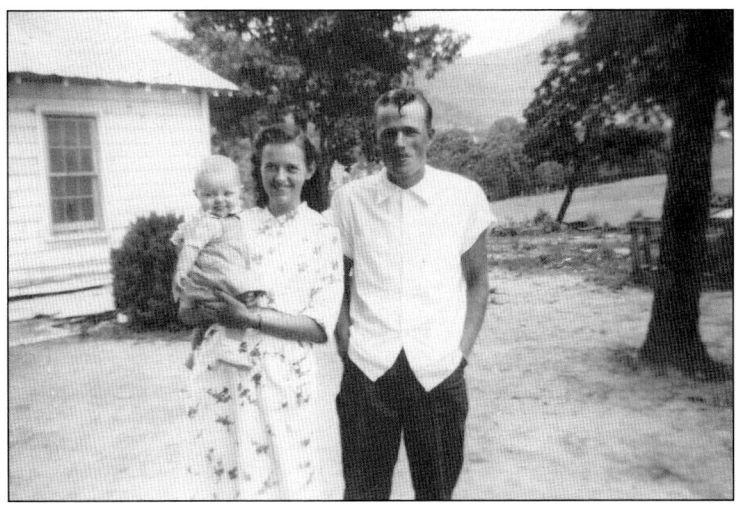

From left to right, the author's mother, Sue; grandmother, Vina Lee; and grandfather, Calvin Tucker, are pictured in Stokes County in the spring of 1954.

Contents

Acknowledgments		6
Introduction		7
1.	Places of Home	9
2.	Where We Were Taught	49
3.	Working the Land	75
4.	The Healing Waters	87
5.	The Women of Stokes	95
6.	The Men of Hanging Rock	107
7.	Sundays in Stokes	119
Bibliography		125
Index		126

ACKNOWLEDGMENTS

This book would not have been possible without the open arms of many Stokes County residents who shared their personal photograph collections and the local historians who shared their knowledge. A very special thank you to King historian Robert Carroll; Pinnacle historian Jean Stone Hall; Sandy Ridge author and historian Darrel Lester (who in addition to photographs gave some wise advice); my mother Sue Tucker Lawson, who helped gather photographs; William Tilley, who shared his mother, historian Ellen Pepper Tilley's photograph collection; and the Stokes County Historical Society.

In addition to the people credited with sharing photographs throughout this collection, my appreciation is extended to Linda Bradley, Lewis Carroll, Danbury mayor Jane Priddy-Charleville, the Dixon Family of the Pine Hall Estate, Sara Giroux and the Stokes County Arts Council, Bonnie Kiser, librarian Steve Massengill of the North Carolina Archives Photograph Collection, Deanne Moore and the King Chamber of Commerce, superintendent Erik Nygard of Hanging Rock State Park, Bill Prince, librarian Molly Rawls of the Forsyth County Public Library Photograph Collection, Ina Smith, Virginia Dare Smith, Sallie Spainhour, Virginia Townsend, Walnut Cove Colored School Inc., and the town of Walnut Cove. And last but not least, thanks to my dear Jenny: without your encouragement and support this project would have remained just an idea.

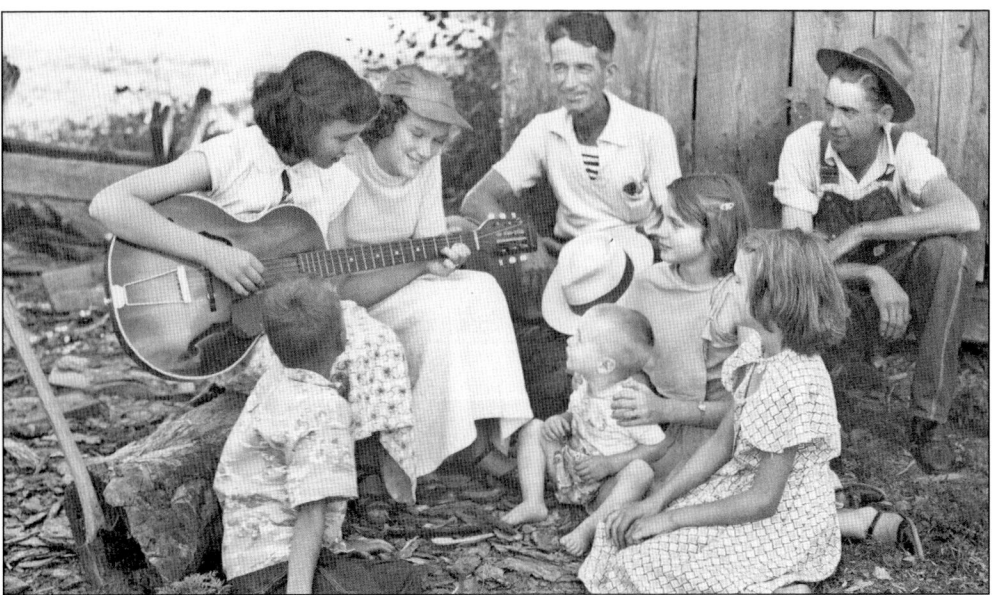

About the Cover
Madeline Pulliam Kiger can remember the July day in 1951 when a *Winston-Salem Journal* photographer captured her playing the guitar for her family and friends near King. "He stopped there at the house, and asked to take our picture . . . but I can't remember it being in the paper," said Kiger in a March 2004 interview. The picture appeared in the July 3, 1951 *Winston-Salem Journal* with the following caption: "Stokes County Hoe-Down." The children in front row, from left to right, are Junior Pulliam, Johnny Pulliam, Marie Pulliam, and Clarice Pulliam. In the back row from left to right are Madeline Pulliam [Kiger], Shirley Bennett, Coy Bennett, and Woodrow Pulliam. (Courtesy the Forsyth County Public Library Photograph Collection.)

INTRODUCTION

From a ridge atop Sauratown Mountain, one sees everything that is Stokes County: foothills nestled with farms, mountains shadowing the mouth of springs, and settled fields where communities of people have come together. It is nothing short of fate that each blessed to call this land home have found roots here. Whether past generations brought us to this point or it is the workings of another, the county's rich soil is open for the taking. Like the first settlers, today's residents have found life in this land and continue to live from it through the generations.

From the birth of photography the images of Stokes County's past have been captured on paper. In the interest of preservation and respect for those who first came here, the following photograph collection is their life captured in black and white. For more than a year, it's been a work of patience and honor, visiting businesses, archives, and homes where closets were opened and photographs were pulled. Albums were dusted to reveal more than 400 images—some fragile and preserved on tin, others tattered by time's toll.

This is a work of a present generation. Preservation should not stop with just this collection. It is work that should continue, before images fade and our past is silent.

—Chad Tucker, at his grandfather's home atop Sauratown Mountain,
Stokes County, February 8, 2004

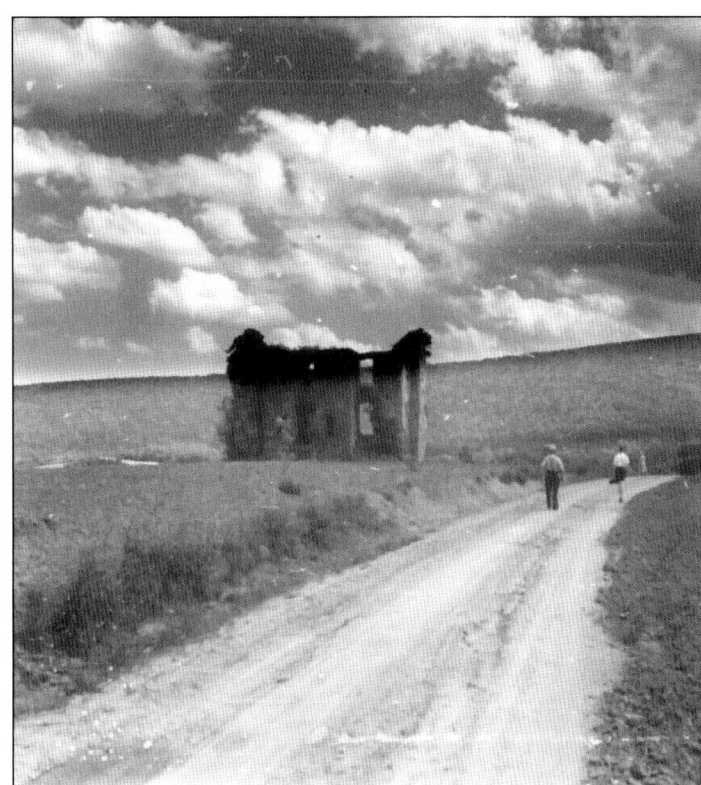

During a weekend family outing c. 1930, photographer Frank Jones captured the Rock House along with family members. (Courtesy the Forsyth County Public Library Photograph Collection.)

Meadows school bus driver Paul Southern is seen here in front of his bus at Meadows in the late 1920s. (Courtesy Adeline Kiser.)

One

PLACES OF HOME

I remember my mom sending me up to the King depot. That's where you'd make money, by selling chickens. They'd send them to buyers up North. I remember I walked up there with a hen and came home with about 70¢.

—Robert Carroll, recalling his childhood in 1910s King

They are the places that gave foundation, building lives and character. They are the places of home with its landmarks we know by name. The buildings, crossroads, and rich farmland intertwine to build the fabric of our communities. Some are erased from present existence but not from the images burned in our memory.

It is an irony of Stokes County's history that many of the communities we call home are actually named for homes. King is named for one of its first homes, King's Cabin. Pine Hall, Sandy Ridge, and Walnut Cove are all names taken from area plantations.

A name is a binding thread that gives one an identity. Underneath that name are the dirt back roads that settlers were not afraid to travel, offering plates that neighbors never hesitated to fill, and welcoming backdoors that community founders kept open.

Unknowingly, the first residents who called these places home laid foundations that affected lives of generations they would never know—just by building in a paradise of rolling hills, red clay ridges, and clear river bottoms. They staked their claim on the hills, plowed the ridges, and were baptized in the clear water, and through the generations they whispered to us, "Welcome home."

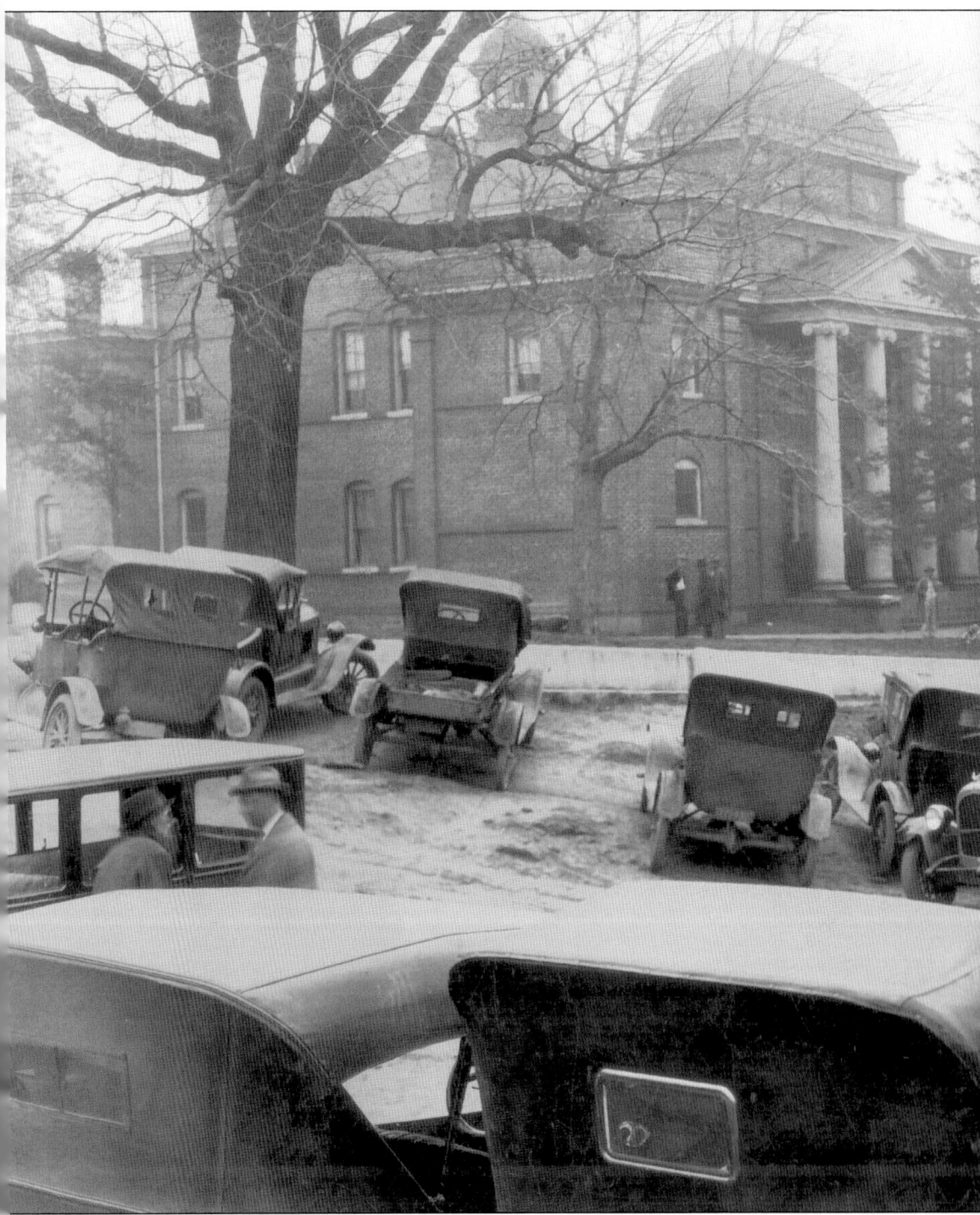

Court Day in Danbury was a busy time in the 1920s. Originally called Crawford, Danbury became the county seat in 1849, when Stokes County was split in half to create present-day Forsyth County. Above is the second courthouse to stand in Danbury. The original, which was built in the same spot in 1850, became too small by the late 1800s and was torn down.

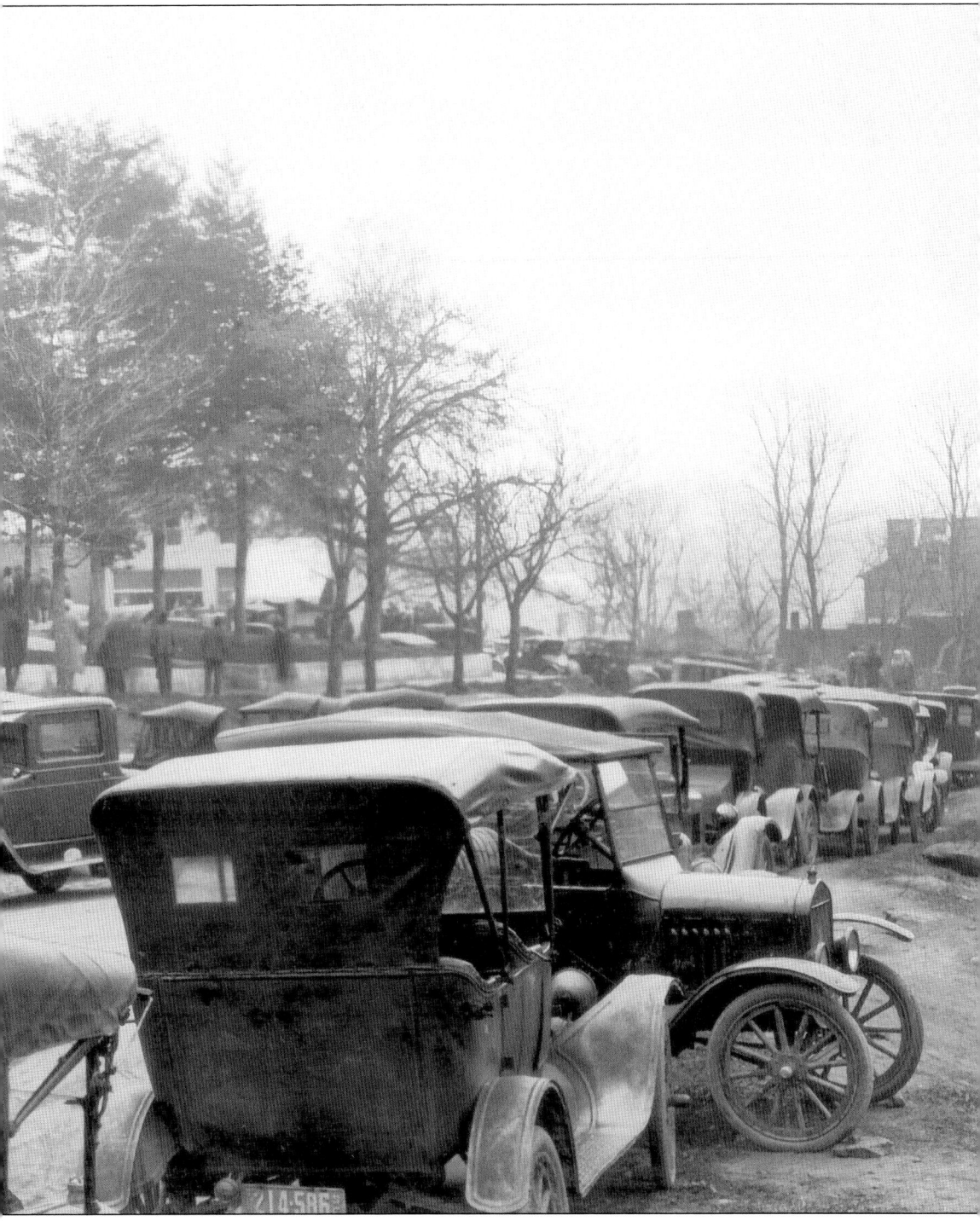

Court was held in a neighboring residence during construction. Workers used clay out of the Dan River bottom to make the bricks for the new courthouse. Court resumed here in 1904. (Courtesy Ellen Pepper Tilley Collection.)

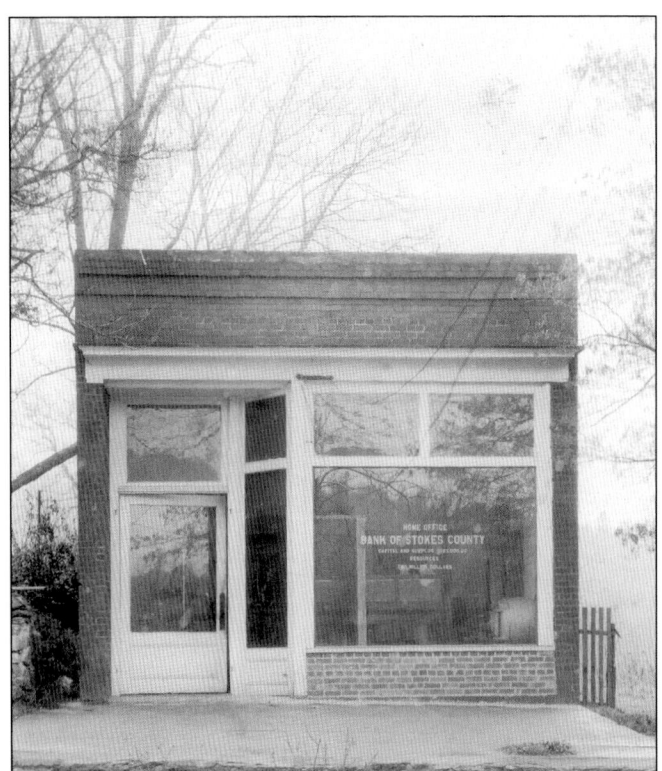

The home office of the Bank of Stokes County was located in Danbury. The bank opened in 1905 and had additional branches in Germanton, King, and Walnut Cove. The bank went bankrupt during the stock market crash of 1929. (Courtesy Ellen Pepper Tilley Collection.)

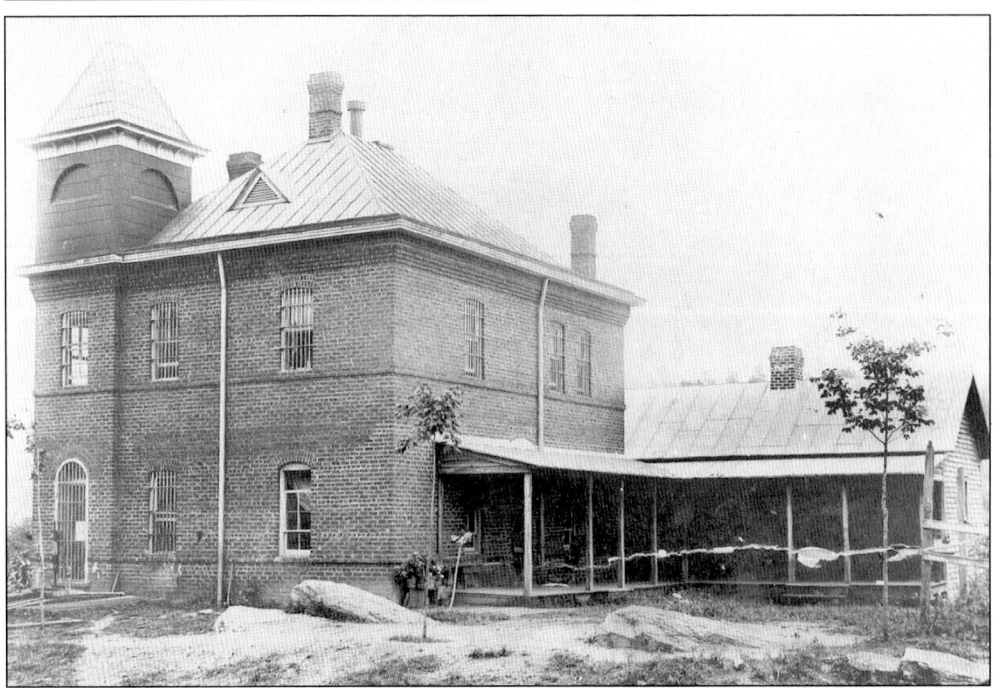

The Second Stokes County Jail, in Danbury, was built c. 1904. The jail was built with a tower above the entrance that held a scaffold for executing criminals. The scaffold was never used. (Courtesy the North Carolina State Archives.)

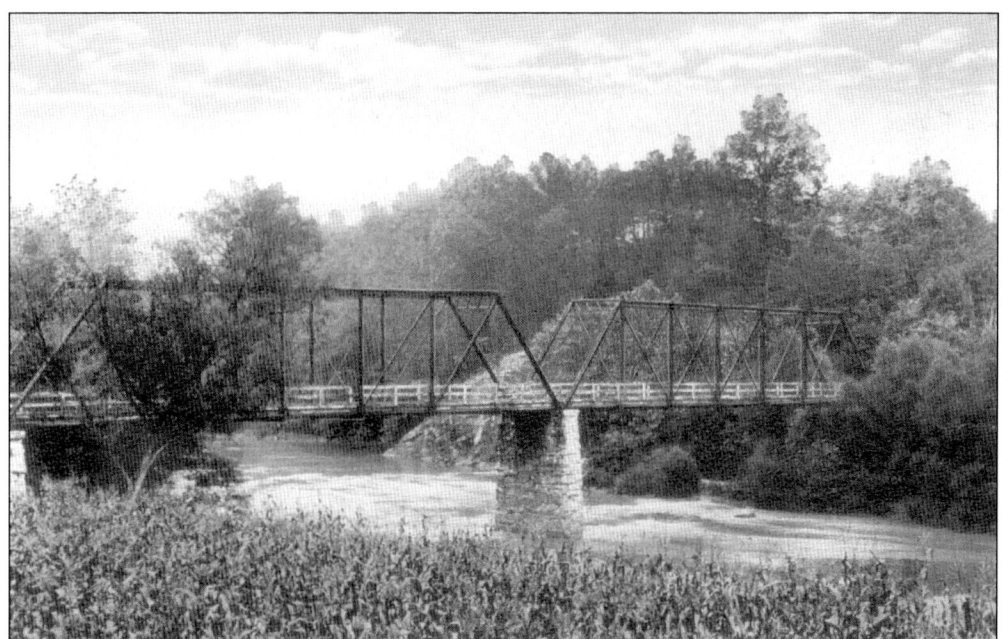

This former Dan River Bridge crossed at present-day Moratock Park in Danbury. It was erected in the mid-1890s. (Courtesy Ellen Pepper Tilley Collecton.)

The Camping Island Creek Iron Bridge bears horse-drawn wagons leaving Danbury c. 1914. The bridge was replaced in 1925. (Courtesy Ellen Pepper Tilley Collection.)

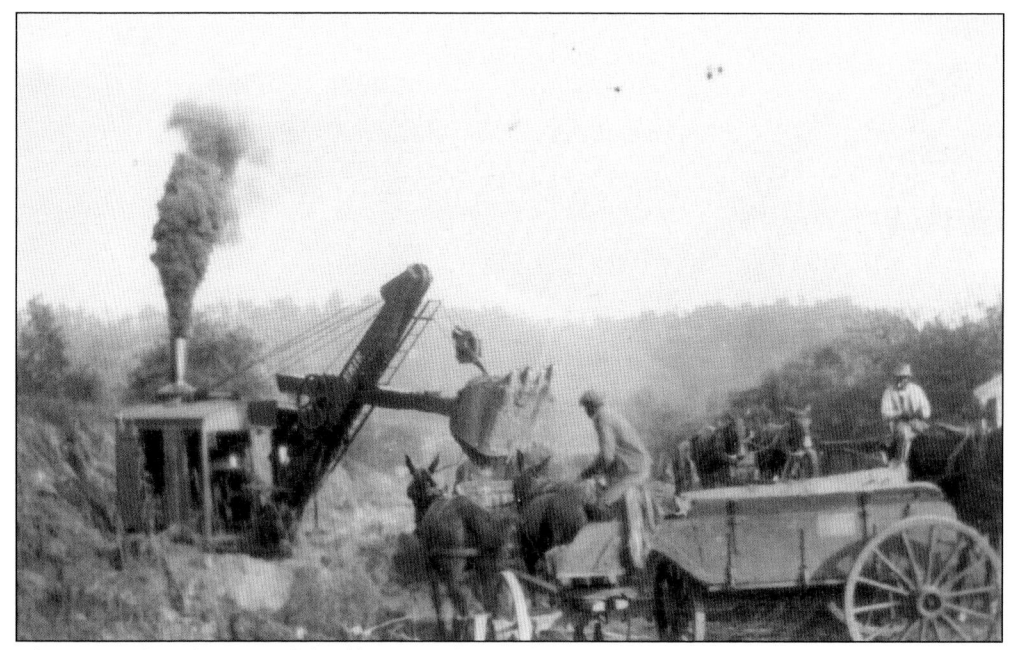

This steam shovel is at work building North Carolina Highway 8 and 89, southeast of Danbury, in 1925. (Courtesy Ellen Pepper Tilley Collection.)

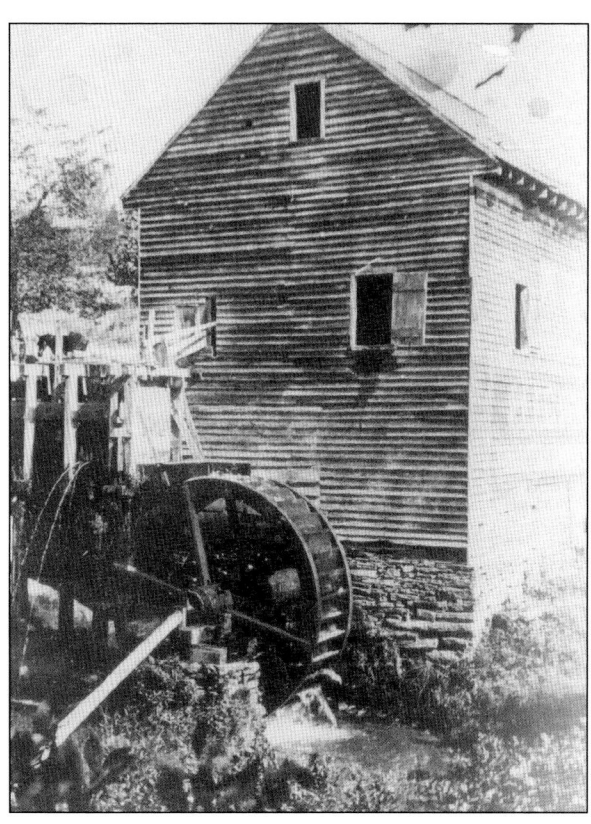

Dodd's Mill, in Danbury, is pictured here c. 1915. (Courtesy Ellen Pepper Tilley Collection.)

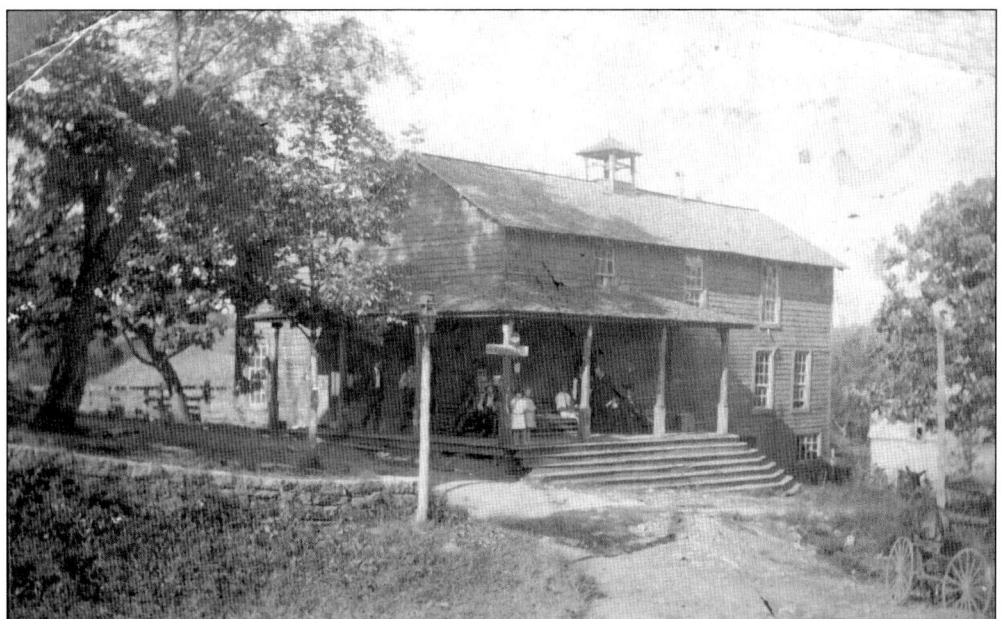

The H.M. Joyce Building served Danbury for decades as a store. The Danbury Post Office was housed in the store for more than two decades beginning in 1889. A second building constructed here became home to the *Danbury Reporter* from the 1930s to the 1960s. (Courtesy Ellen Pepper Tilley Collection.)

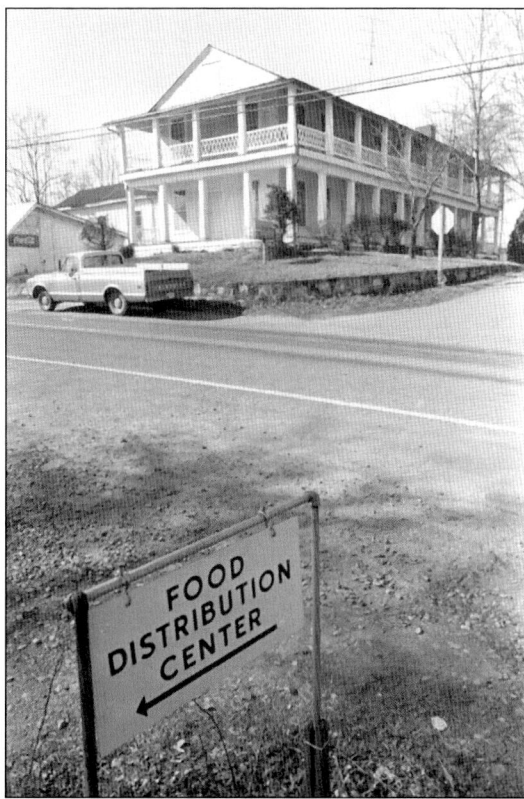

The McCanless House in Danbury is pictured here in 1969. The building was constructed c. 1854 by Nathaniel and Alexander Moody as an Inn. Civil War Maj. Gen. George Stoneman's Union raiders used the building as their headquarters while passing through and destroying the area in April 1865. Dr. William McCanless bought the Inn as a home in 1870 and expanded it to house visitors of the nearby springs resorts and those doing business at the courthouse. (Courtesy the Forsyth County Public Library Photograph Collection.)

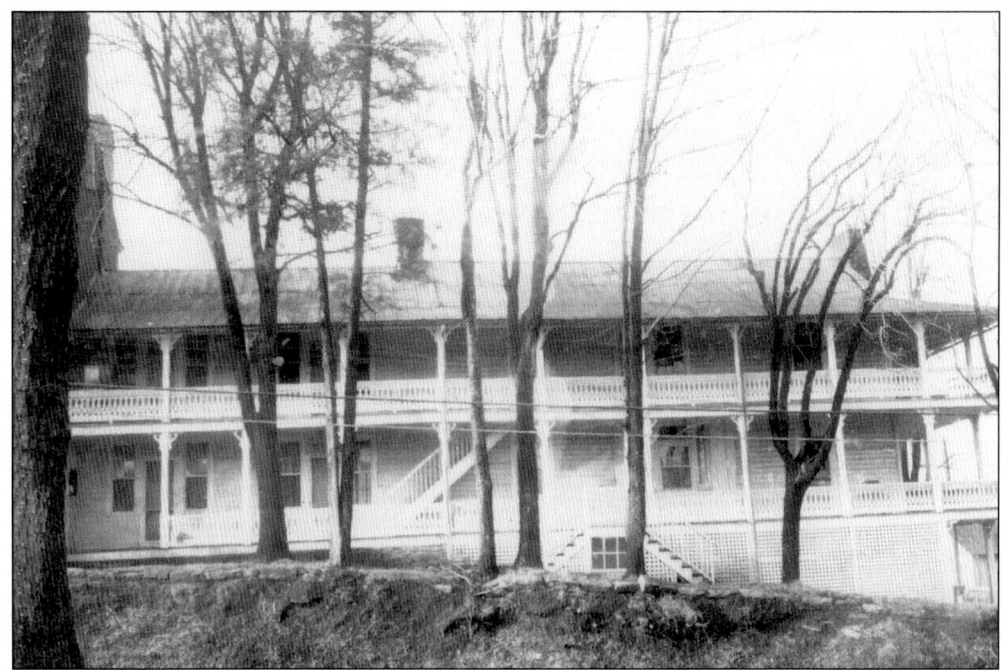

Samuel Taylor, a former Stokes County clerk of court, is believed to have constructed this Danbury building after the Civil War. After Taylor left Stokes County for Surry County, where he was elected sheriff, he sold the building to his brother Spottswood B. Taylor, who converted the structure into the Taylor Hotel c. 1879. The hotel closed before the start of World War I. (Courtesy Ellen Pepper Tilley Collection.)

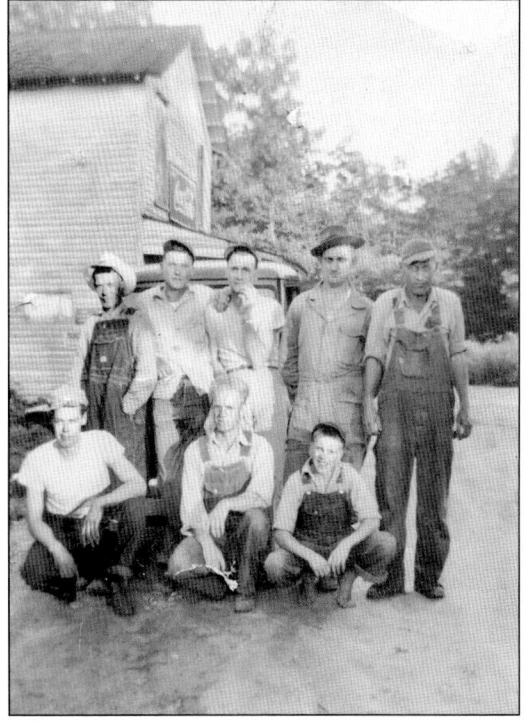

The "Good Ole Boys" gathered around Priddy's General Store in Danbury in the early 1950s. For years the "Good Ole Boys" would gather to toss horseshoes under the old oak trees. They are, from left to right, (front row) Elwood Priddy, Guy Woods, and Thurman "Shorty" Mabe; (back row) Lim Bullins, Vance Alley, Ernest Mabe, Moir Wood, and Reid Mabe. (Courtesy the Priddy family.)

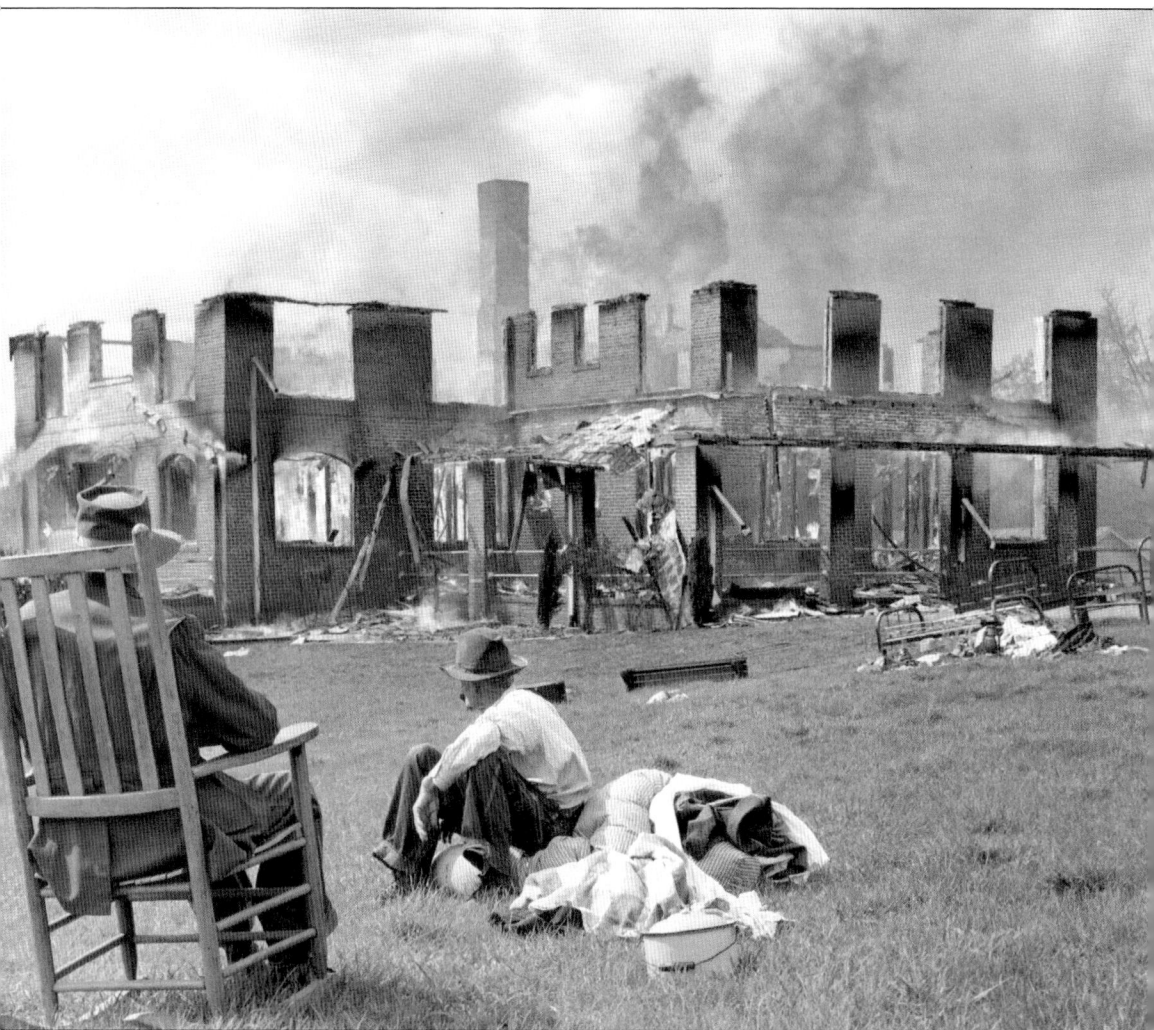

Stokes County Home for the Elderly and Handicap, near Danbury, was destroyed by fire on April 27, 1954. The fire started after a resident lit a cigarette in a closet. *Winston-Salem Journal* photographer Jim Keith won an award for capturing the fire; it made the front page of the paper the following day. An excerpt from *Winston-Salem Journal* Reporter Roy Thompson read:

> Danbury - Twenty-nine panicky inmates were saved when fire gutted the Stokes County Home two miles southeast of here early yesterday afternoon. Some of the old people - frightened and confused in the flames, noise and excitement - had to be dragged and carried from their burning rooms. Others had to be held once they had reached safety because they wanted to go back and search for cherished pictures, articles of clothing and other treasured belongs. . . . By mid-afternoon, as the flames still roared fiercely through the building, the inmates sat outside in the sun and watched their home burn. Around most of them were little heaps of clothing, magazines and other things they'd managed to grab as they fled their room. Most of them seemed confident that something would be done for them so they sat quietly and watched the fire burn.

(Courtesy the Forsyth County Public Library Photograph Collection.)

Like many Stokes County communities, it was the postal system that gave the Francisco community its name. When mail was delivered to the Francis brothers, who owned the community store called Francis Company, the mail would be addressed "Francis Co." By 1846 the two words had come together. The Francisco post office served the community for more than 100 years. It closed when mail started being delivered from Westfield in 1959. The community is known for its strong spirit and will. In 1955, the community wanted to add an agriculture department to the Francisco High School, but their request was denied because of low enrollment. The state agreed to appoint a teacher for the job if the community would build and equip its own agriculture building. They did. (Courtesy the Priddy family.)

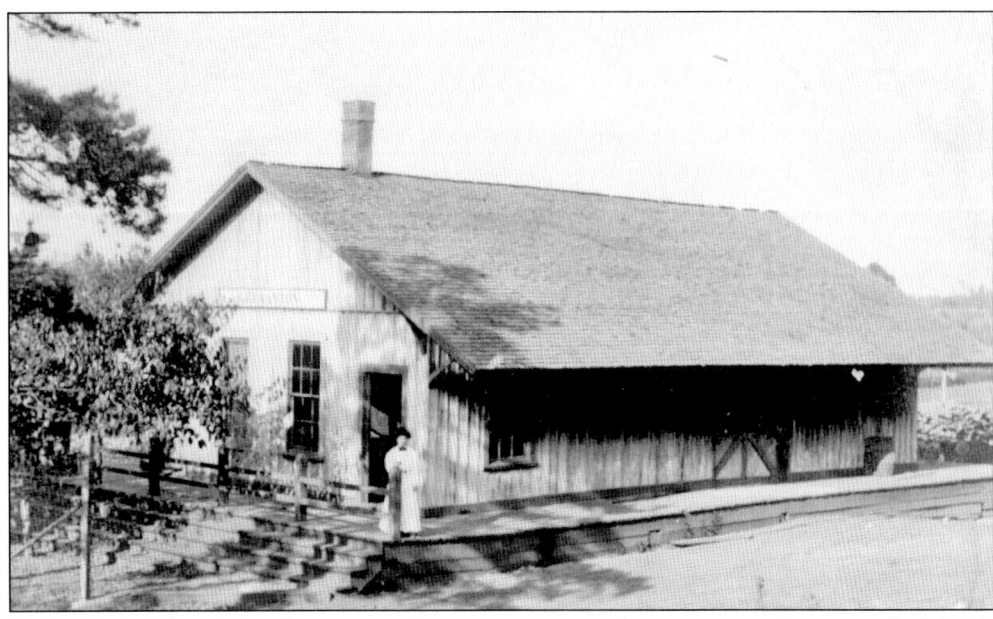

This photograph of the Germanton Depot was captured on a postcard, postmarked 1906. (Courtesy Dot Barrett.)

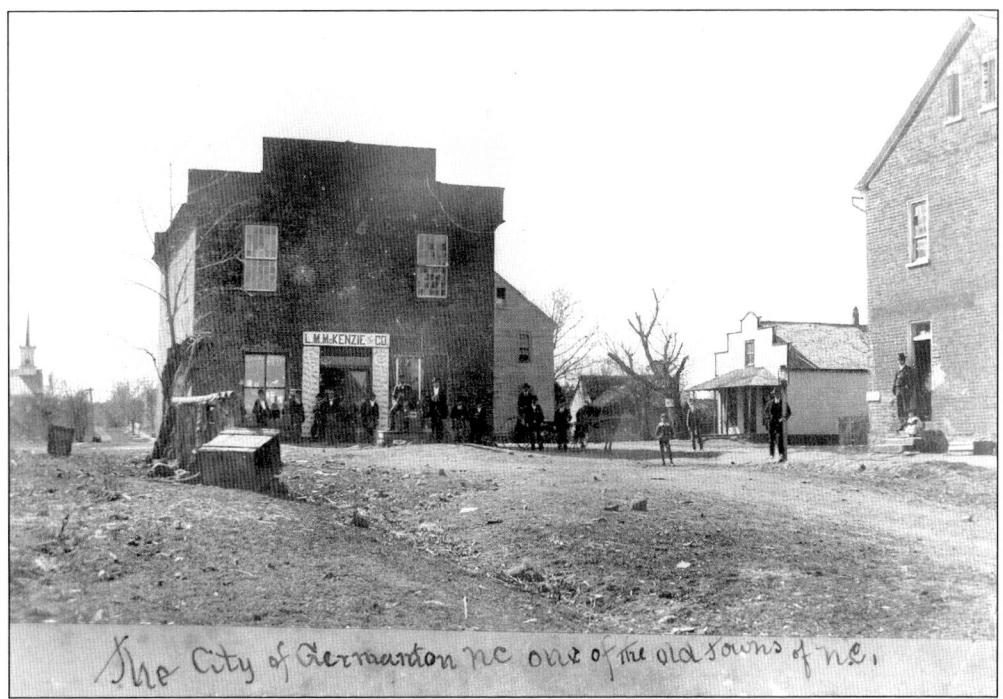

Stokes County's first courthouse was in Germanton. After the county seat was moved to Danbury in 1849 the building was used by local merchants like the L.M. McKenzie Company, seen in this 1898 photograph. Looking south the Germanton Methodist Church is seen in the distant left. (Courtesy Max Bennett.)

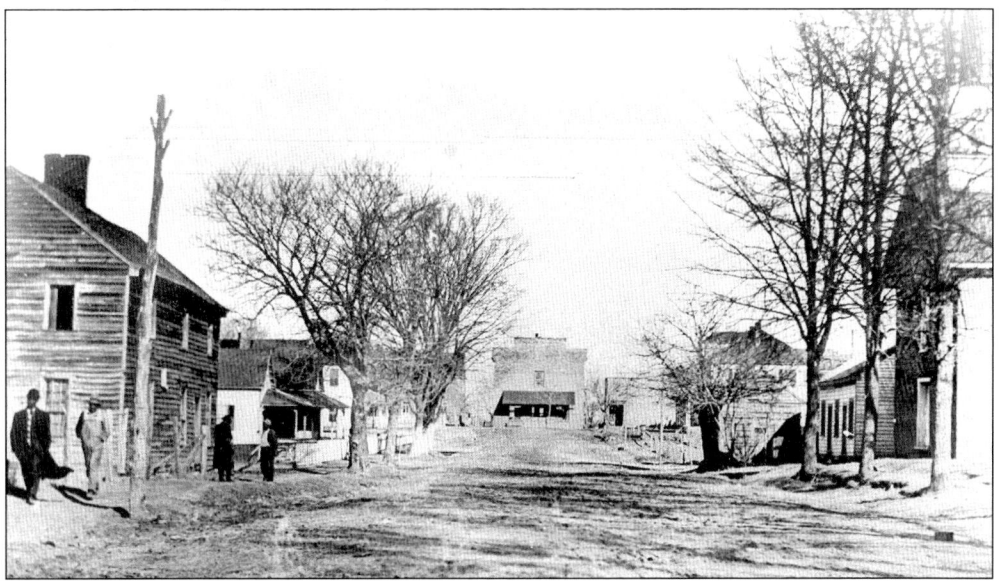

Originally known as Germantown, Germanton became the county seat of the newly formed Stokes County in 1790. Fifty-nine years later the county was split in half, creating present-day Forsyth County. Looking north in this c. 1903 photograph, the Germanton Methodist Church is on the right, and the courthouse is located in the center of Main Street. Main Street was part of the original Great Wagon Road. (Courtesy Max Bennett)

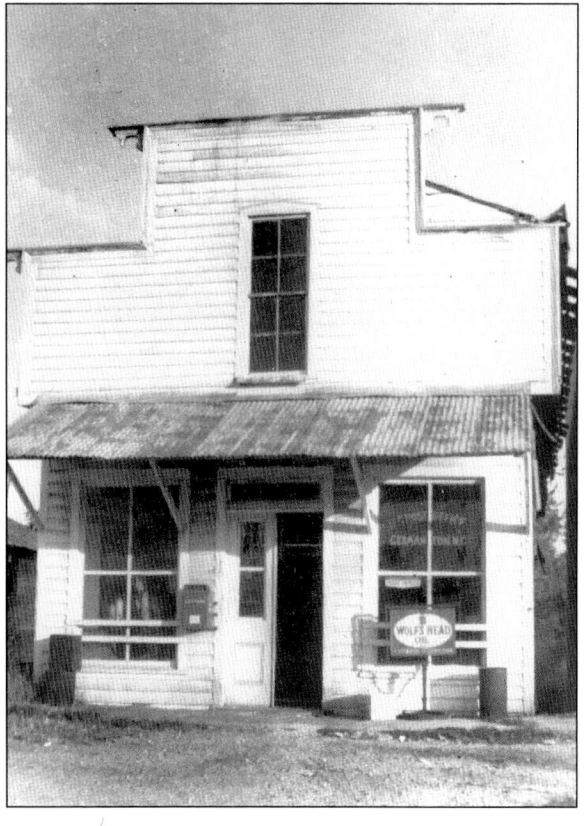

The old courthouse square in Germanton is seen here in 1948. The courthouse building, being used by the H. McGee and Company General Merchants, sat in the middle of Main Street until 1957, when the North Carolina Department of Transportation demolished it in the interest of "traffic safety." (Courtesy North Carolina State Archives.)

The Germanton post office is captured in this c. 1959 photograph. (Courtesy Max Bennett.)

A photographer captured this freight train heading west away from the Germanton Depot; the date of the photograph is unknown. (Courtesy Max Bennett.)

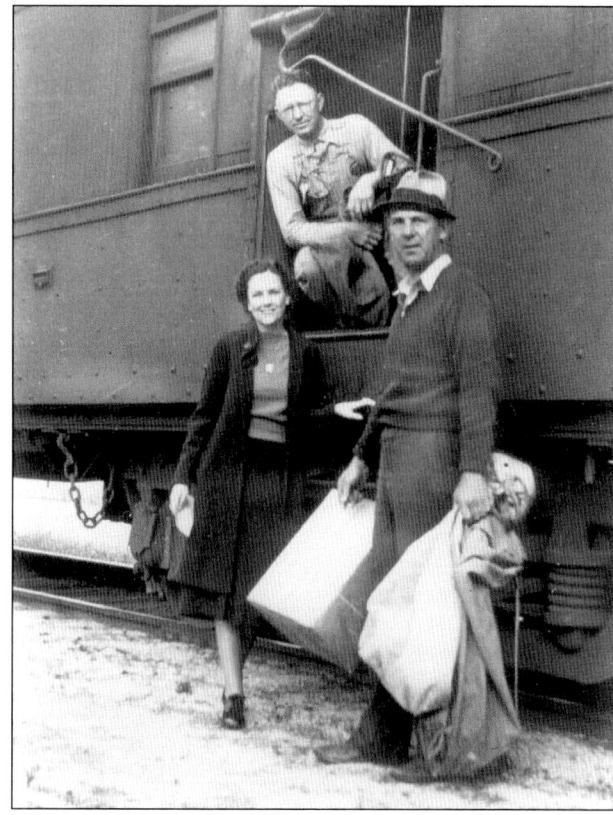

Germanton Depot agent Maggie Phillips and postal carrier Walter Beck are seen receiving the mail from Joe Sam Dorsett (inside the train) of Siler City. (Courtesy Max Bennett.)

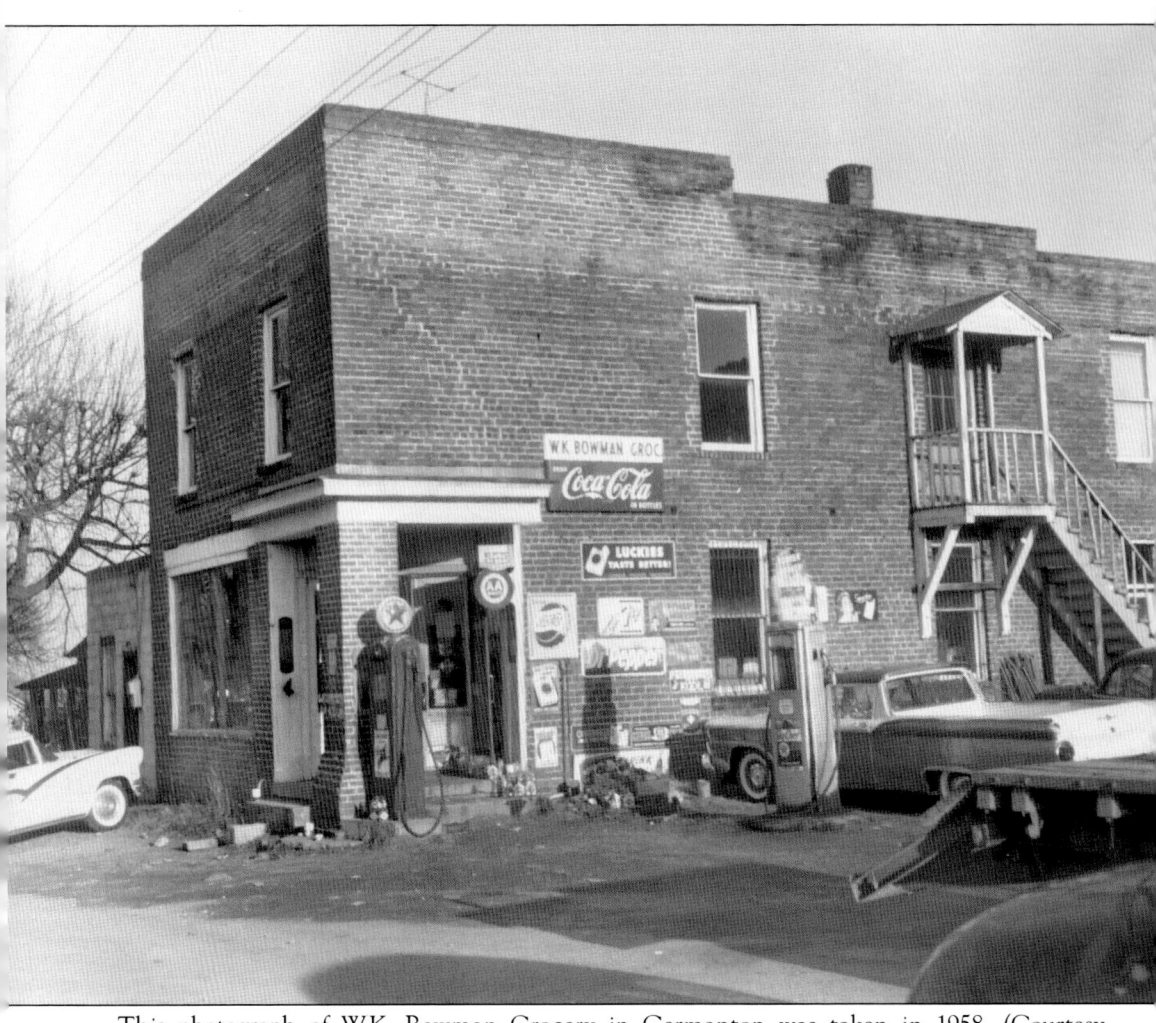

This photograph of W.K. Bowman Grocery in Germanton was taken in 1958. (Courtesy Max Bennett.)

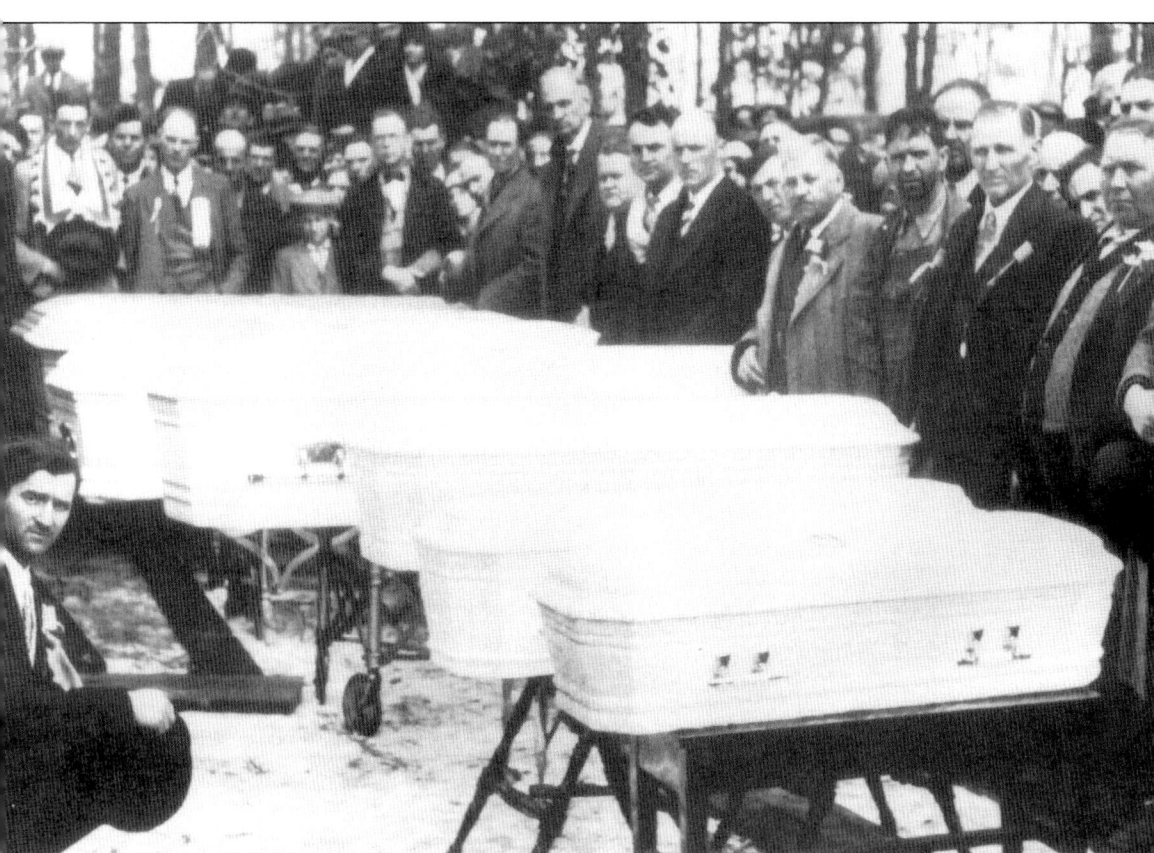

One of the most infamous events in Stokes County's history happened on Christmas morning, 1929, on the Charlie Lawson farm just outside of Germanton. Charlie Lawson murdered his wife, Fannie, and children, Carrie, Mae Bell, Marie, Mary Lou, James, and Raymond, and then committed suicide. The only survivor, his oldest son, Arthur, was in town at the time. The event made front page news around the country. Nearly 5,000 people were estimated to have attended the funeral. For decades, residents believed Charlie Lawson went insane, until close family members broke their silence in a 1990 book claiming Charlie had committed the acts to hide his oldest daughter Marie's pregnancy, which he fathered. Arthur died in an automobile accident in 1945. Pictured above, the Lawson family funeral was held at Browder Cemetery, near Germanton, on Friday December 27, 1929. (Courtesy Bill Flynt.)

David Nickolas Dalton bought this home in 1854 and expanded it to accommodate travelers on their way to Mount Airy. He created a thriving community around his home. The Dalton Institute opened in 1872, a depot opened in 1888, and by 1890, the Little Yadkin post office had changed its name to Dalton. But the community faded from existence when David Dalton died in 1895. The date of this photograph is unknown. (Courtesy the North Carolina State Archives.)

The three-story Dalton Home had a ballroom on the third floor and a underground passageway leading to the kitchen and smokehouse that stood away from the main section. This photo dates from May 1942. The home was condemned and demolished in the 1990s. (Courtesy the Forsyth County Public Library Photograph Collection.)

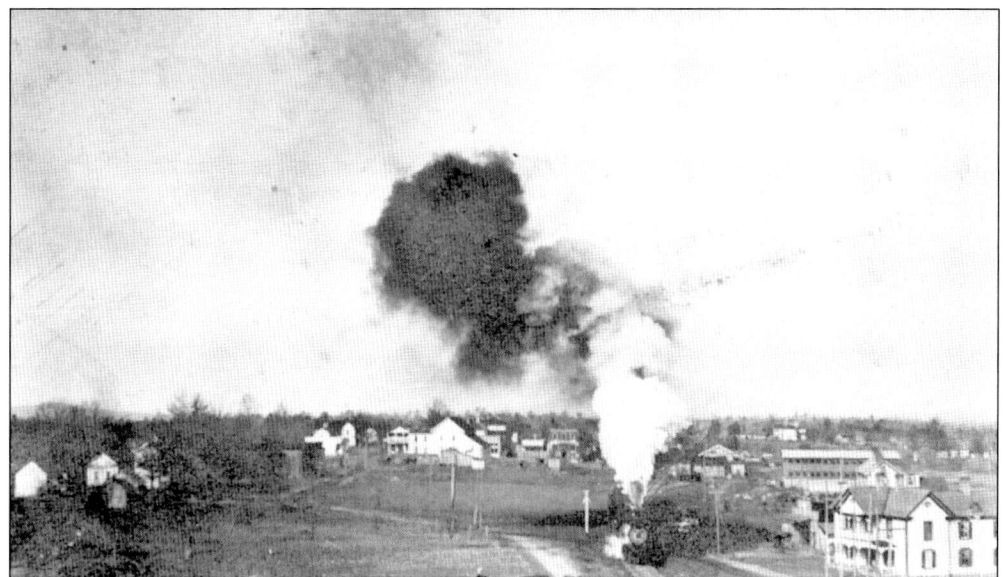

A train is seen leaving King c. 1911. This is a postcard photograph taken from the bell tower of the State High School. Present-day downtown King is located in the distance under the train's black smoke. (Courtesy Robert Carroll.)

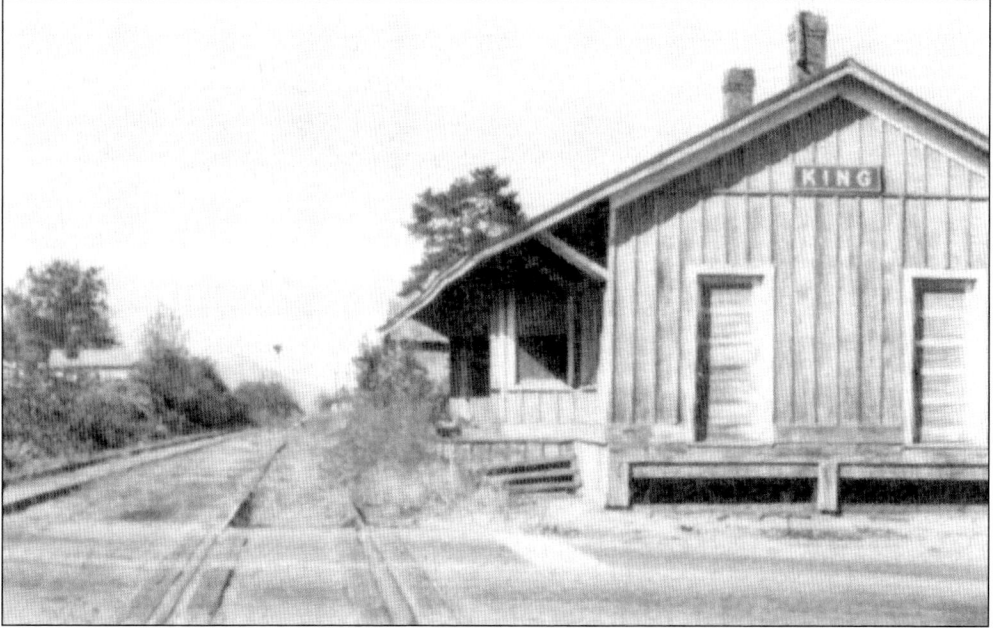

This photo of King Depot dates from c. 1965. King is a community named for one of its first homes, rather than a person. It was originally called King's Cabin after Charles and Francis King built their home here in 1830. The name was first shortened to King by the railroad that laid tracks in 1888. The postal service officially shortened the name in 1894. Its close proximity to Winston-Salem and high traffic generated first by the railroad and then by Highway 52 fueled the city named for a home into a growing bedroom community. By 1970, four subdivisions were built, increasing the population by 25% in just a couple of years. The community was incorporated in 1983. (Courtesy Stokes County Historical Society.)

Grabs Furniture Manufacturing Company, seen here c. 1904, was located behind downtown King, near present-day City Hall. Owner V.T. Grabs used his manufacturing company to help King find its place on the railroad. When the community found out the train would not stop in King, Grabs promoted the idea of residents donating wood that his company would saw and dress for free, to build a depot. The community built the depot and sold it to the railroad for a dollar, and the train started stopping in King. Grabs also invented many household furnishings including the pie safe and bed railings with wire chips to hold slats in place. (Courtesy Robert Carroll.)

This c. 1920 postcard photograph was taken from the railroad tracks looking south at downtown King.

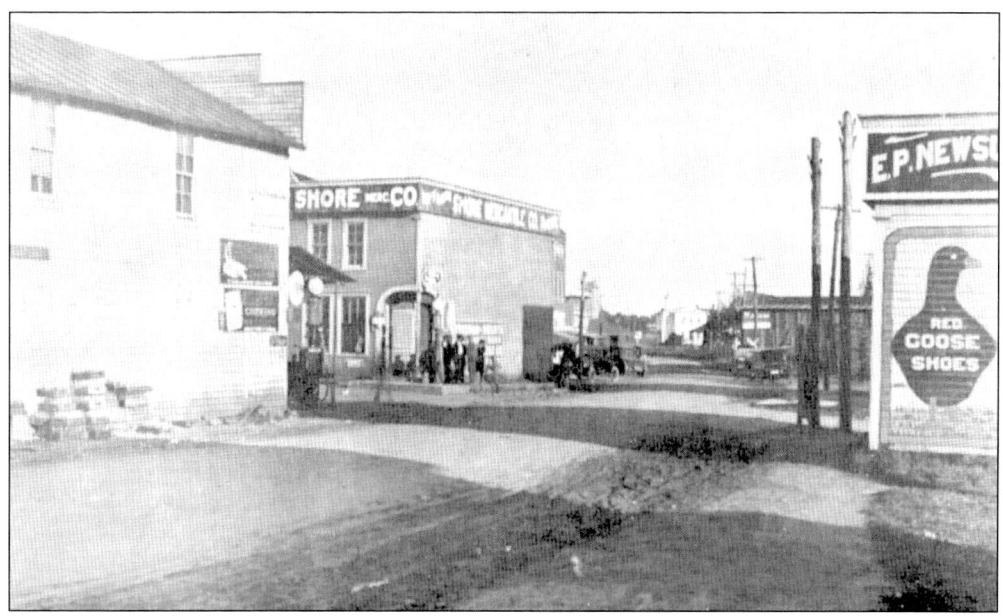
This postcard photograph was taken on present-day Dalton Road, looking east at the Dalton Road and Main Street intersection in King, c. 1920. (Courtesy Sallie Spainhour.)

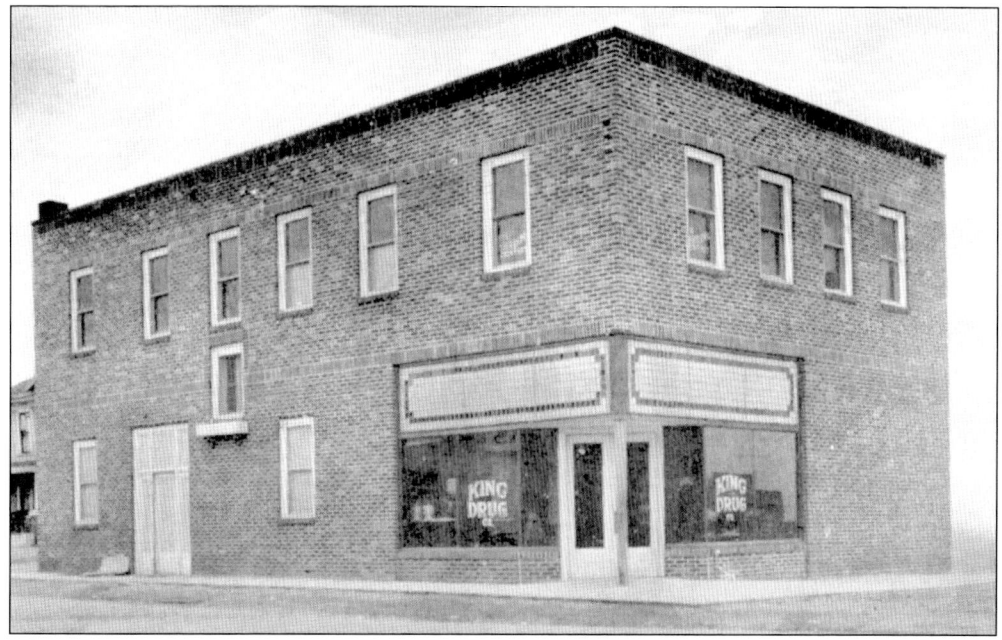
The Stone Building in King is pictured here in a c. 1930s postcard. The building has been home to the King Drug Company since it was built in 1927. (Courtesy Adeline Kiser.)

This Shell service station stood on present-day Dalton Road in this 1930s photograph. The gas station was built between the current location of Slate Funeral Home and King's downtown buildings. (Courtesy Eddie Marshall.)

American Legion, Carl Calloway Post 290, was built in King c. 1946. The Legion grounds have been home to the Stokes County Fair since the early 1950s. (Courtesy Kathleen Mendenhall.)

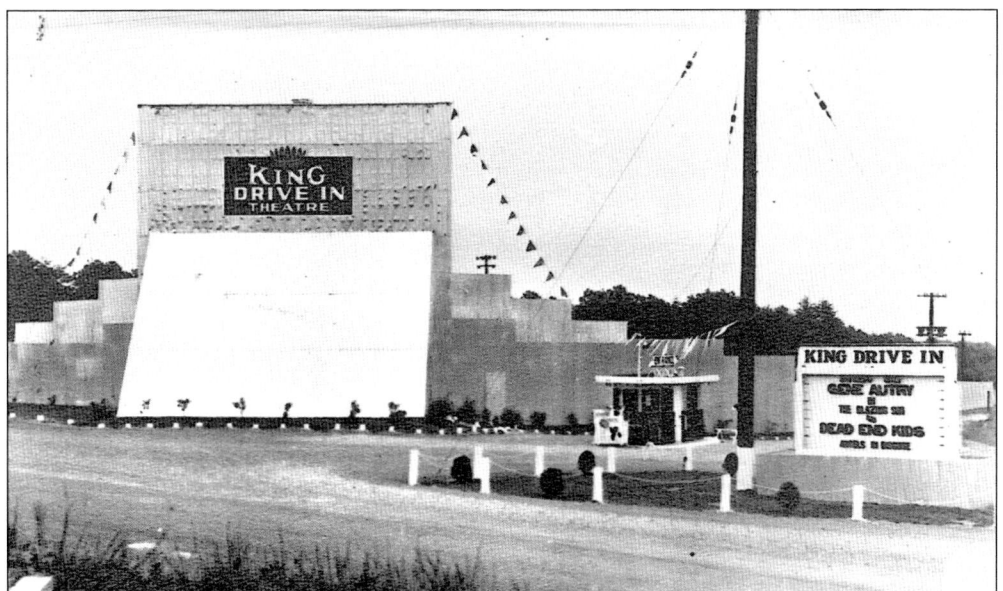

The King Drive-In sat at the corner of East King Street and Mountain View Road in 1950. (Courtesy Eddie Marshall.)

The Dairi-O was a King hangout in 1952. (Courtesy Coster Collins.)

Stokes County's first stoplight, was raised on July 17, 1952, in downtown King. (Courtesy the Forsyth County Public Library Photograph Collection.)

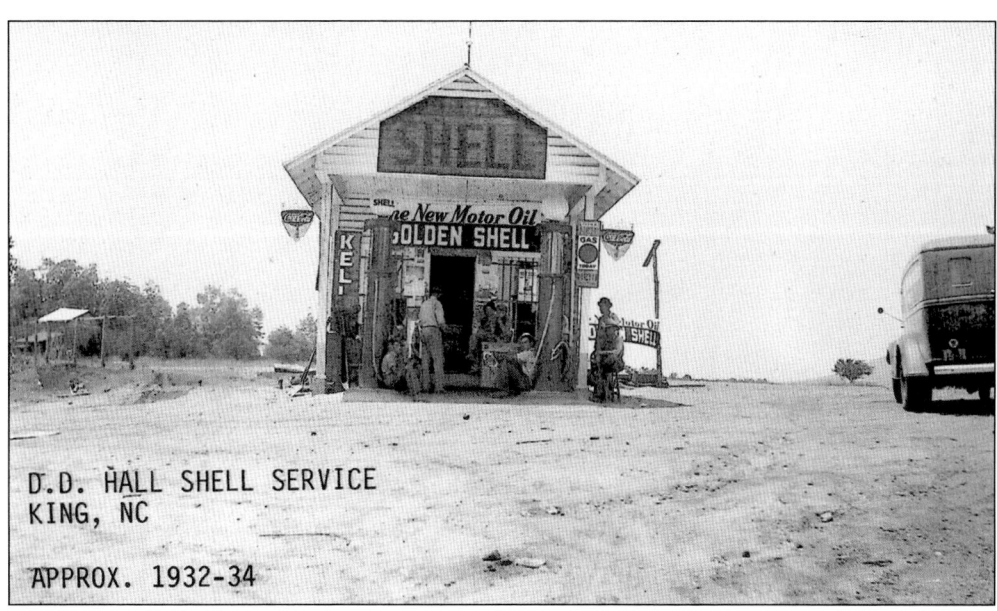

The D.D. Hall Shell Service Station stood at the corner of YMCA Camp Road and Chestnut Grove Road, near King. A community ball field was located behind the service station. (Courtesy Eddie Marshall.)

Fifteen-year-old Grant Moore just finished using 25 gallons of paint to cover R.V. Moore's 10-sided barn in Lawsonville when photographer Frank Jones took this photograph in December 1961. The barn, built by Dr. Marion Sheppard in 1886, has 10 adjacent stalls that face a Dutch-type entrance. (Courtesy the Forsyth County Public Library Photograph Collection.)

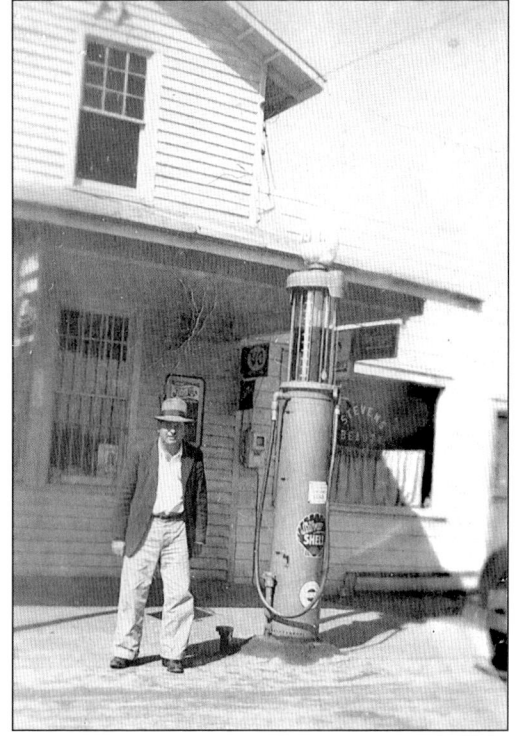

At right, Manie Stevens is seen in front of his store in Lawsonville, September 1945. First settled in the 17th century, Lawsonville was a small farming community named for its early residents. A Lawsonville post office opened in the 1920s when the Campbell and Smith community post offices closed. Lawsonville High School was built in 1929 and closed in 1964 to consolidate with Francisco, Nancy Reynolds, and Sandy Ridge at North Stokes High School. (Courtesy Velma Leake.)

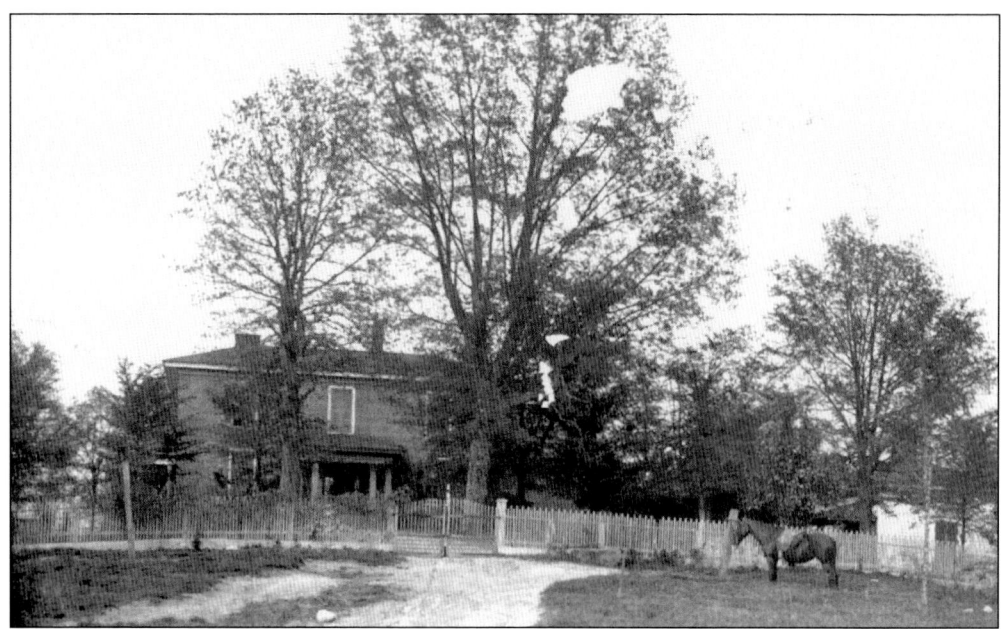

The community of Pine Hall takes its name from this home, the Pine Hall Plantation, pictured here in the late 1890s. The home was built by Patrick Henry's great-granddaughter Martha Fontaine and her husband, Maj. Leonard Anderson, in the 1850s. It took several years to build this home on the 3,000-acre plantation that sits along the Dan River. Slaves used clay from the river bottom to make the bricks. It is on the National Register of Historic Places. (Courtesy the Byerly and Dixon families.)

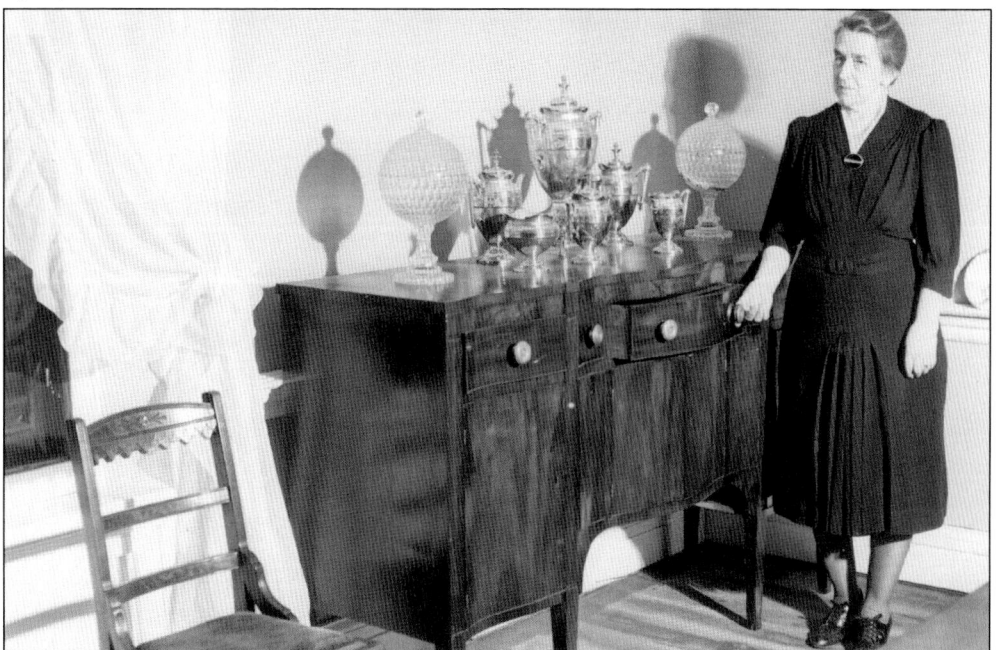

Former Pine Hall owner Mrs. J.L. Hanes is shown standing in front of a 150-year-old Sheraton buffet in January 1942. The fruit stands at the ends of the buffet are from Patrick Henry's home. (Courtesy the Forsyth County Public Library Photograph Collection.)

The heart of Pine Hall is pictured here in 1969. (Courtesy the Forsyth County Public Library Photograph Collection.)

The Dan River Bridge is shown here under construction to replace the Iron Span Bridge at Pine Hall, 1969. (Courtesy the Forsyth County Public Library Photograph Collection.)

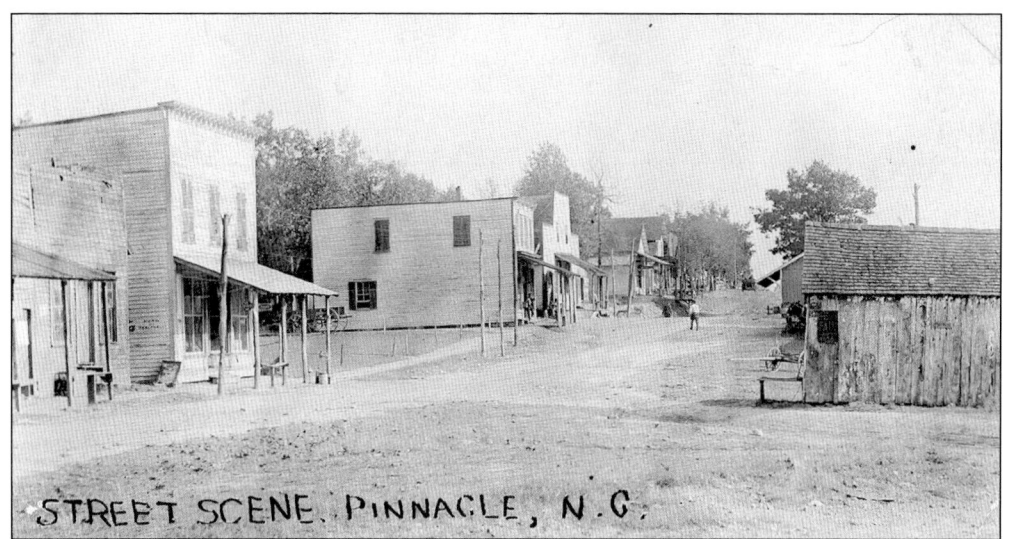

Pinnacle was originally named Culler, after Manuel Culler (also known as E.W. Culler), who laid out the town in 73 lots in 1885. The name changed to Pinnacle when the community incorporated in 1901. Named for the "pinnacle" of Pilot Mountain, the new town had several businesses including two tobacco factories, a depot, a bank, two newspapers, and a police department. Manuel Culler was elected its first mayor. Four years later, after no elections were held, the town ceased to exist as an incorporated community. (Courtesy Jean Stone Hall.)

Manuel Culler built Pinnacle Milling Company for his son Walter. After the mill closed, it became "Culler Canning Factory." It re-opened as a mill again in 1928. (Courtesy Jean Stone Hall.)

With a authorized capital stock of $10,000, the Bank of Pinnacle opened in 1919. J.W. Slate was the bank's first president, with H.H. Brown a cashier. It went bankrupt when the stock market crashed in 1929. (Courtesy Jean Stone Hall.)

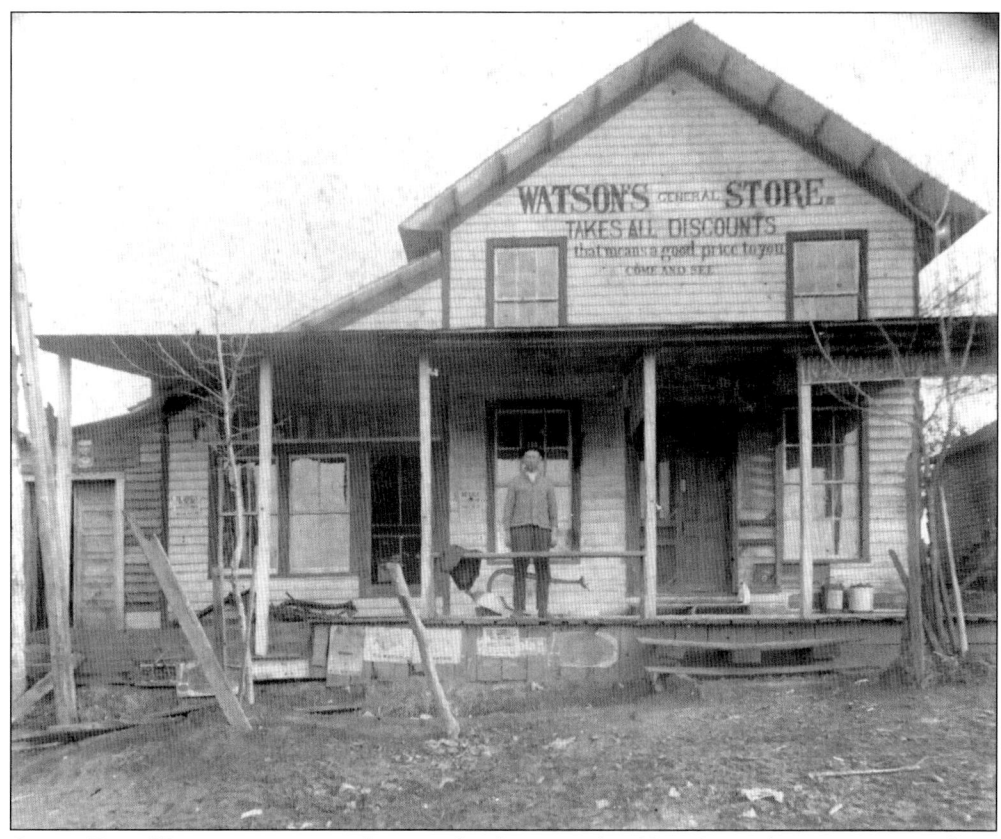

Owner Tom Watson is seen standing on the front porch of his General Store in Pinnacle, c. 1931. He sold coffins, feed, fertilizer, and furniture. (Courtesy Jean Stone Hall.)

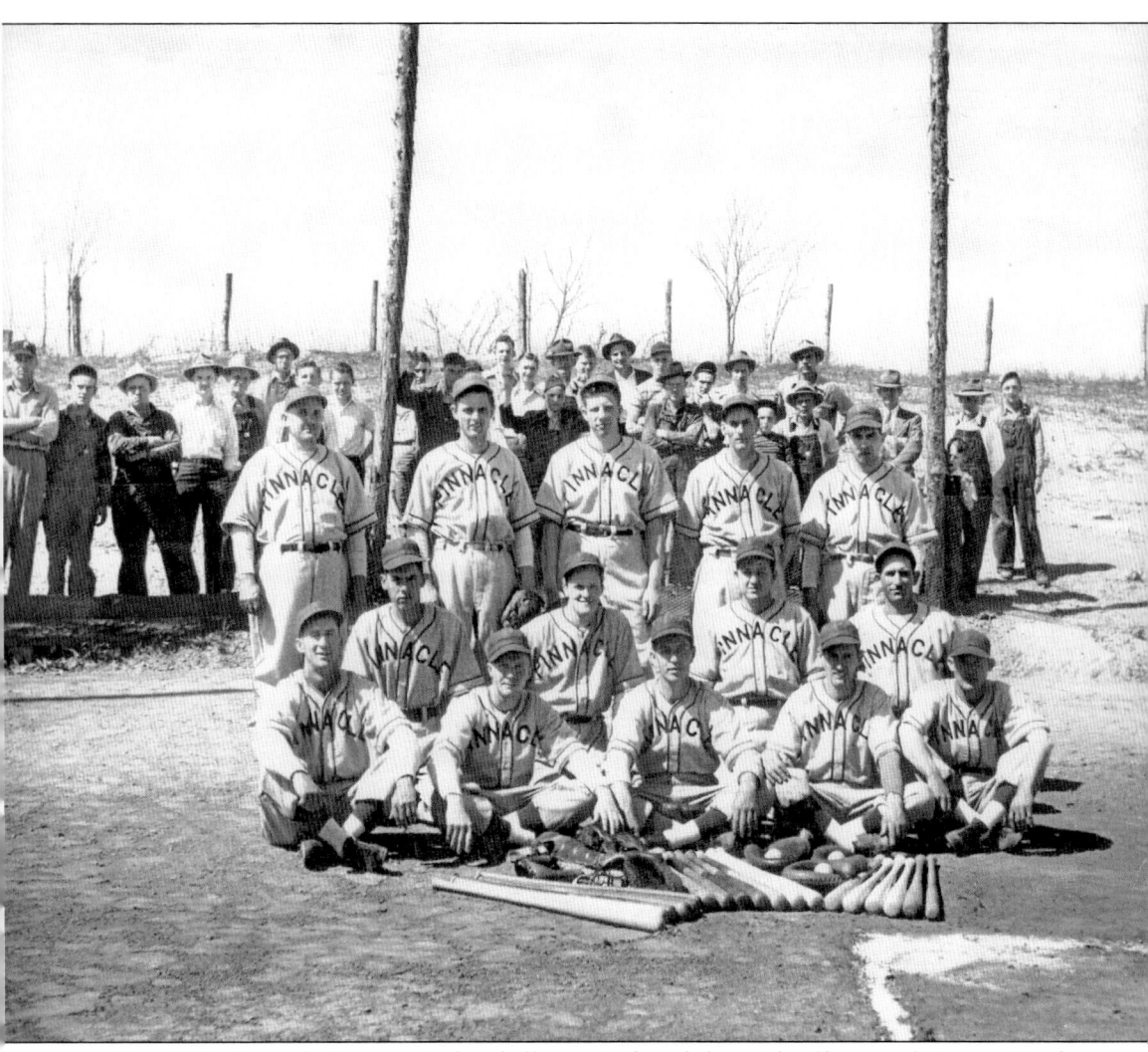

This 1940s Pinnacle Community baseball team is, from left to right, (front row) Sammy Gordon, M. Kirby, Charles Kallam, and Gray McGee; (middle row) Bobby Gordon, E.R. Sams, Raymond Kallam, and Alonzo Cole; (back row) Ralph McGee, Leonard Gordon, Norman Gordon, Bryce Cromer, and Vance Gordon. In addition to school teams, many communities like Pinnacle had their own baseball team that would bring many local residents (in the background) out to watch. (Courtesy Jean Stone Hall.)

Col. Jack Martin and his wife Nancy raised ten children in this four-story Rock House. The first stone was laid in 1770, when Colonel Martin was 14. The walls were three-feet thick and made of flat stones, with an outer covering of a type of stucco. The Rock House had a wooden roof. Construction did not end until 1785, due to the Revolutionary War. Martin died in 1822, and his wife in 1841. Both are buried near the home, surrounded by the graves of their numerous slaves. At right is the Rock House shown in the middle of a plowed field, 1930s. For years land owners and farmers worked around the crumbling landmark until preservation efforts began in the late 20th century. (Courtesy the Forsyth County Public Library Photograph Collection.)

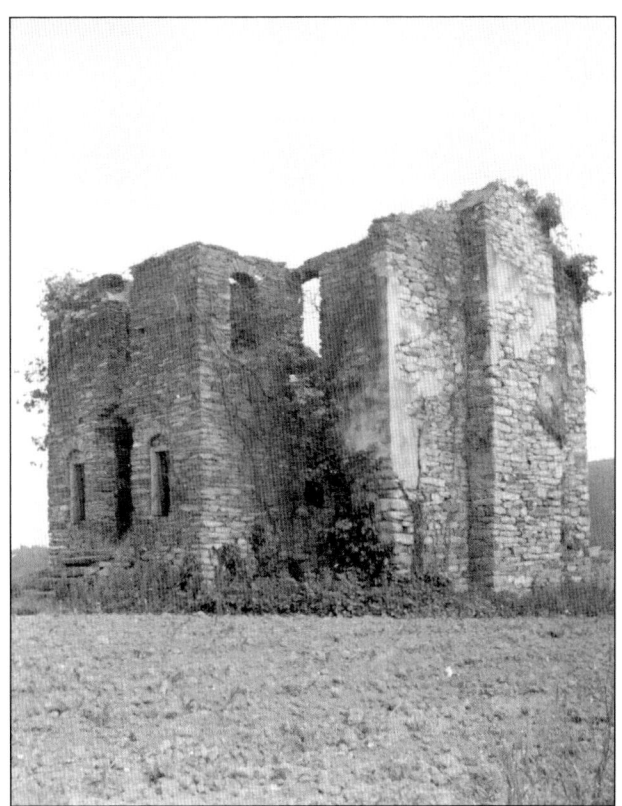

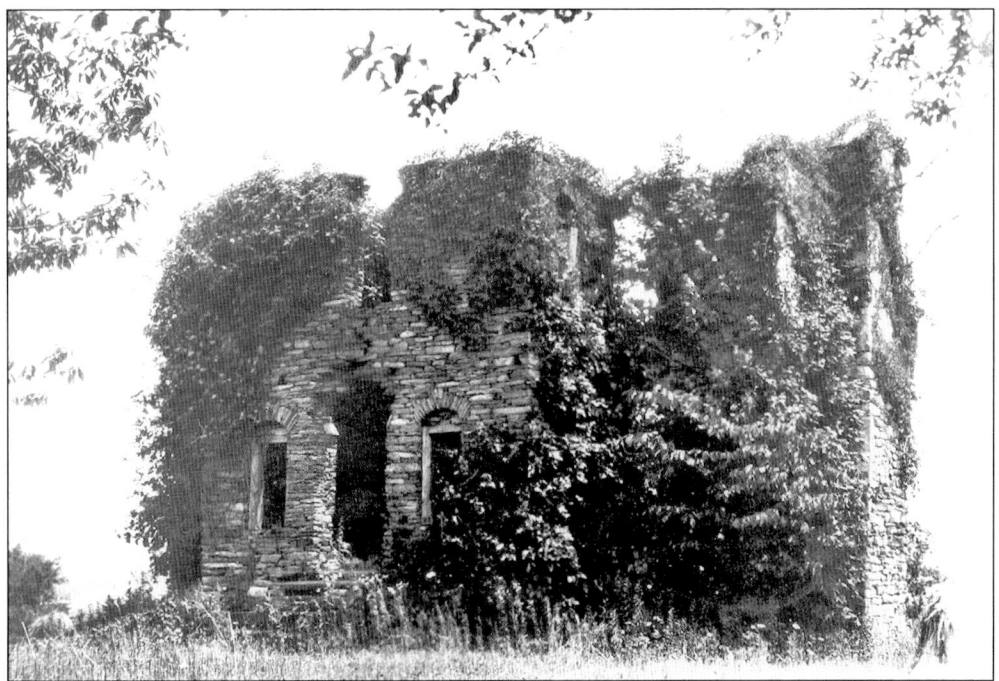

Many believe the kudzu vines that wrapped the Rock House for decades actually helped preserve the structure from crumbling. (Courtesy the North Carolina State Archives.)

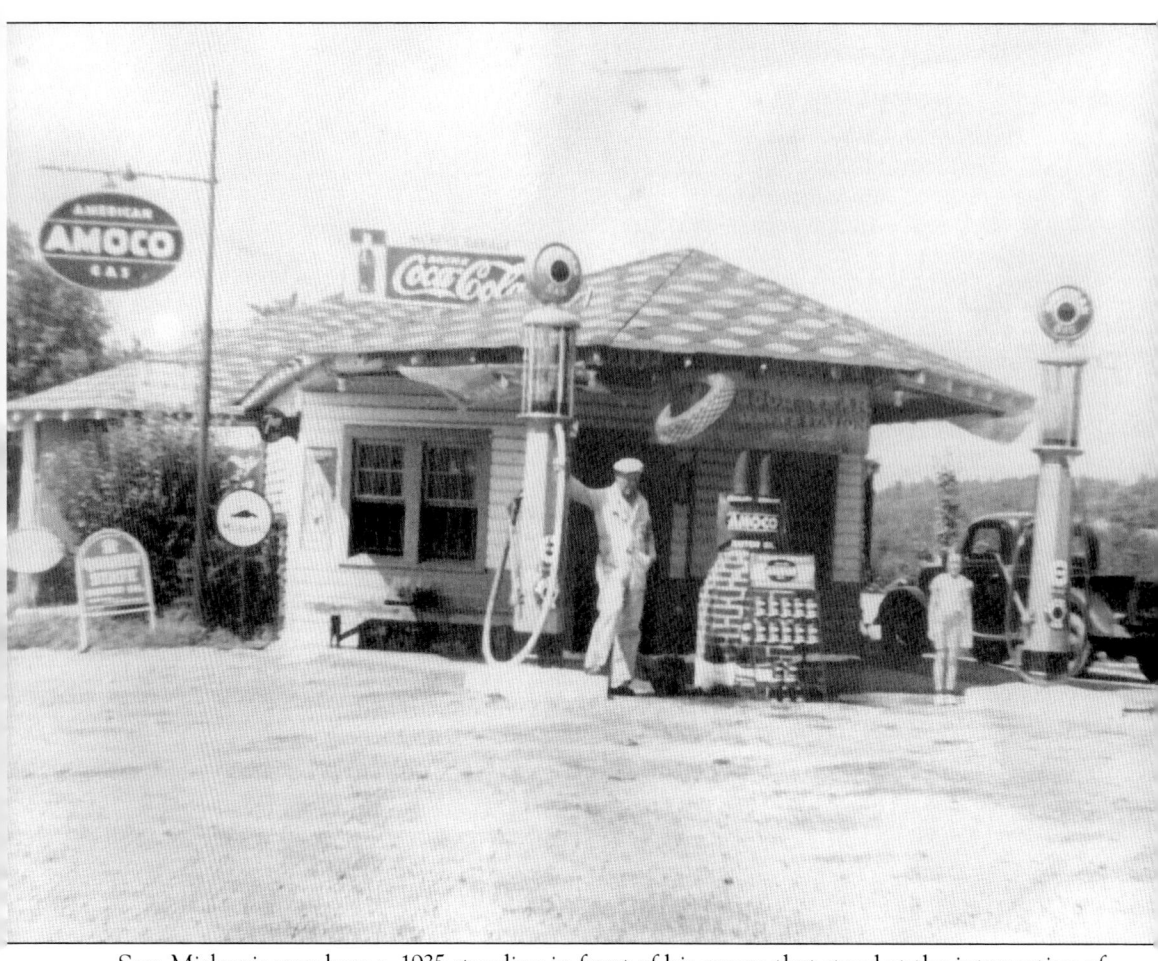

Sam Mickey is seen here c. 1935 standing in front of his garage that stood at the intersection of Highway 66 and Moore's Springs Road. A decedent of blacksmiths and a mechanic, he continued the trade for 50 years, adding a store to his garage in the mid-1920s. It became a popular hangout for locals and a stopping point for visitors of Hanging Rock State Park. It closed in 1972, after Sam suffered third-degree burns when his clothes caught fire repairing a tractor. He died seven years later. (Courtesy Norman and Shirley Mickey.)

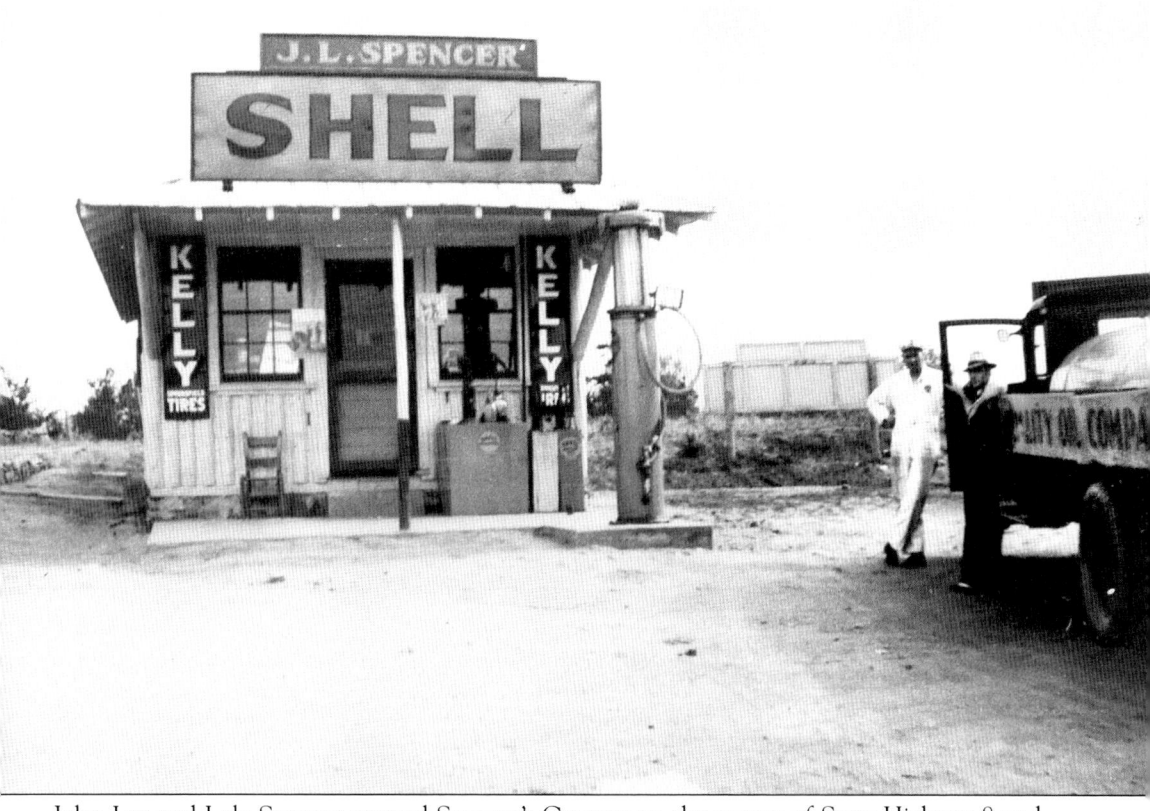

John Lee and Lola Spencer opened Spencer's Grocery on the corner of State Highway 8 and Rosebud Road in 1934 when there were no paved roads in sight. Originally built out of split logs from the family farm, it later was covered in rock. When the general store opened there was no electricity; only two oil lamps gave light to the family and their customers. When John Lee became ill and died, Lola ran the store alone until 1987. The couple's daughter Virginia Townsend reopened the store in 2004. (Courtesy Johnny Spencer.)

Sandy Ridge is seen here in the 1950s. It was from Sandy Ridge that surveyor William Byrd saw Pilot Mountain, calling it a stone chimney. Originally known as "Crooked Creek," the postal service changed the name to Sandy Ridge in 1873. The name Sandy Ridge comes from Joseph Scales's plantation, due to its sandy soil. (Courtesy the Priddy family.)

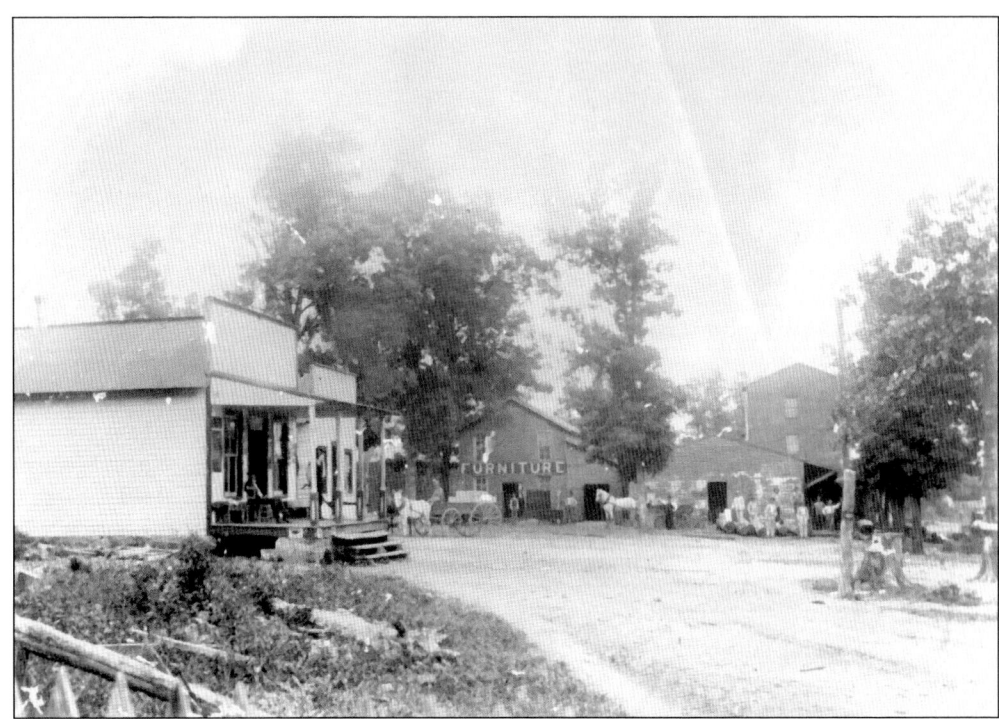

A.T. Overby, a traveling photographer, captured this c. 1899 picture of Jim Shelton's Furniture Company, Rolling Mill, and (far left) General Mercantile in Sandy Ridge. Shelton employed several workers from the community who made coffins, furniture, and oak boxes used for packaging plug chewing tobacco. The boxes were hauled by wagon to Madison, 14 miles away where they were placed on a train and shipped to Winston-Salem. (Courtesy Darrel Lester.)

The Colonel Covington Home, between Danbury and Walnut Cove is seen here in 1951. (Courtesy the Forsyth County Public Library Photograph Collection.)

Built in 1820, the Covington home was photographed in 1951 for a *Winston-Salem Journal* article about the newly restored home. It took owners Stanley and Grace Rodenbough two years to restore the estate. (Courtesy the Forsyth County Public Library Photograph Collection.)

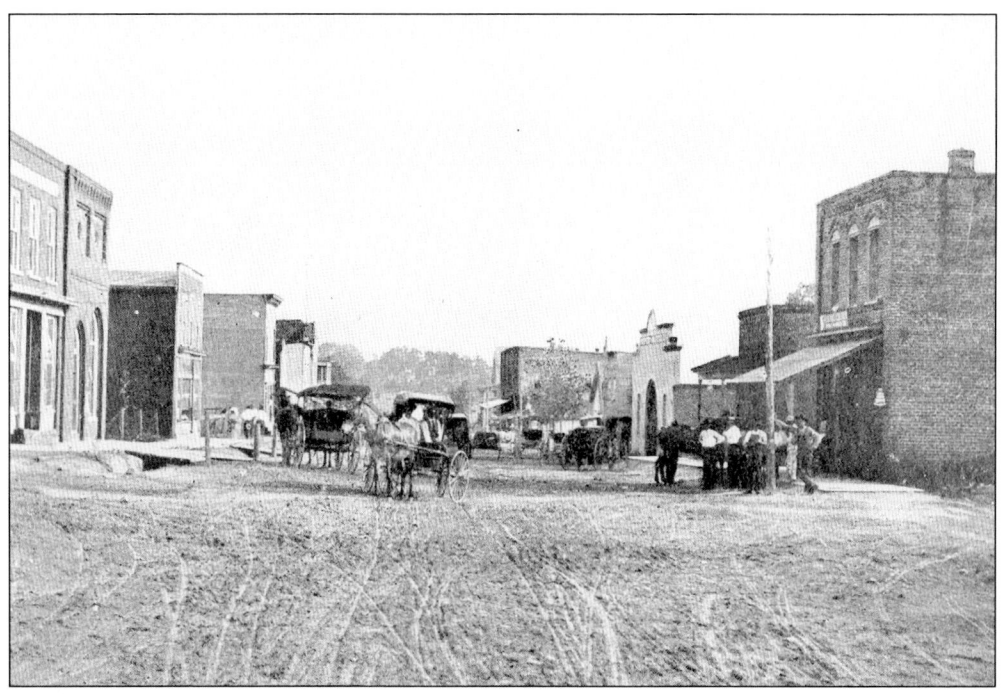

Main Street in Walnut Cove is pictured above c. 1915. (Courtesy the North Carolina State Archives.)

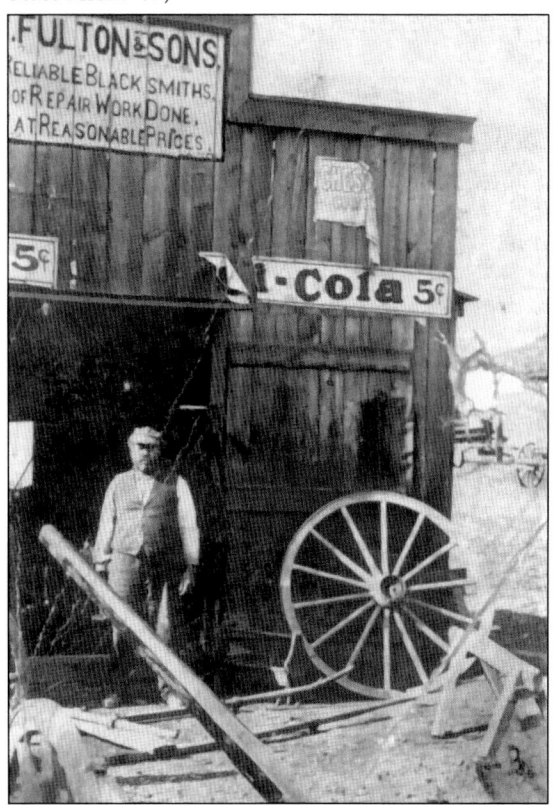

George Fulton, shown at left c. 1900, was born into slavery and worked most of his life as a blacksmith in Walnut Cove with his sons. Walnut Cove's namesake comes from the Lash Family Estate. The family bought land along the Town Fork Creek in 1830. Over several decades and generations the family built a plantation they called "Walnut Cove" for the numerous walnut trees growing in the coves of the Town Fork Creek. First called "Lash's Store," the community took on the "Walnut Cove" name when its charter was signed in February 1889. (Courtesy Mabel Johnson.)

From left to right, Roosevelt Hairston, Joe Hairston, Cecil Landreth, and James Hairston are pictured working on the Southern Railroad in Walnut Cove, 1940s. (Courtesy Mabel Johnson.)

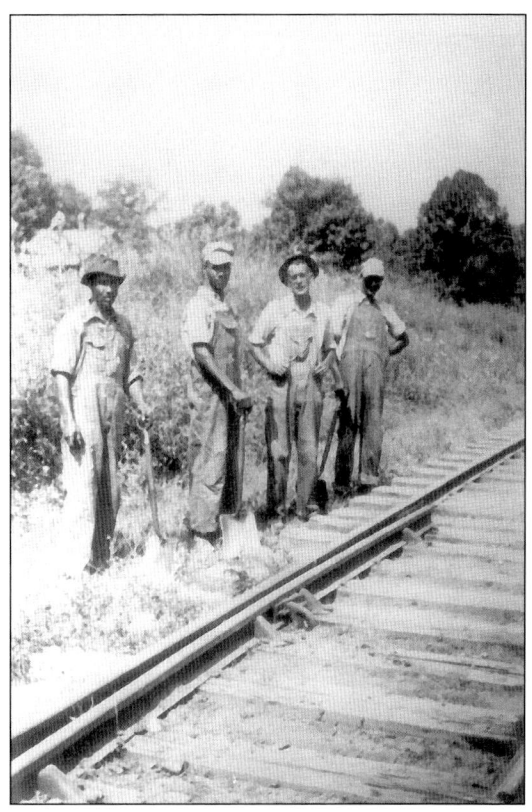

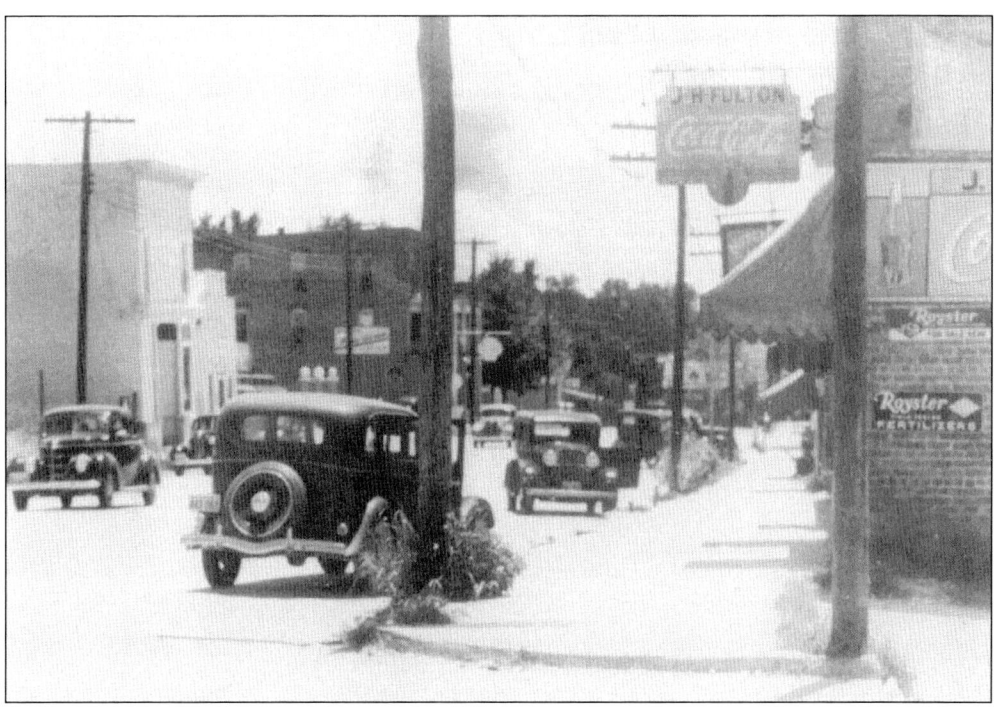

Main Street in Walnut Cove is pictured c. 1937. (Courtesy Town of Walnut Cove.)

The Bank of Stokes County had a Walnut Cove office on Main Street, in this c. 1905 photograph. (Courtesy Mabel Johnson.)

The Walnut Cove Motor Company sold Fords on Main Street in the 1920s. (Courtesy Ellen Pepper Tilley Collection.)

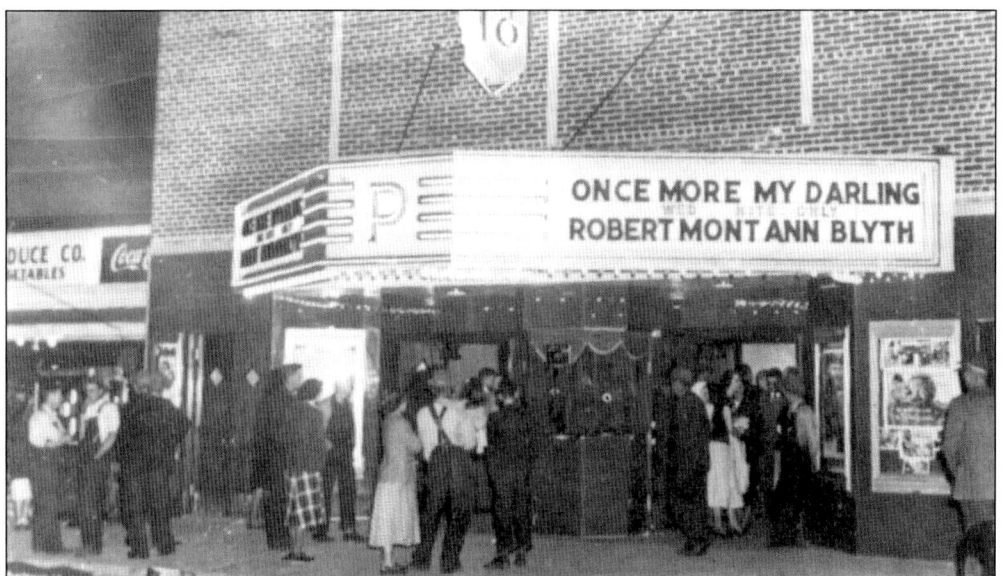

The Palmetto Theater stood on Main Street in Walnut Cove c. 1947. (Courtesy Town of Walnut Cove.)

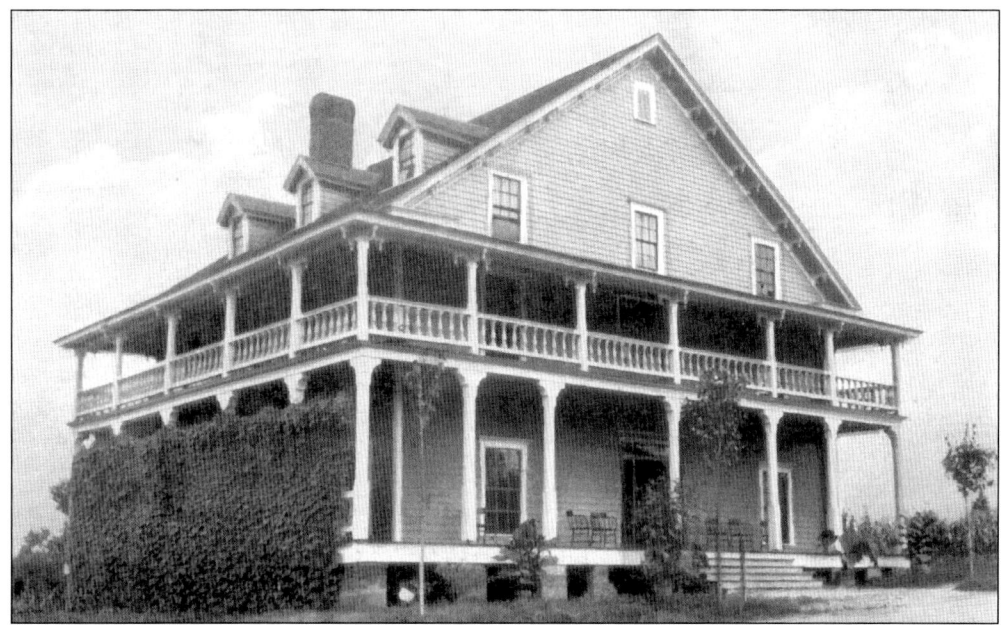

The Walnut Cove Hotel is seen in this postcard postmarked August 1910. The three-story framed gingerbread structure with wrap-around porches was also known as the Vaughn Hotel. (Courtesy Wayne and Louise Biby.)

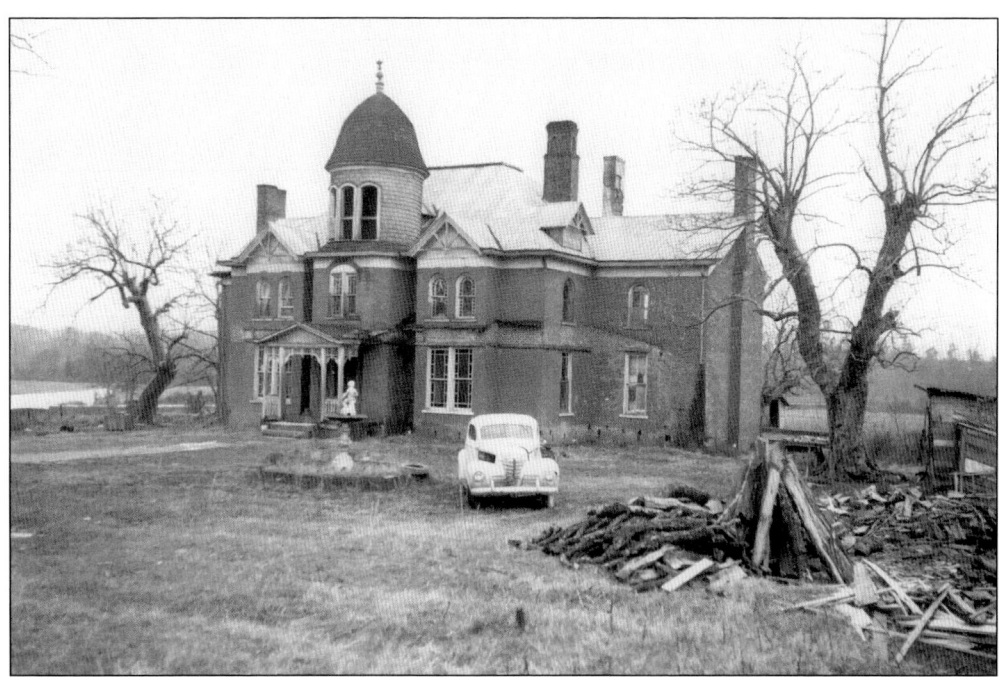

The Lash House in Walnut Cove is pictured here in February 1950. The Lash family were one of the first families to move near Town Fork Creek. The family called this plantation "Walnut Cove," which became the community name in 1889. Their Victorian-style home, seen above, had numerous rooms including a wine cellar, recreation room, and laundry room with a large fireplace that also served as a bedroom for a servant. The grounds had a summer house on the south lawn, a water fountain on the front lawn, barns, stables, and a carriage house, as well as individual living quarters for slaves. The attic was topped with a large dome making the house appear to have three stories. A windmill was erected to pump water to the plantation. (Courtesy the Forsyth County Public Library Photograph Collection.)

Sauratown Plantation stood near Walnut Cove in this 1942 picture. (Courtesy the Forsyth County Public Library Photograph Collection.)

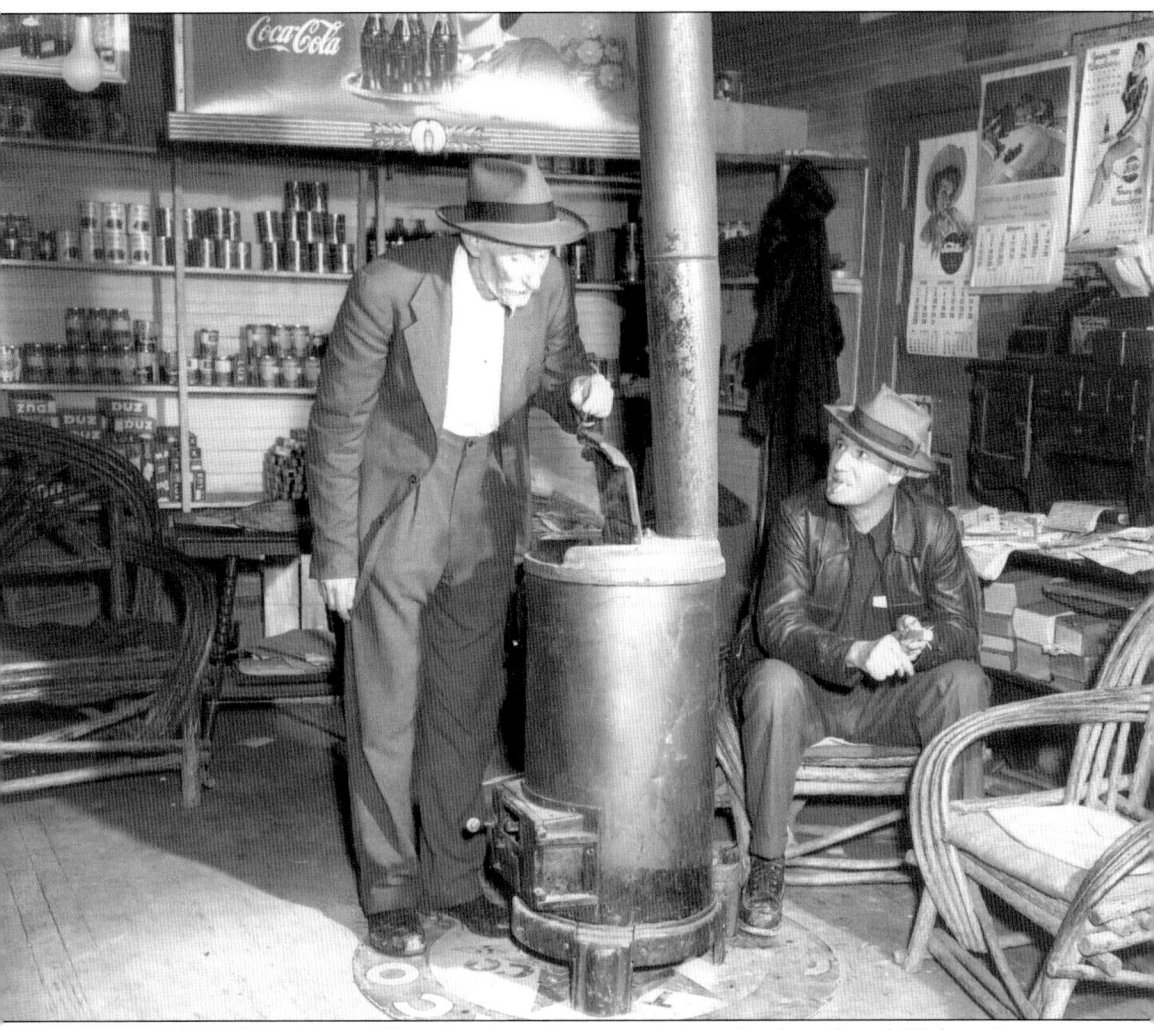
Former Walnut Cove Mayor Elkin Smith is shown with his whittling friend Walnut Cove businessman Hassell Fagg in Walnut Cove, February 1950. (Courtesy the Forsyth County Public Library Photograph Collection.)

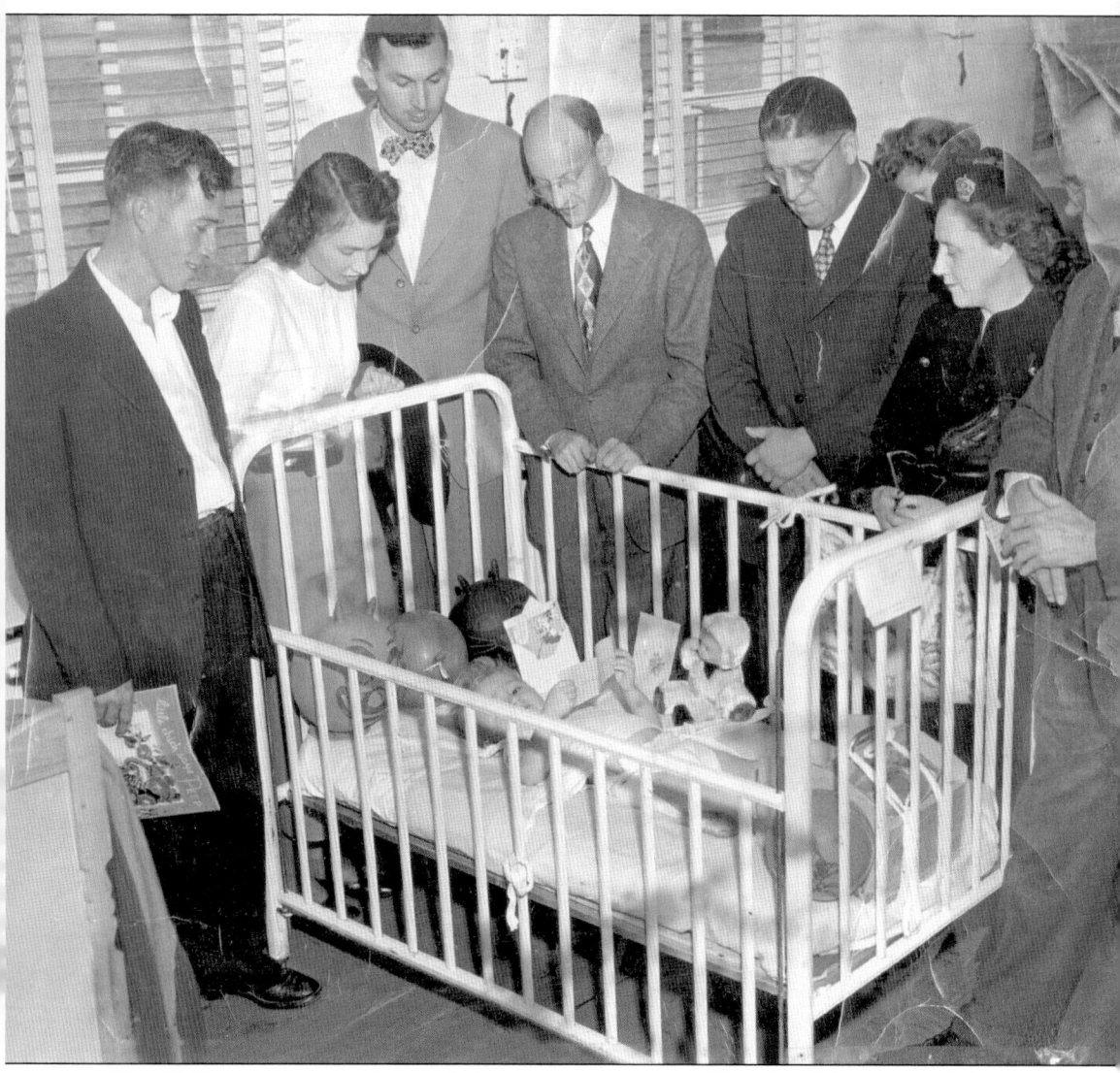

The 1948 newspaper caption read, "no new cases reported," under this picture of three-year-old Billy Heath of Walnut Cove, a victim of the polio epidemic. The newspaper photographer captured the toddler, his parents, and members of the Walnut Cove Rotary Club who had come to present a check of nearly $4,000 to the Central Carolina Convalescent Hospital in Greensboro. The hospital was built in just 95 days during the epidemic to help hundreds of children from all over the area, including Stokes County, suffering from polio. (Courtesy Billy Heath.)

Two

WHERE WE WERE TAUGHT

I remember it, like it was yesterday, it would be cold, but we did it, we would walk up and down those hollers, every morning all the way to Old Orchard School. It was a small building and we were kin to just about everyone in it.
—Johnsia Burwell Hall, recalling walking to school in the Gap community in the 1920s

It was each community's foresight that gave birth to the education system in Stokes County. At first, children were taught in churches and community-built schools that were at most nothing more than small wooden structures. Such structures make up most of the more than 100 schools recorded in Stokes County history.

The students, who started the school year when the crop was in and ended when the seeds were sown, rarely attended school for more than a couple of years. A 1915 census showed over half of Stokes County students quit their first year. Teachers, usually brought in, were paid about $3 a month to teach in the late 1800s. For some schools they were so small there wasn't even a grade level.

By the turn of the 20th century the public school system in North Carolina had finally taken shape, postponed by the Civil War. The small wooden structures started consolidating into districts created throughout the county. As communities and towns started to take shape, so did the center of learning. By 1940 each present-day community had its own school, teaching all grades, most in one building. Early community founders donated the land and labor that gave birth to stronger minds. Many present-day Stokes County schools still sit, some in newer form, on that donated land—places where students are still yielding the benefits of founding hands.

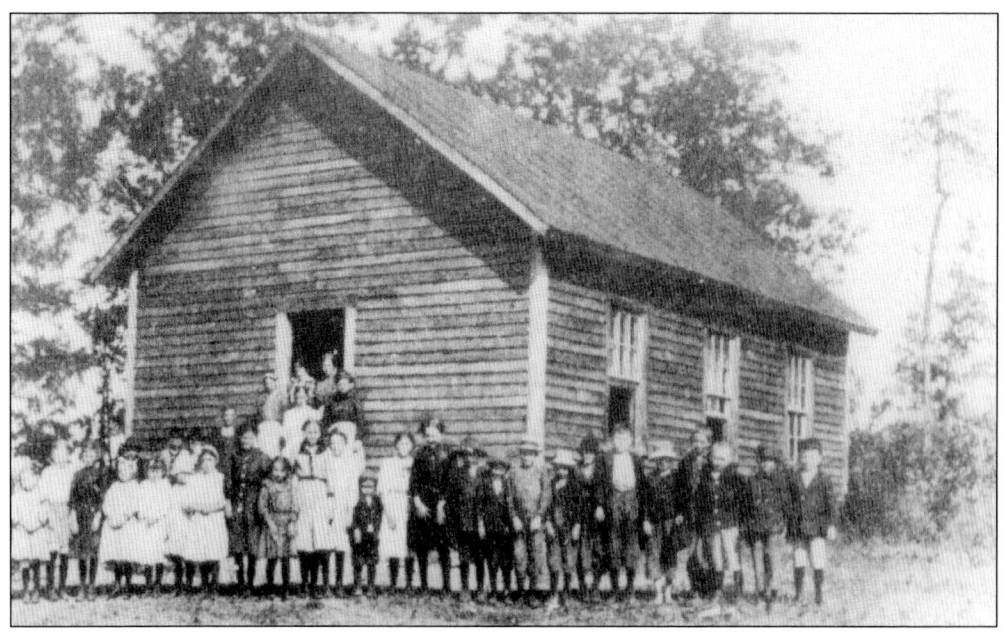

Some students had to walk nearly five miles to the Amostown School near Sandy Ridge, where teacher Mrs. Cadelia Martin started her classes at eight o'clock on the dot. She taught from first to seventh grade here with an average of 30 students a day when this picture was taken c. 1914. (Courtesy Stokes County Historical Society.)

The Creason School near King is pictured here c. 1898. (Courtesy Adeline Kiser.)

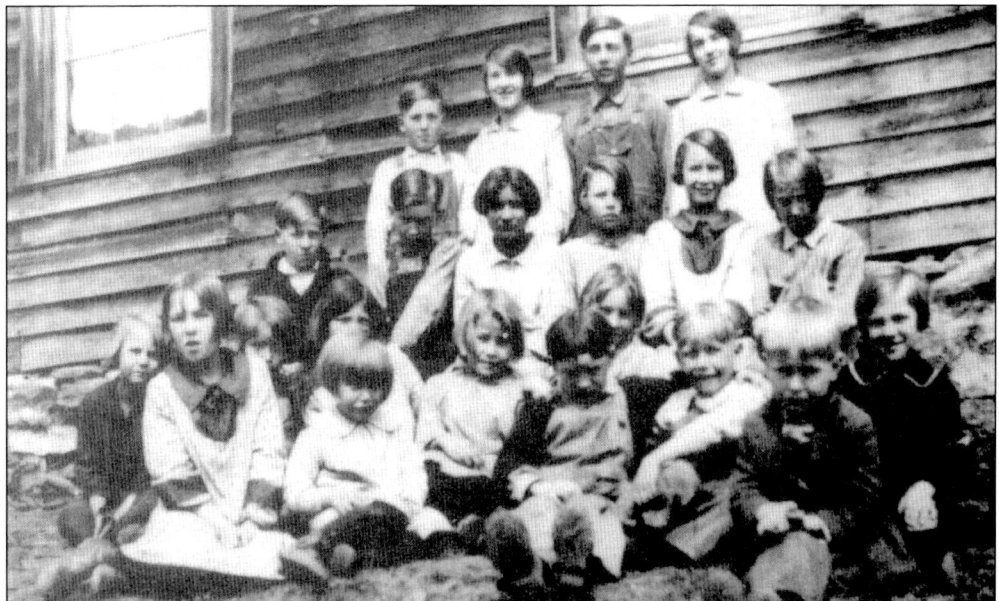

Students of the second Boaz School, in the Vade Mecum Community, are shown here in the late 1920s. From left to right are (first row) Connie East, Evelyn Vaden, Sam Pyrtle, Troy Vaden, and Harden East; (second row) Dorothy Tilley, unidentified, Eunice Tilley, Nellie East, and Lucille Vaden; (third row) Harvey Vaden, Tom East, LuElla Pyrtle, Sadie May Lightsey, Juanita East, and Annie Vaden; (fourth row) Herman Vaden, Delise Vaden, Howard Vaden, and Elise Vaden. (Courtesy Norman and Shirley Mickey.)

Built in 1872, the Dalton Institute, near King, was known for being one of the best private schools in the area. As many as 25 male and female students attended each year from as far away as Mount Airy and High Point. Dalton Institute is noted for turning out many students who went into the field of medicine and law. Tuition per session included primary English $10; higher English $15; languages $18; and board, including fuel and washing, $7 to $8 per month. The institute closed its doors in 1908. (Courtesy Jean Stone Hall.)

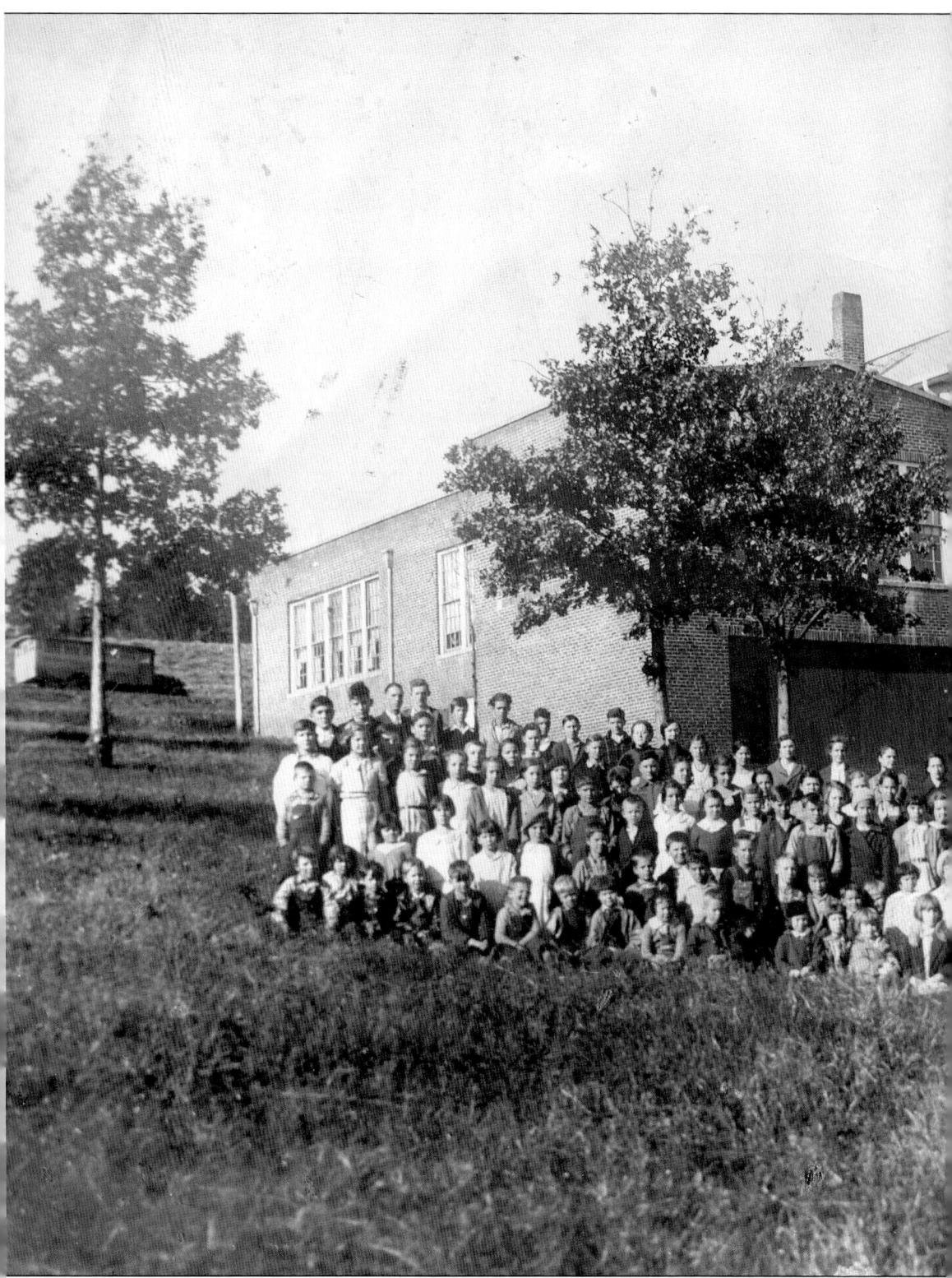

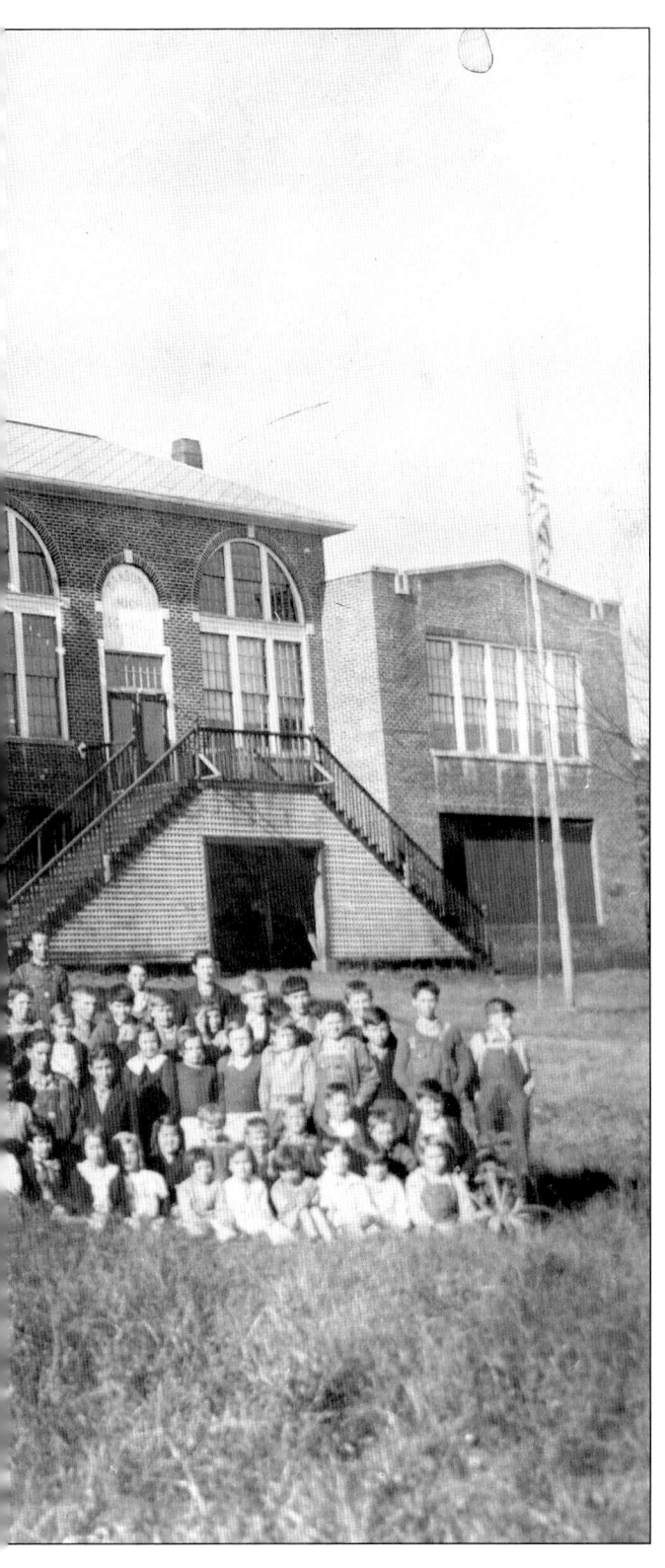

Danbury High School, seen here in the early 1930s, was built in 1925 for grades 1 through 10. Some students would have to travel to Walnut Cove to finish high school. The Danbury School was later reduced to grades one through seven due to low enrollment and closed in 1964 when the county schools consolidated. Some of the students identified in this picture are Junior Alley, Vance Alley, Lena Priddy Brann, Glenn Fagg, "Poe" Fagg, Edith Flinchum, Stedman Flinchum, Carrie Goins, Marie Goins, Lyman Hall, Winfred Hall, Ginger "Jenna" Joyce Hammet, Robert King, Paris Pepper, Carlyle Petree, Margie Petree, J. Elwood Priddy, Jean Priddy, Angela Taylor, Roy Lee Venable, Lois Wall, and Magaline Wilson; teachers included ? Hall, Janie Martin, and Mallie Sue Taylor. (Courtesy the Priddy family.)

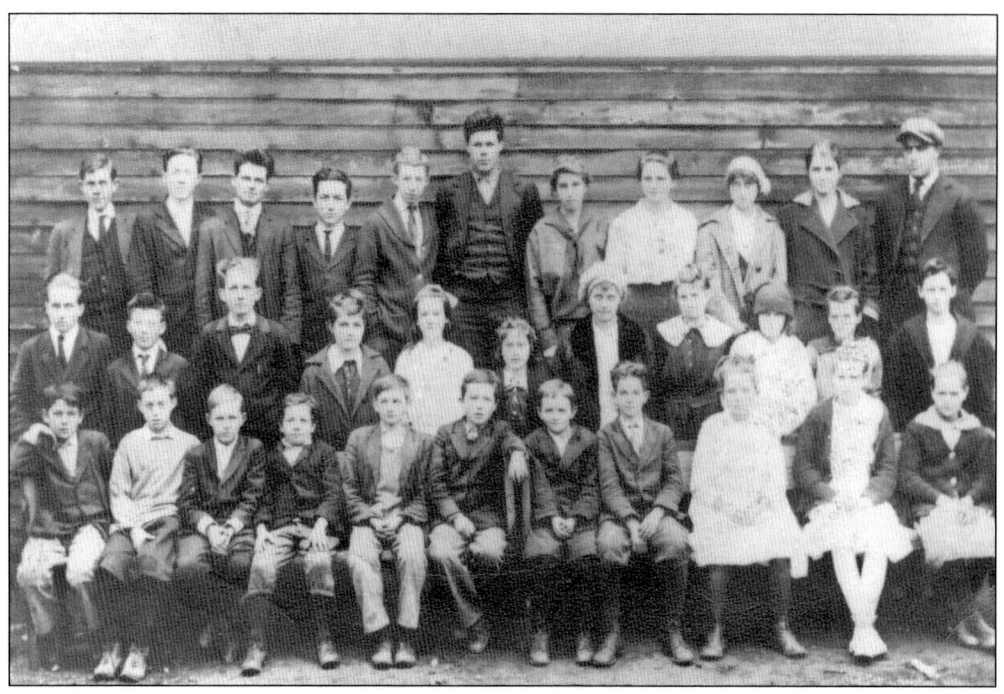

Danbury School students are pictured above in the fall of 1914. (Courtesy Ellen Pepper Tilley Collection.)

From left to right Weldon Mabe, Homie Mabe, and Will Bennett are seen standing outside of the Fagg School, near Lawsonville on State Highway 8, in the early 1920s. Student Felmore Flinchum is standing in the doorway. (Courtesy Virginia Whitten Mitchell.)

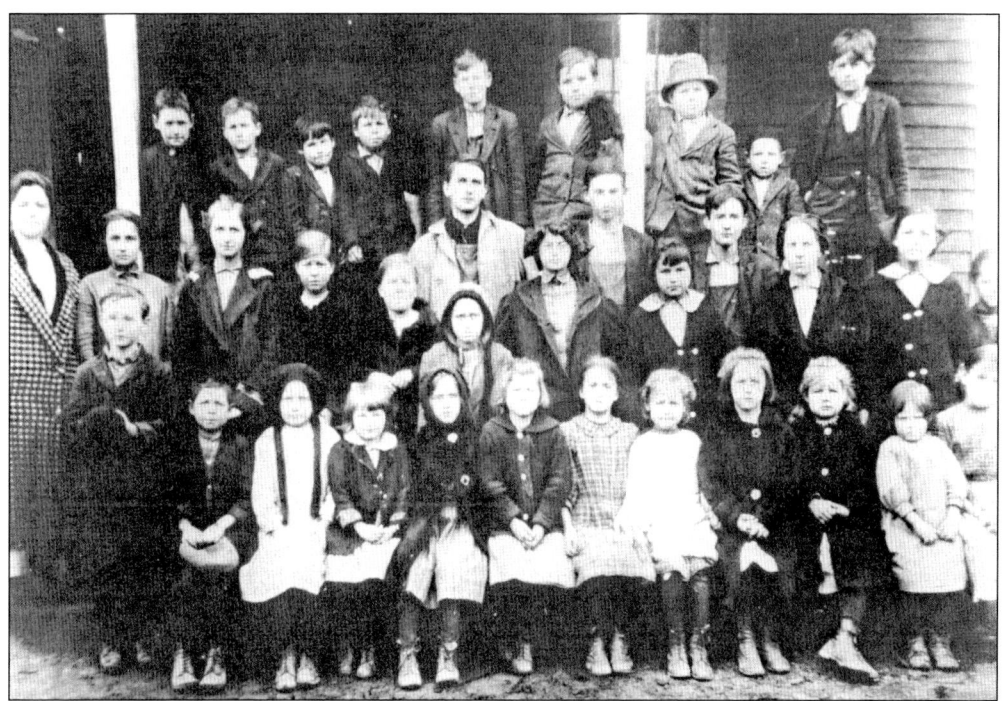

Flat Shoals School's students are pictured here c. 1905. (Courtesy Virginia Whitten Mitchell.)

Francisco High School, Class of 1926 and 1927 are seen in this photo. After a larger school was constructed in 1930, Harts Academy, Collinstown, and Asbury Schools consolidated with Francisco School. (Courtesy Stokes County Historical Society.)

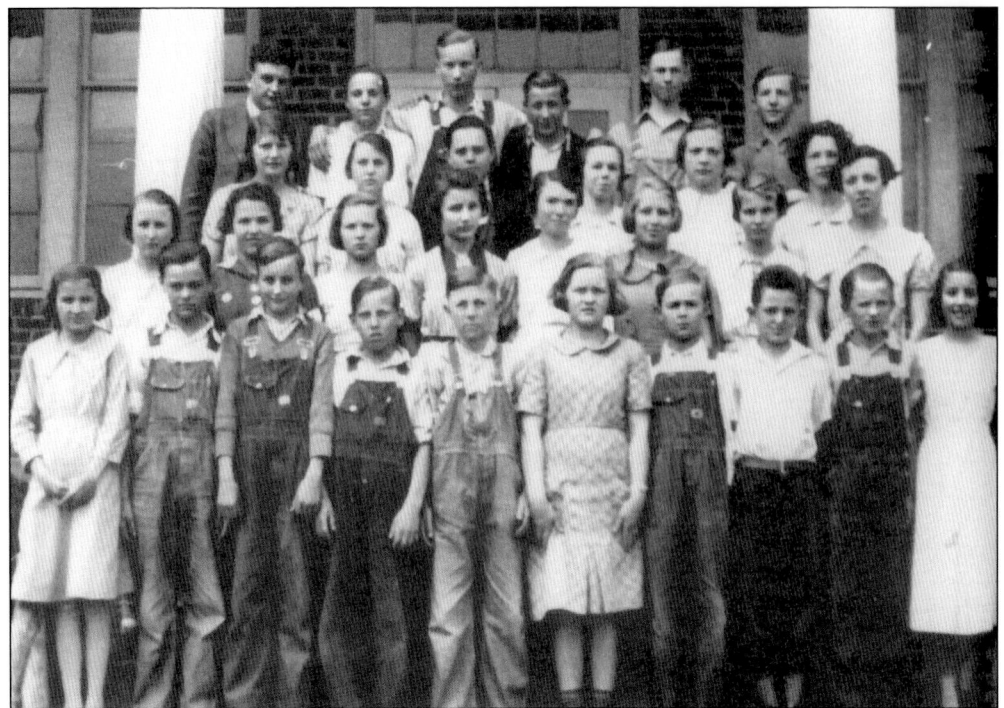
The seventh-grade class of Germanton School lined up for this picture c. 1934.

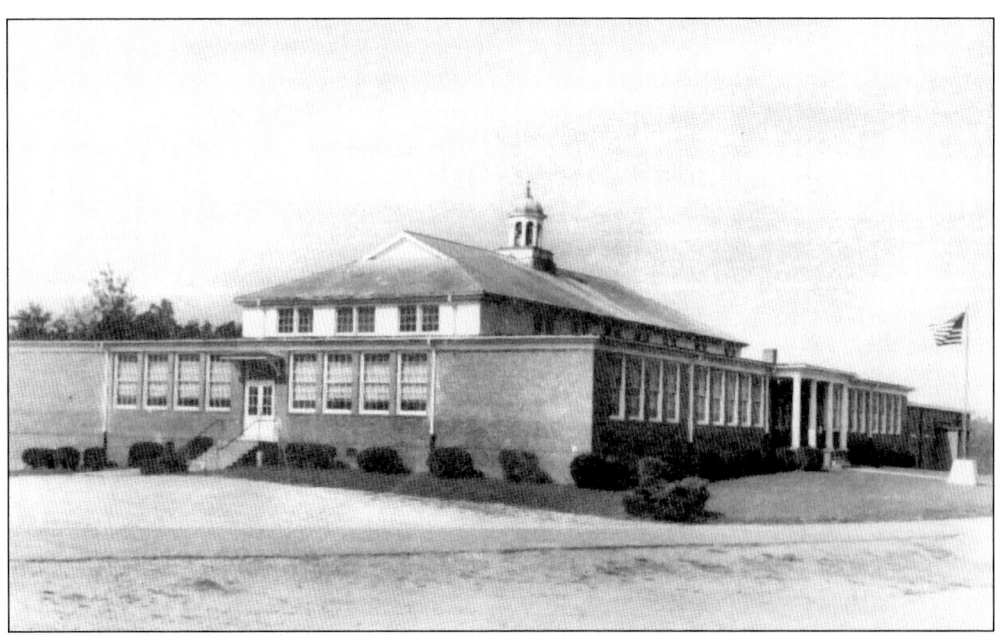
Germanton School was built in 1923 for all grades. When the county schools were consolidated in 1964, the school became a K–8th grade school. The school closed and was abandoned after the construction of a new elemenrary and junior high school in 1975. (Courtesy Stokes County Historical Society.)

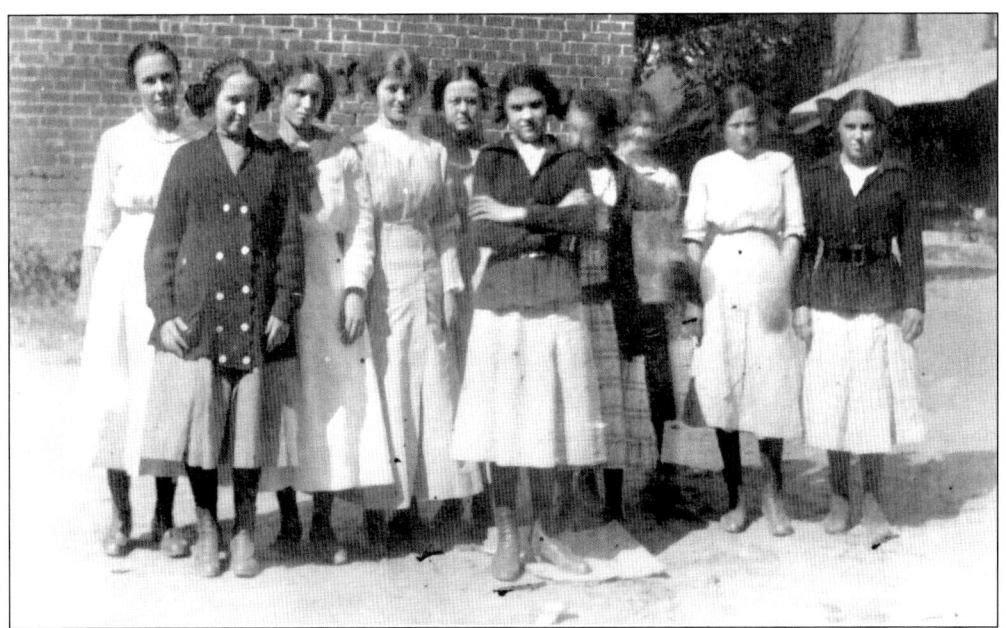

Graduates of the Stokes County Teachers Institute in Germanton pose in 1917. People wanting to teach in the area's many one-room schoolhouses would travel to the institute to receive teacher training from the State of North Carolina. (Courtesy Virginia Whitten Mitchell.)

Ida Mae Bowman's temporary certificate to teach was issued in 1917. Seen fourth from the left in the picture at the top of this page, Bowman would receive her permanent teaching certificate as a county elementary teacher the following year. (Courtesy Virginia Whitten Mitchell.)

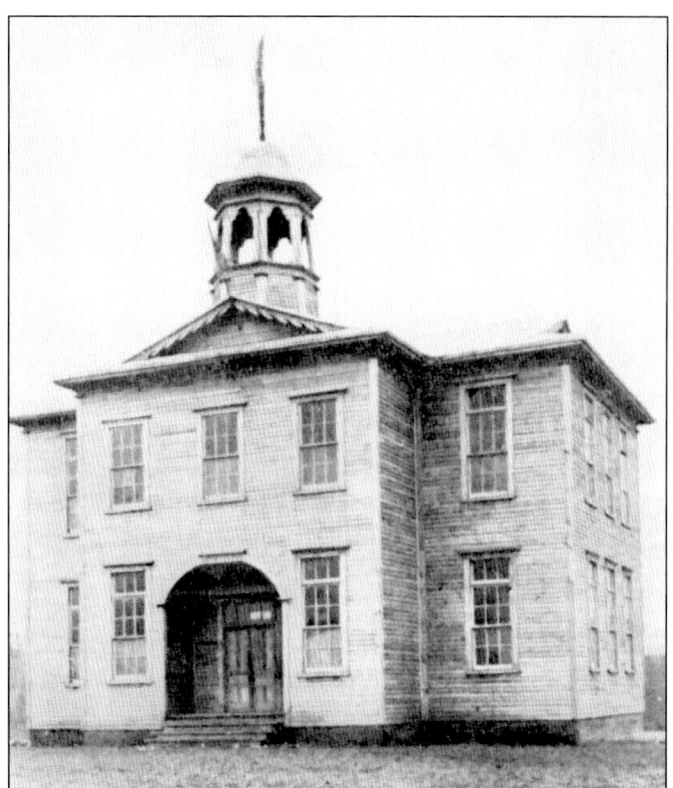

State High School, in King, is seen at left c. 1910. (Courtesy Stokes County Historical Society.)

In 1909, people in the King community raised the elementary school house to build two rooms underneath, creating the State High School. In 1928, small schools in the surrounding communities of Capella, Chestnut Grove, Creason, Dry Springs, Flat Shoals, Friendship, Haw Pond, Mount Olive, Mountain View, Oak Grove, and Pine Log consolidated in King. The new 20-room brick building (right), in front of which second-grader Jerry Stanley stands in 1954, housed many firsts, including indoor bathrooms, drinking fountains, electricity, and central heating. (Courtesy Stacey Bennett and Julia Vanhoy.)

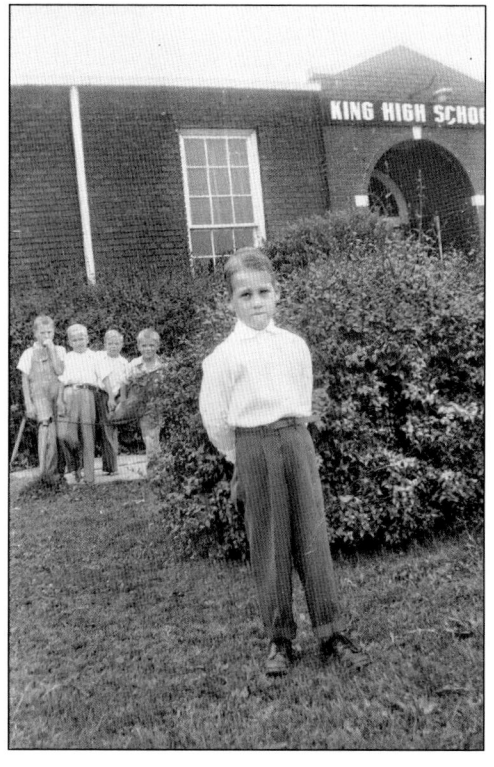

Members of State High School's Class of 1925 are photographed in front of Stokes County school bus 11 in King. (Courtesy Becky Rains Moser.)

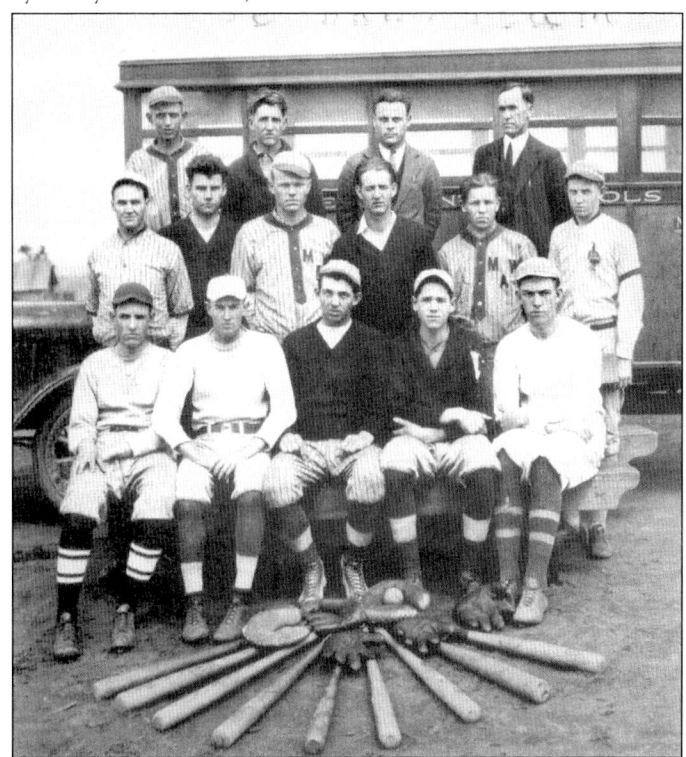

King was represented by State High School's 1925 baseball team. (Courtesy Becky Rains Moser.)

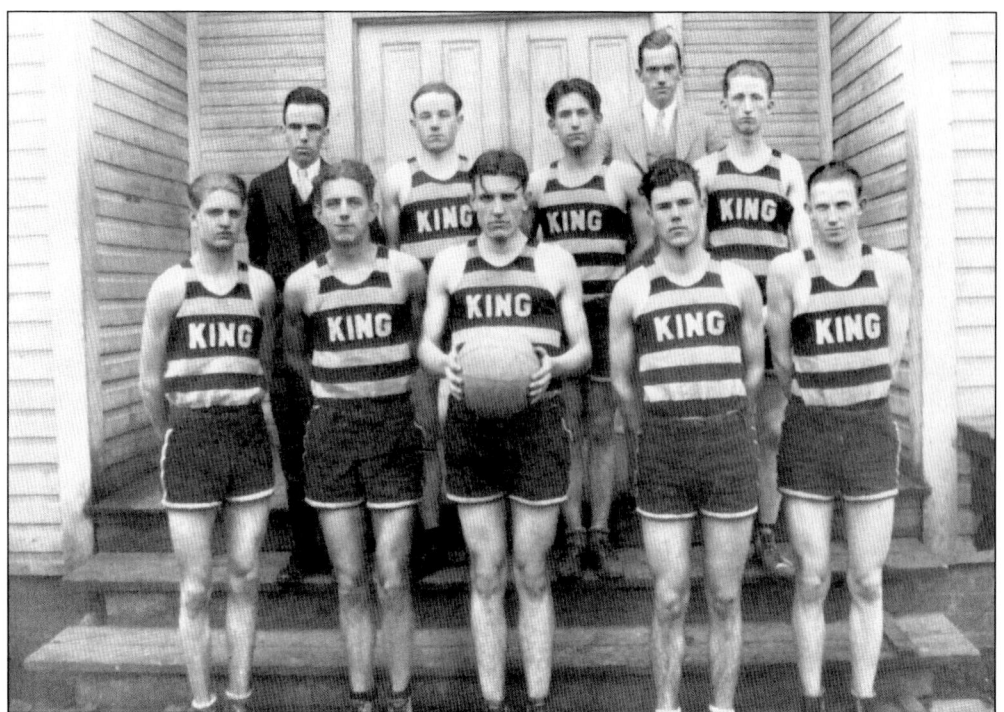

Here is State High School's Men's Basketball Team of 1927–1928. (Courtesy Becky Rains Moser.)

The women's basketball team of 1937–1938 stand outside of King High School with their trophies. (Courtesy Becky Rains Moser.)

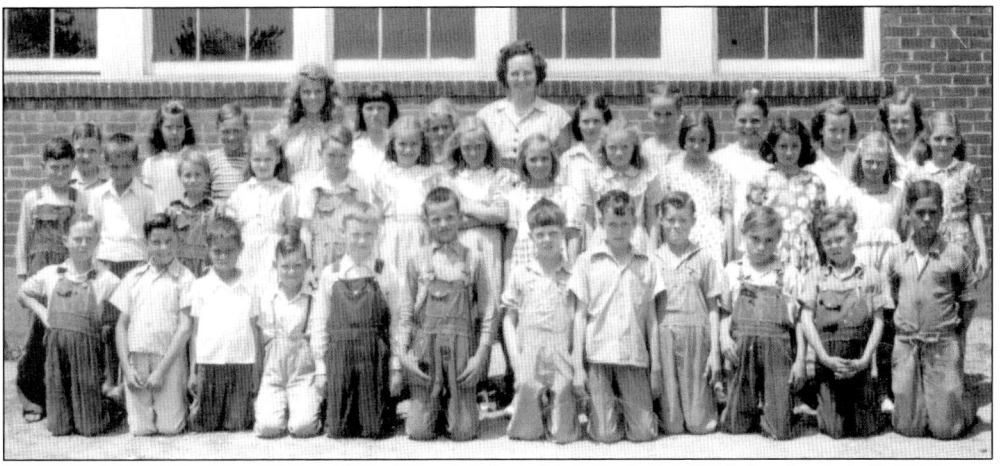

Pictured here is Agnes Tucker's fourth-grade class from Lawsonville School in 1947. (Courtesy Virginia Whitten Mitchell.)

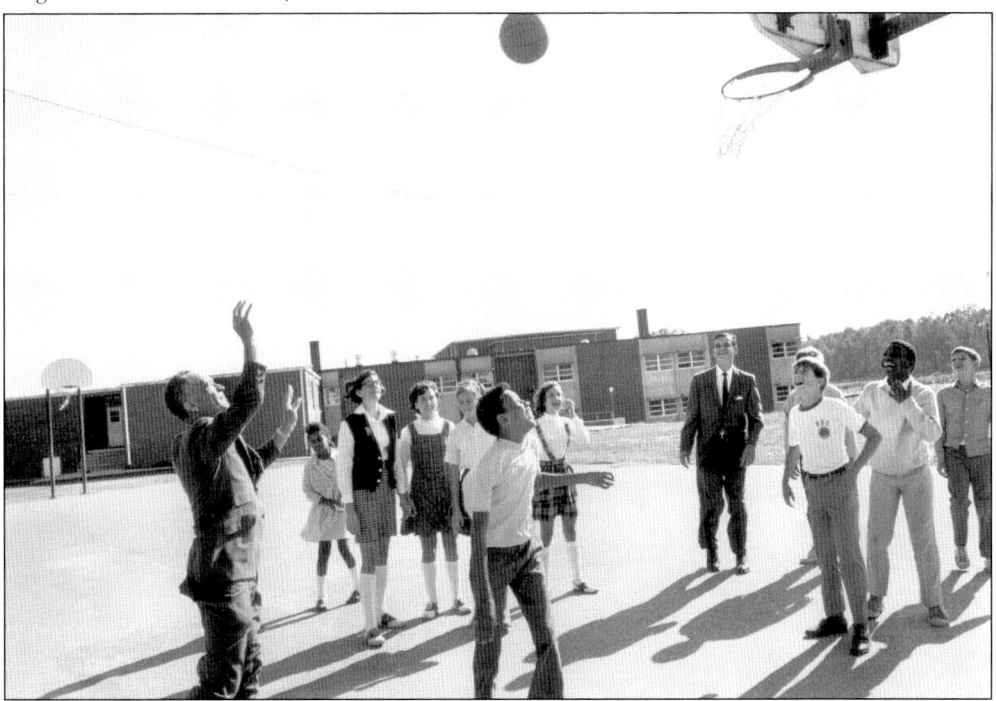

London School principal John L. Hairston, shown tossing the basketball, is credited with saving the London School from closing. In 1968, to complete desegregation in Stokes County, the school board voted to close London School, dividing the all black-school into other schools in Walnut Cove. Built in 1952 as the county's first and only all-grades school for blacks, London School was an achievement for the black community. With his determination, perseverance, and calmness, Principal John L., as he was called, fought and even put his job on the line to keep the school open. The London community followed, petitioning and protesting the school board. The children, alone, marched through the streets of Walnut Cove in protest. In the end, the school remained open; today it is an elementary school attended by students of all races. Also pictured is former Walnut Cove mayor Jack Gentry playing basketball with students at London Elementary. (Courtesy Mabel Johnson.)

Nancy Jane Cox Reynolds Memorial School is shown with its student body c. 1924. (Courtesy Norman and Shirley Mickey.)

The Nancy Reynolds Class of 1934 pose on the front steps of their school. (Courtesy Paul Covington.)

When William Neal Reynolds and Walter R. Reynolds, brothers to tobacco tycoon R.J. Reynolds who died in 1918, started gaining wealth in the tobacco industry, they built a memorial school in honor of their mother at her homeplace in Stokes County. With six classrooms, two offices, and one auditorium, the school cost $25,000 to build in 1923. It was considered one of the most elaborate schools of its day, opening its doors to students who were attending one-room cabin schools with poor heat and no running water. At right is the Nancy Reynolds first women's basketball team, 1924–1925. Sallie Tilley, Mabel Coffer, Gladys Paige, Myrtle Hall, and Ethel Taylor are pictured. (Courtesy Norman and Shirley Mickey.)

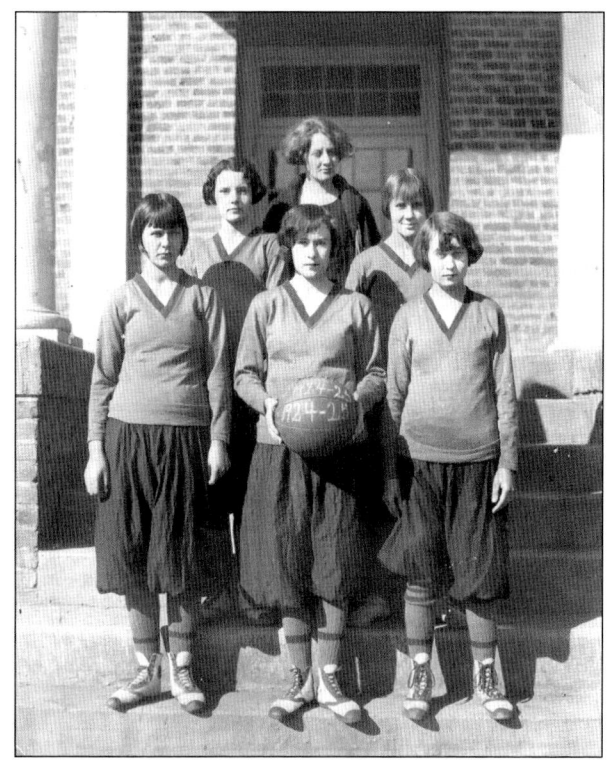

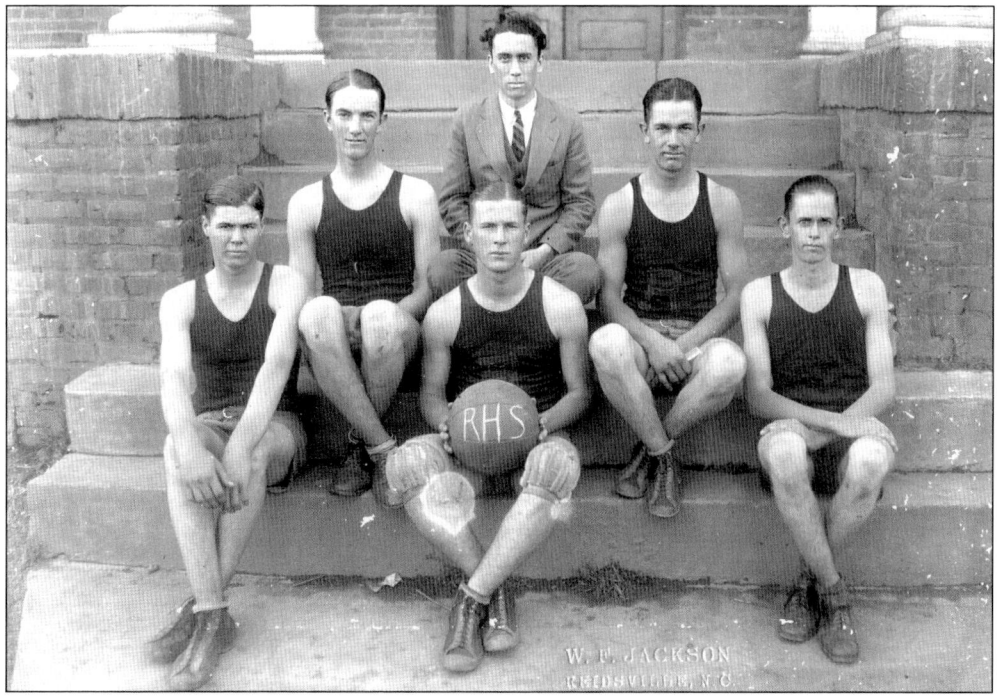

Nancy Reynolds's 1927–1928 men's basketball team is, from left to right, (front row) Wesley Cox, Orville Nunn, and Joe Coffer; (back row) Lester Owen, Tom Burwell, and coach Charles Williams. (Courtesy Norman and Shirley Mickey.)

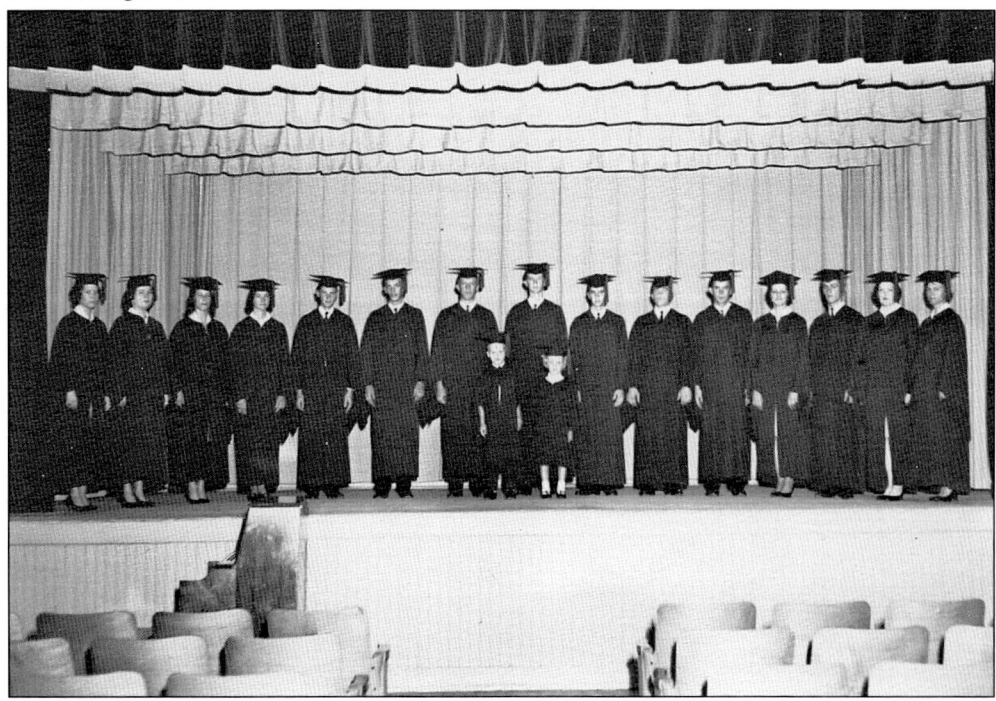

The Nancy Reynolds Booster Club members pose in their long johns in 1953. (Courtesy Paul Covington.)

This was Nancy Reynold's last graduating class before consolidation of the county high schools in the fall of 1964. (Courtesy Paul Covington.)

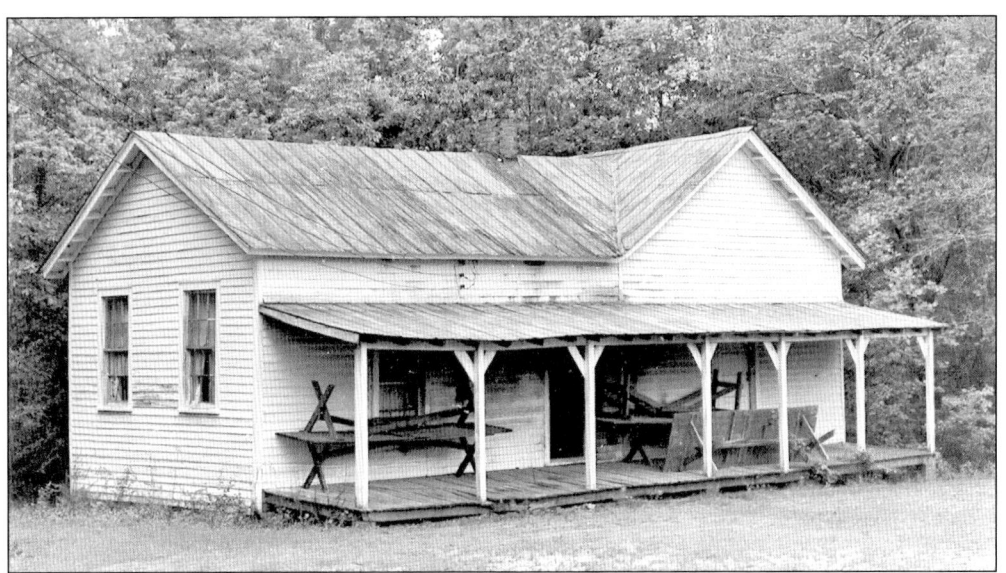

The Old Pole Bridge School was located near Pine Hall. (Courtesy the North Carolina State Archives.)

The Perch School House was located on Perch Road in Pinnacle. School was taught here until 1936. It is now the present location of the Friends Union Friends Church. (Courtesy Jean Stone Hall.)

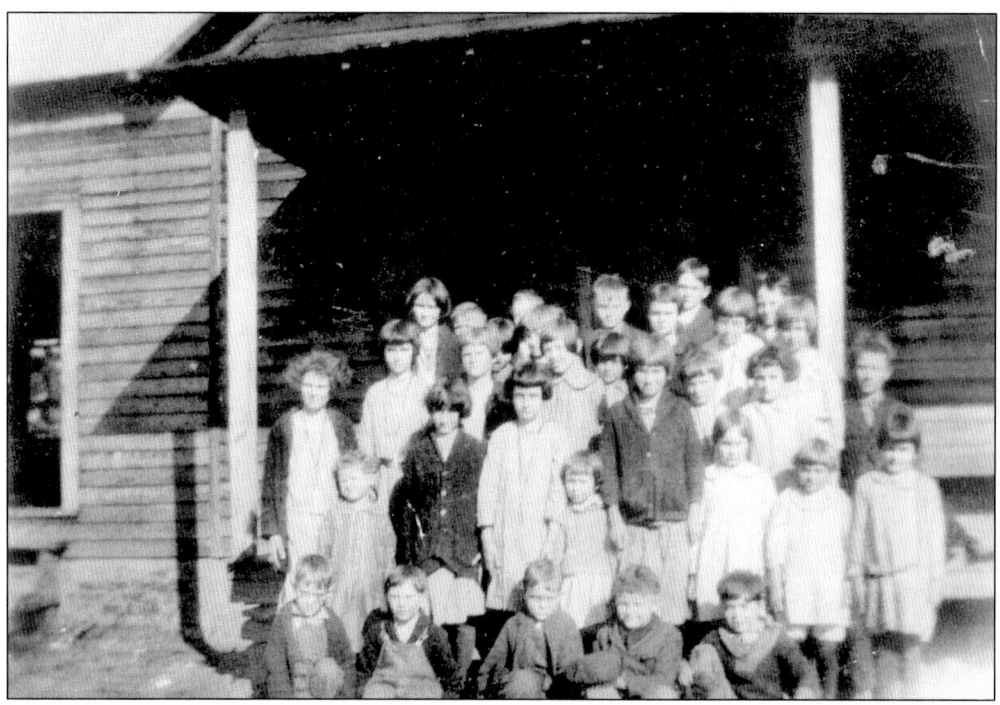
The Volunteer School stood about 500 feet from the Volunteer Primitive Baptist Church near Pinnacle. The one-room school started in 1900 and closed in 1937 to consolidate with Pinnacle School. (Courtesy Jean Stone Hall.)

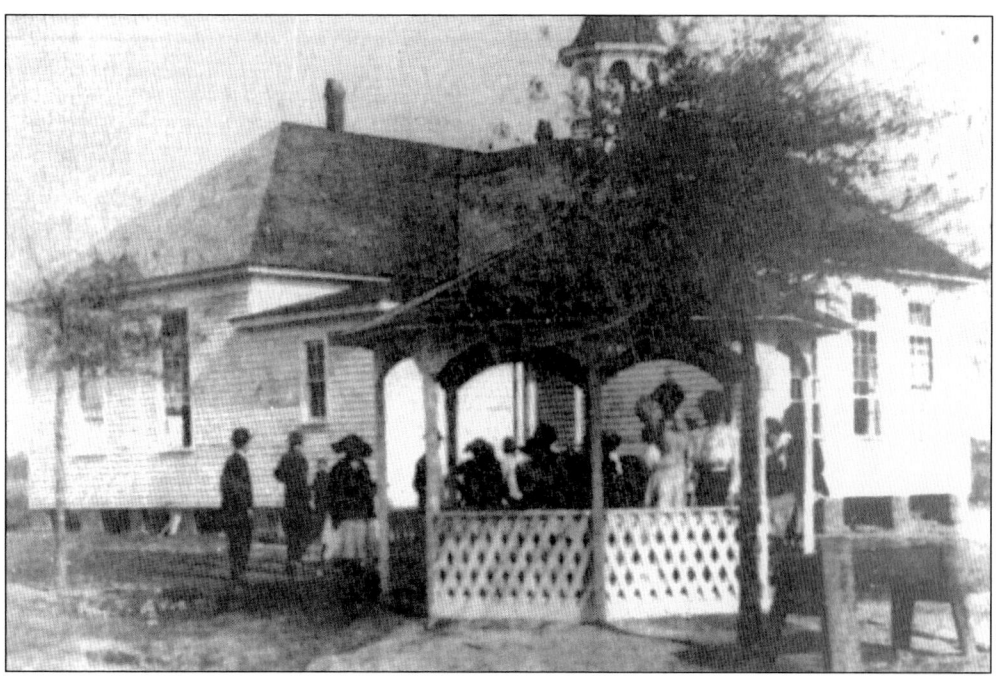
The only known photograph of the wooden-structure Pinnacle School is seen here in 1912. (Courtesy Jean Stone Hall.)

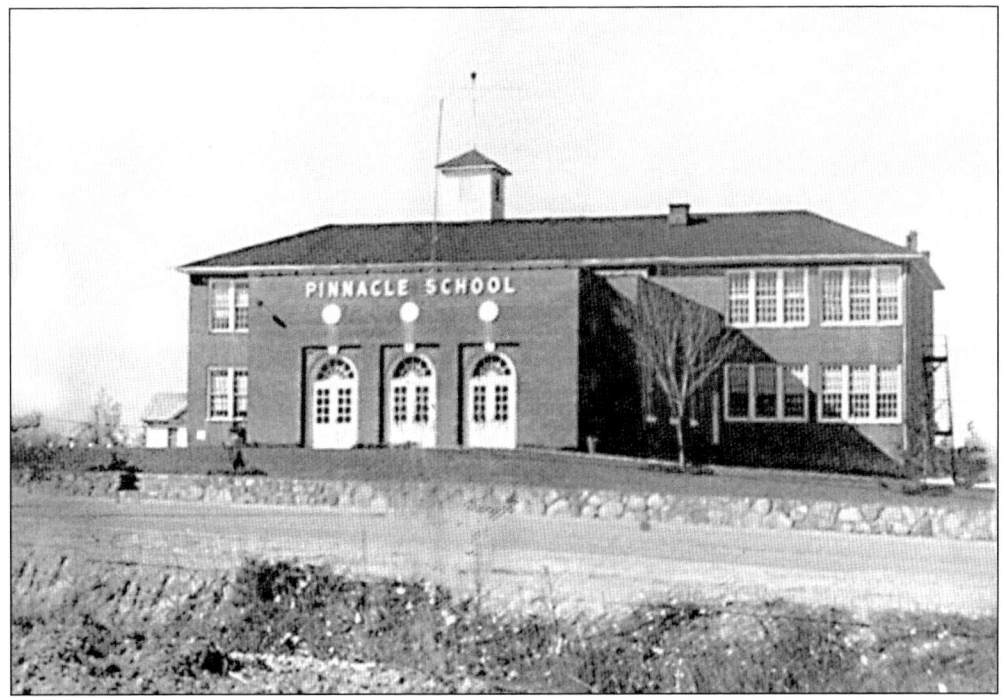

Pinnacle School is captured in this 1922 photograph. (Courtesy Jean Stone Hall.)

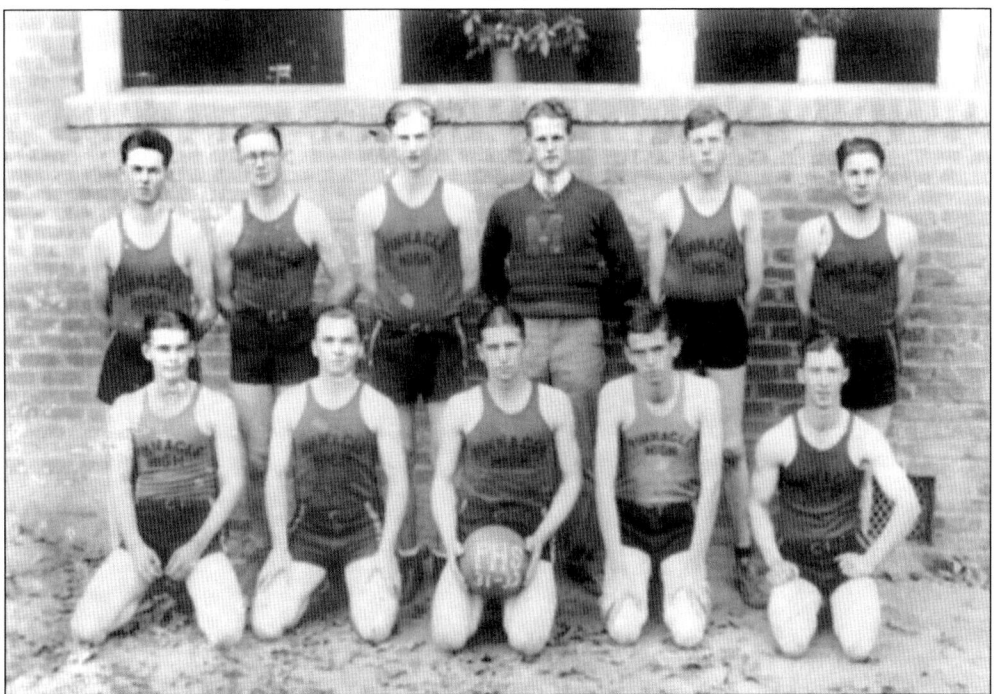

The 1931–1932 Pinnacle Men's Basketball Team is, from left to right, (front row) Wess Watson, Ray George, Paul Randleman, Tom Jones, and Sammy Gordon; (back row) G.K. Watson, Thomas Eaton, Kermit Boyles, Coach Ray Graham, Joe Stone, and Gray McGee. (Courtesy Jean Stone Hall.)

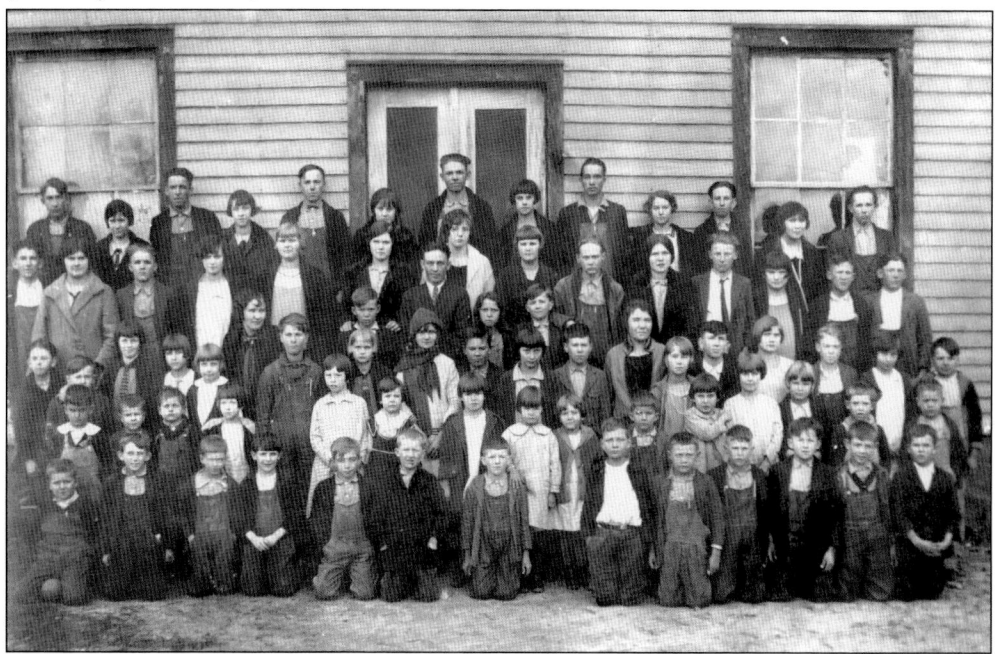

Twenty-five different classes were taught in Sandy Ridge Academy, built in 1892. The second story was divided by a curtain to make two rooms. One of the rooms was used for a playroom. (Courtesy Darrel Lester.)

The Sandy Ridge Academy student body poses in front of the school for this 1922 photo. (Courtesy Cranford Priddy.)

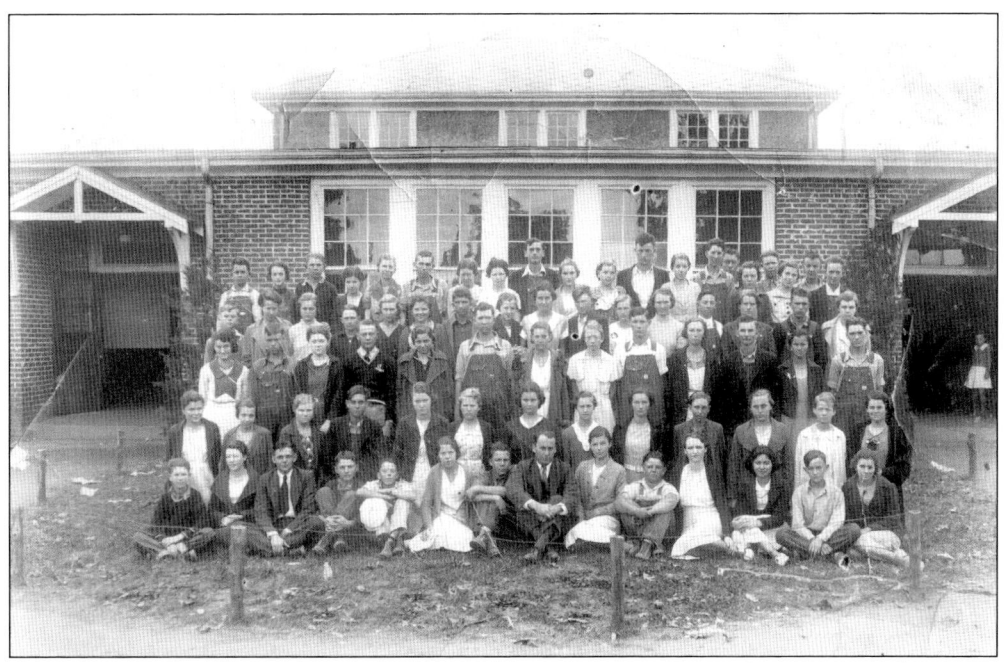

Sandy Ridge School was built one year before this picture was taken in 1929. (Courtesy Darrel Lester.)

The 1929–1930 Sandy Ridge High School student body pose for this photograph in the spring of 1930. (Courtesy Darrel Lester.)

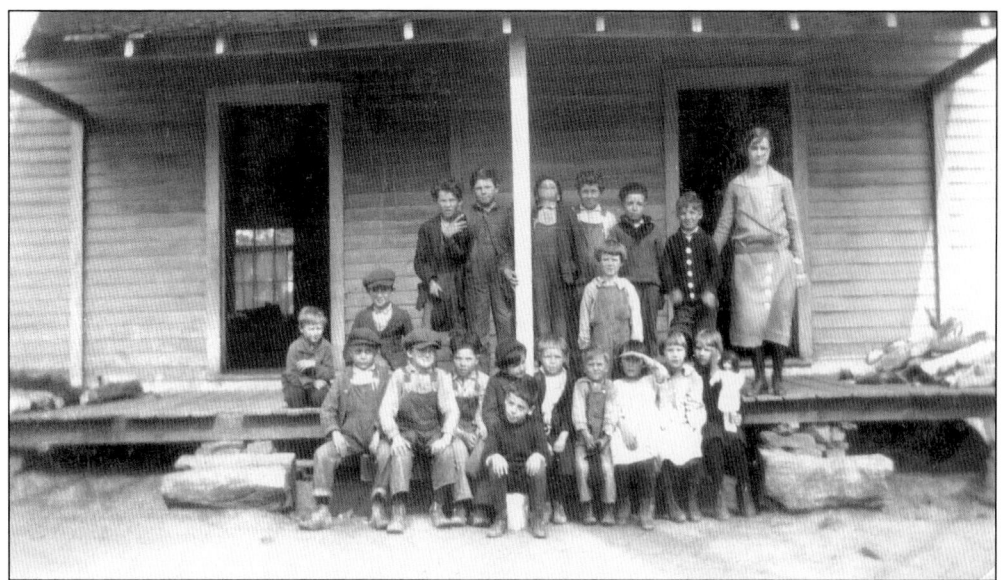

Stewart's School was named for farmer and Primitive Baptist preacher Alfred Stewart, who donated the land for the school in the Meadows community. It closed after consolidating with Meadows School in 1932. The school is seen here with students in the 1920s. (Courtesy Arnold and Hilda Mabe.)

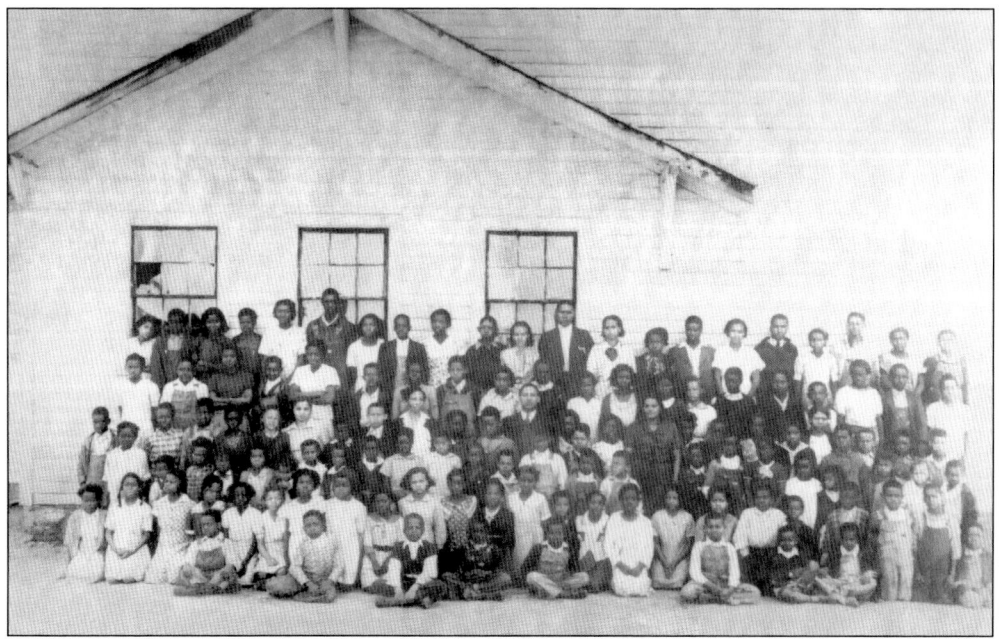

Walnut Cove Colored School was a five-room school built in 1921 with help from the Rosenwald Fund, which was established by Booker T. Washington of the Tuskegee Institute and Sears Roebuck president Julius Rosenwald. The fund constructed 813 schools for blacks in North Carolina. Fewer than 40, including the Walnut Cove Colored School, remain standing. The school closed in 1952 and was left vacant until 1994 when alumni bought the property to restore it. It is now a senior citizens center. It is seen here in the late 1930s. (Courtesy Walnut Cove Colored School, Inc.)

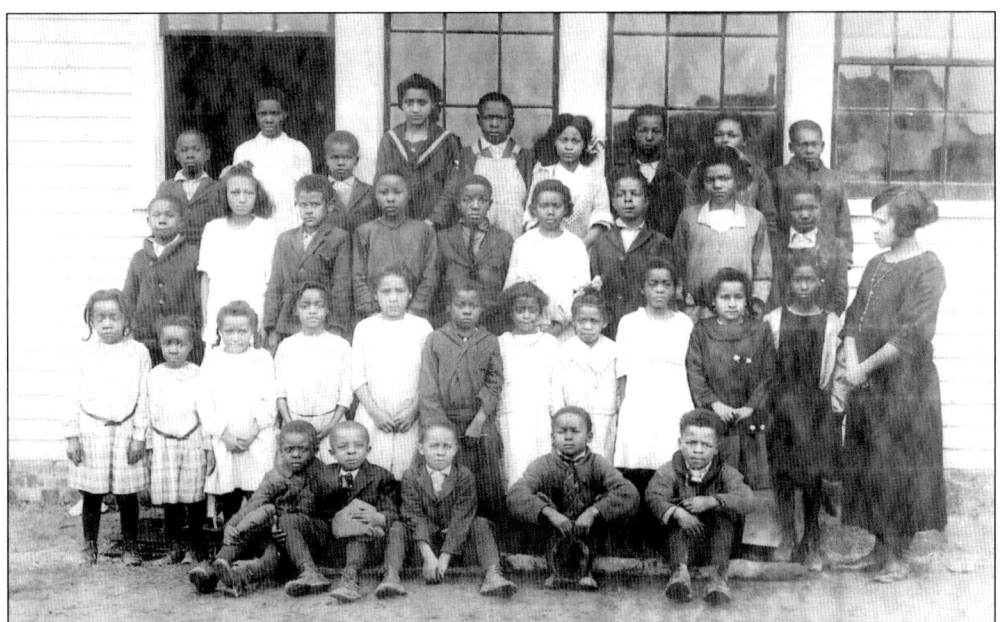

The Walnut Cove Colored School is seen here in the 1930s. At the far right is teacher Roberta Sleigh. (Courtesy Walnut Cove Colored School, Inc.)

The 1934 Walnut Cove Colored School women's basketball team is pictured here. Coach Troy Williamston stands in the middle. (Courtesy Mabel Johnson.)

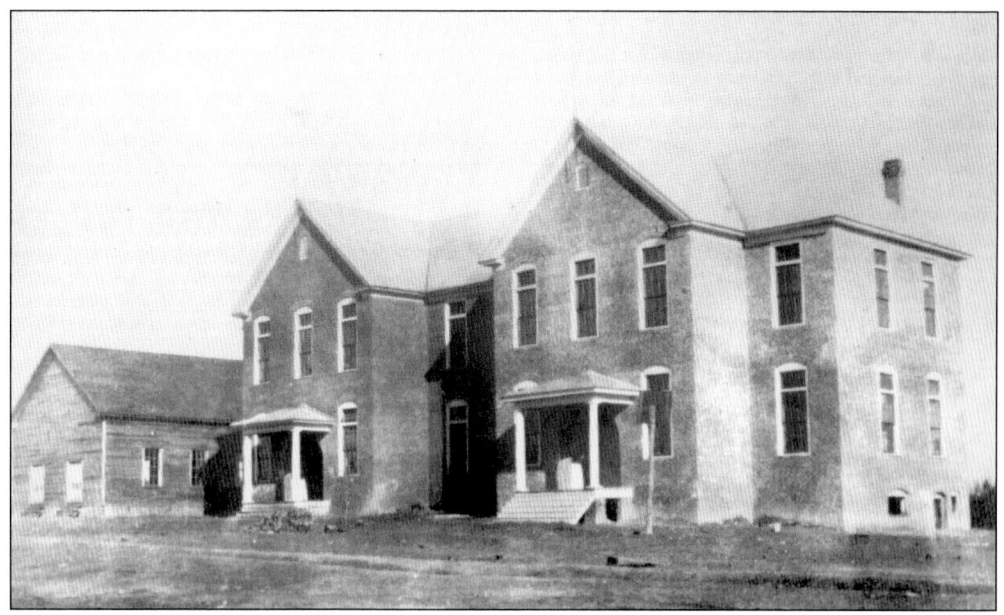

The Walnut Cove Elementary and High School is seen here in 1920. By 1922, schools in the surrounding communities of Freeman, Fulp, Meadows, Rosebud, Stewarts, and Tuttles had consolidated with Walnut Cove. In 1922, a new school building was built on Summit Street and 20 years later a new high school opened on north Main Street. In 1964, South Stokes High School opened east of Walnut Cove, consolidating Germanton, King, Pine Hall, Pinnacle, and Walnut Cove High Schools. (Courtesy Town of Walnut Cove.)

This is the Walnut Cove High School student body in 1923. (Courtesy Town of Walnut Cove.)

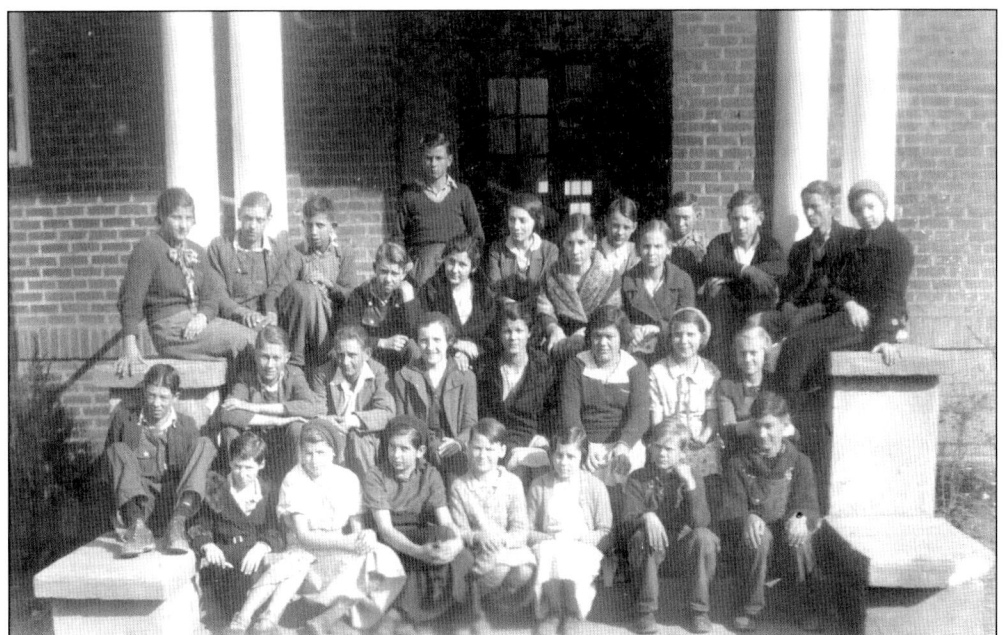

Pictured here is Walnut Cove School teacher Mary Mitchell's seventh-grade class in 1933. (Courtesy Arnold and Hilda Mabe.)

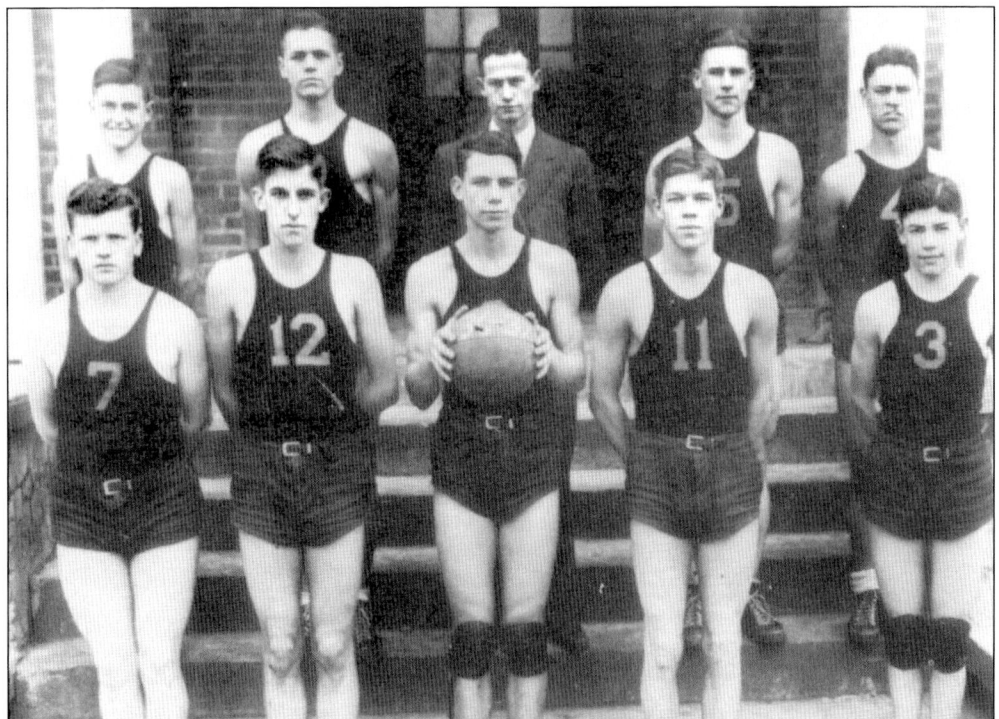

The 1936–1937 Walnut Cove men's basketball team is, from left to right, (front row) Junior Campbell, Dunk Dunlap, Jack Hutchison, Jim Bullin, and Walter Sands; (back row) Byron Hill, Joe Helsabeck, Coach Furches, William Smith, and Buck Wall. (Courtesy Town of Walnut Cove.)

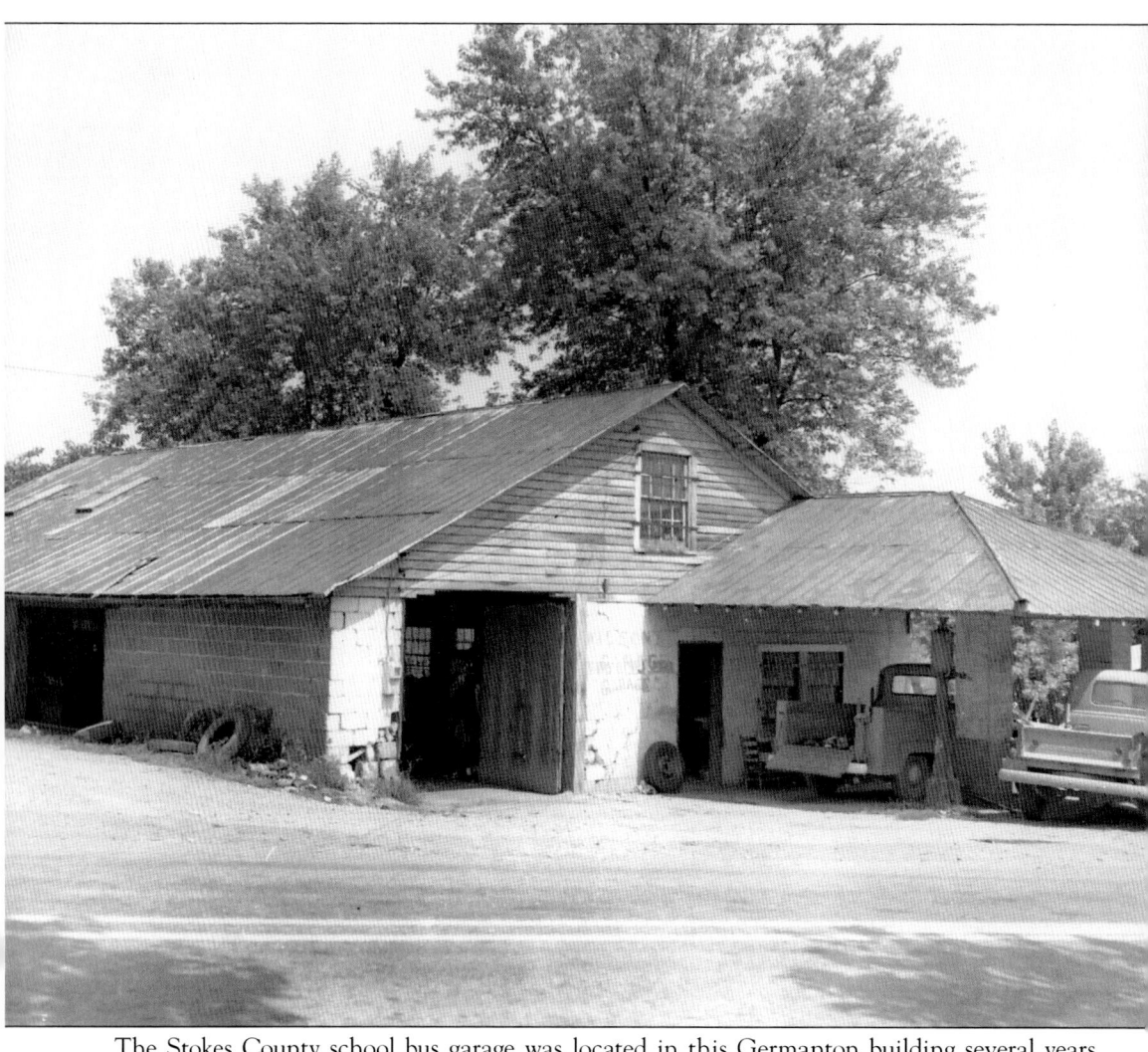

The Stokes County school bus garage was located in this Germanton building several years prior to this 1959 photograph. (Courtesy Max Bennett.)

Three

WORKING THE LAND

Farmers couldn't have survived if they hadn't helped each other—corn shuckings, wheat thrashings. It became a real social function as well as a work thing. They'd have chicken stews, quiltings, apple peelings to make apple butter.

—Marguerite Slate Gentry, recalling farm life growing up in the Mountain View Community.

It is what brought the first souls to Stokes County: the fertile soil along the Dan River, Little Yadkin River, and Town Fork Creek. Native Americans like the Sauras first called the land around these waterways home, followed by the European decedents from the North and East. Once the fertile river banks were plowed, the rich red clay that wove the foothills and ridges slowly started to turn. Stokes County was being settled with each new family's plow cutting her open, planting their future, and yielding her harvest. The daily chores of labor and sweat kept Stokes's first families alive, producing meat, grains, and fruit. By the early 1800s the rows of survival were turning to profit. The golden leaf, tobacco, was creating cash for families who once farmed food for survival. By 1840, Stokes County had become the second leading manufacturer of tobacco sold in the southeast United States. Money made from the golden leaf was helping give birth to plantations worked by slaves. Tobacco helped some families get out of the sun and rise the economic and social ladder, but the Civil War brought most back down. During Reconstruction families had to turn to each other. Neighbors helping neighbors became a necessity for survival even into the late 20th century. From wheat thrashings to corn shuckings to tobacco harvesting, every act of the farm involved the help of neighbors. It brought communities closer and in turn began early foundations of towns. The fabric of Stokes County is sewn tight with every hand that was blistered from a mule-drawn plow to every bead of sweat that was perspired from the heat in the fields. It is what laid our being. The families who first turned the land opened our souls and unconsciously gave us founding.

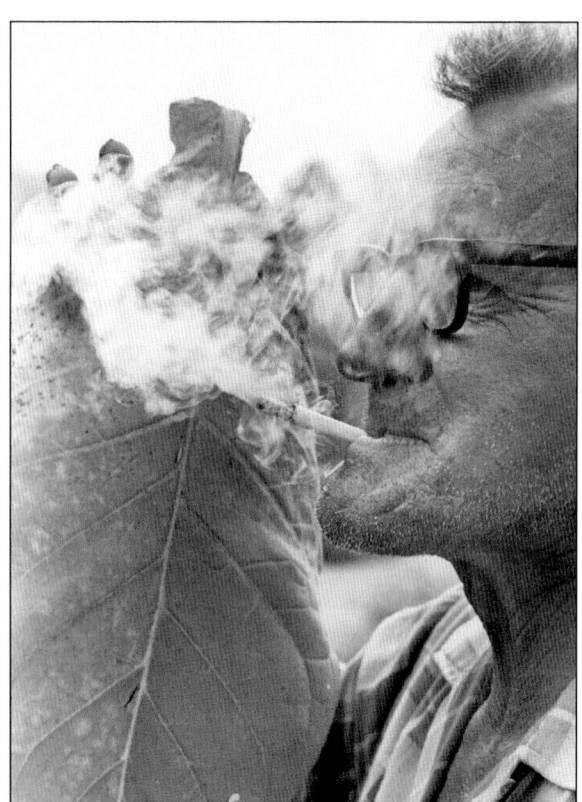

Ed White, with his tobacco in hand, is pictured stopping for a smoke while priming his crop near King, 1970. (Courtesy the Forsyth County Public Library Photograph Collection.)

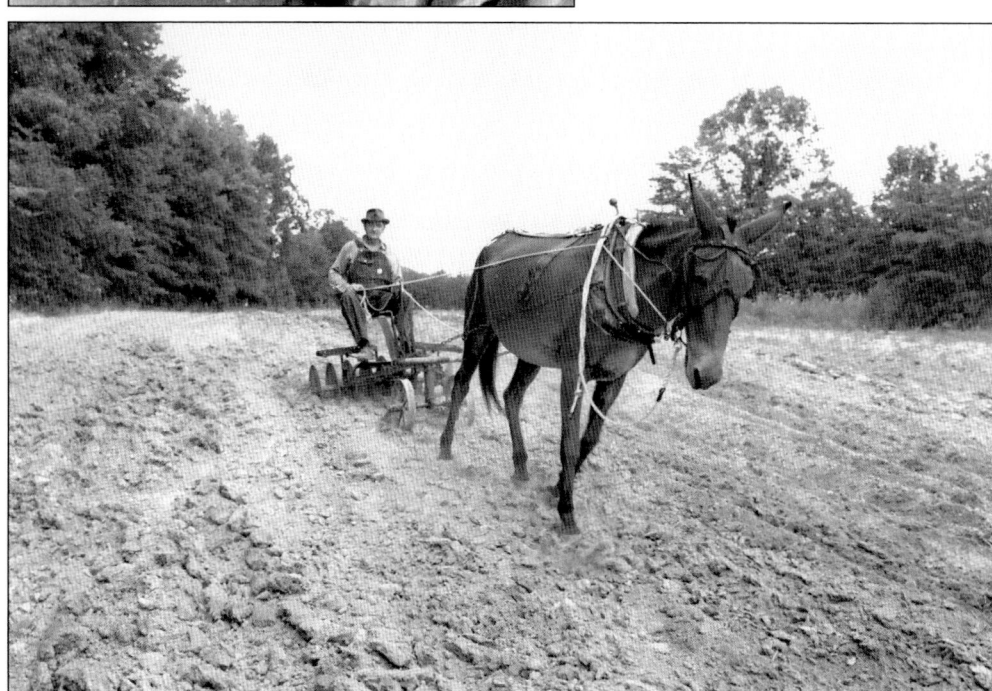

Ralph Hill is pictured here working the land with his mule Mary in Pine Hall, 1970. (Courtesy Ralph Hill.)

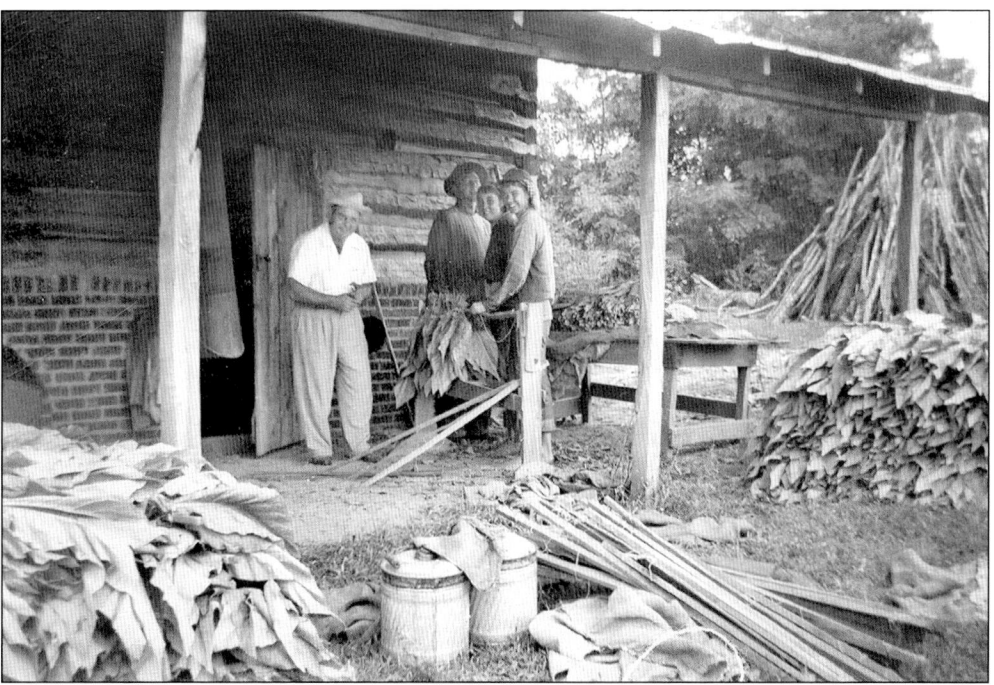

Farmer Glenn Lawson turns his tobacco field for the following spring at Quaker Gap, 1973. (Courtesy the Forsyth County Public Library Photograph Collection.)

The Stevens family is shown stringing tobacco on their Lawsonville farm, c. 1940. (Courtesy Velma Leake.)

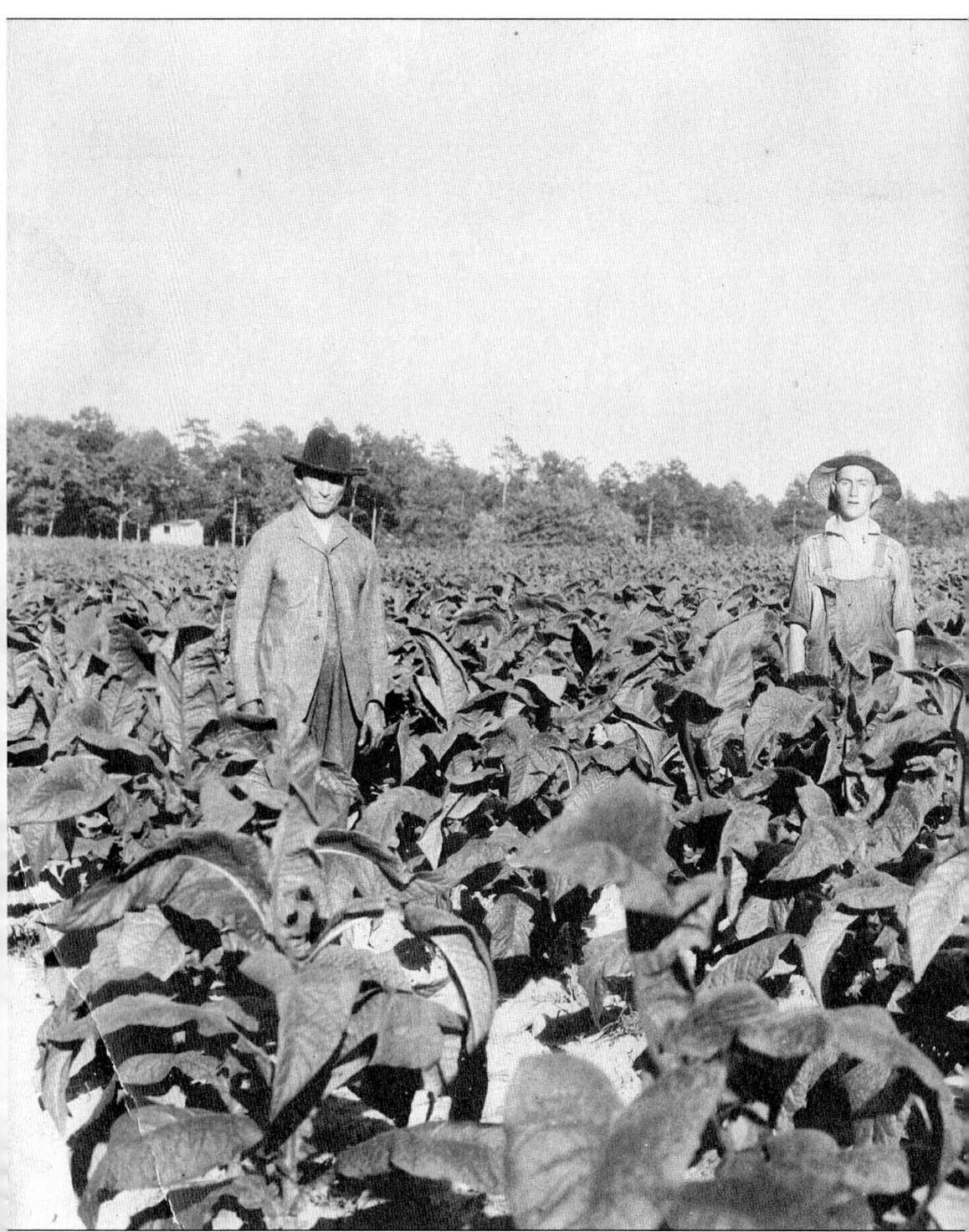

Along with a season order, some fertilizer companies offered farmers a complementary photograph of themselves and their family in their field. This became popular for families who rarely got their picture taken and fertilizer companies who posted an advertisement in the photograph. Ed

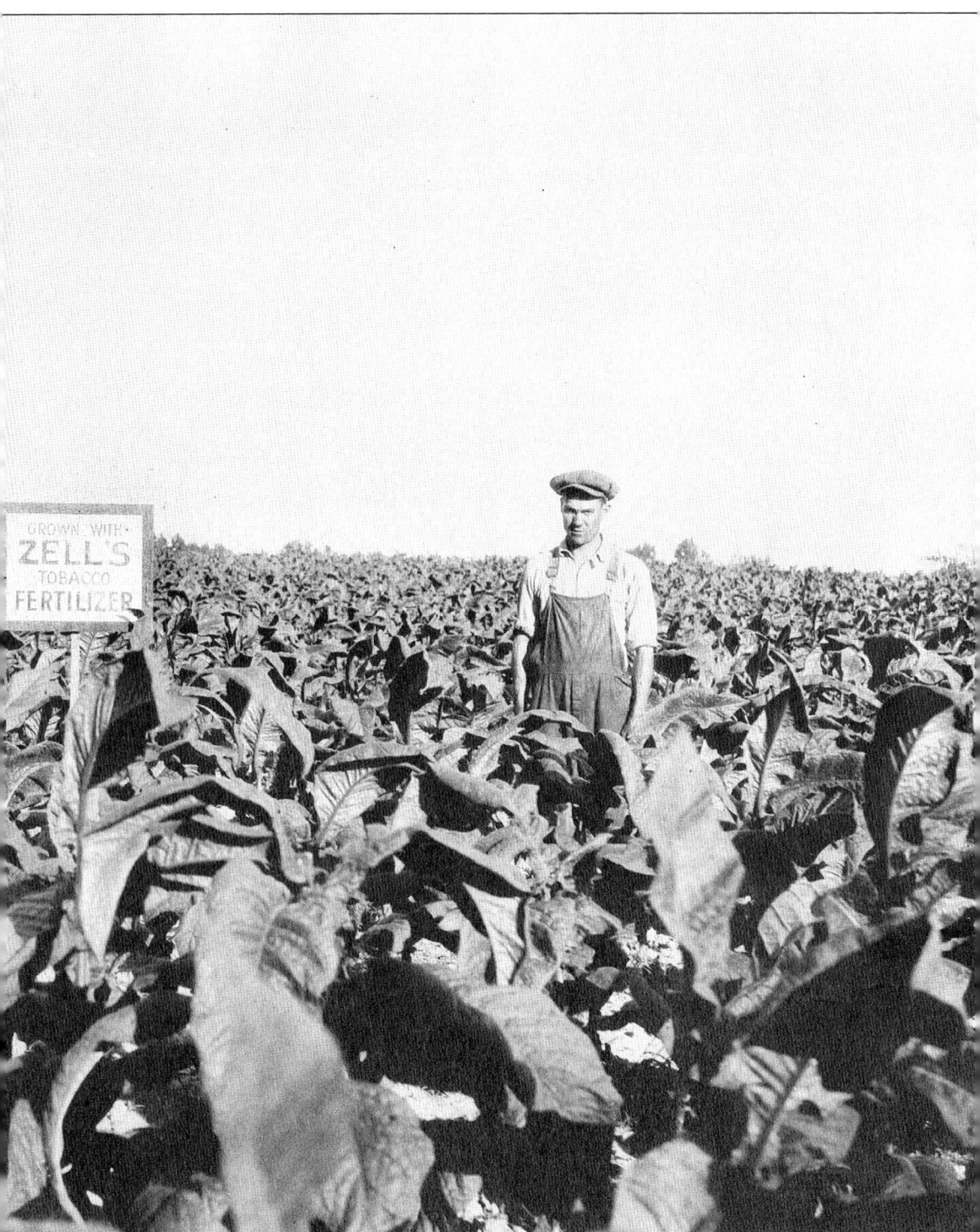
Kiser and two unidentified men are pictured in his tobacco field, "Grown With Zell's Tobacco Fertilizer," in King in the 1930s. (Courtesy Adeline Kiser.)

The Lash family is shown stringing tobacco on their farm in the Baileytown community near Walnut Cove, 1940s. (Courtesy Mabel Johnson.)

David Bill Nance put a suit and tie on when taking his tobacco crop from Sandy Ridge to the tobacco warehouse in Martinsville, Virginia, early 1940s. (Courtesy Darrel Lester.)

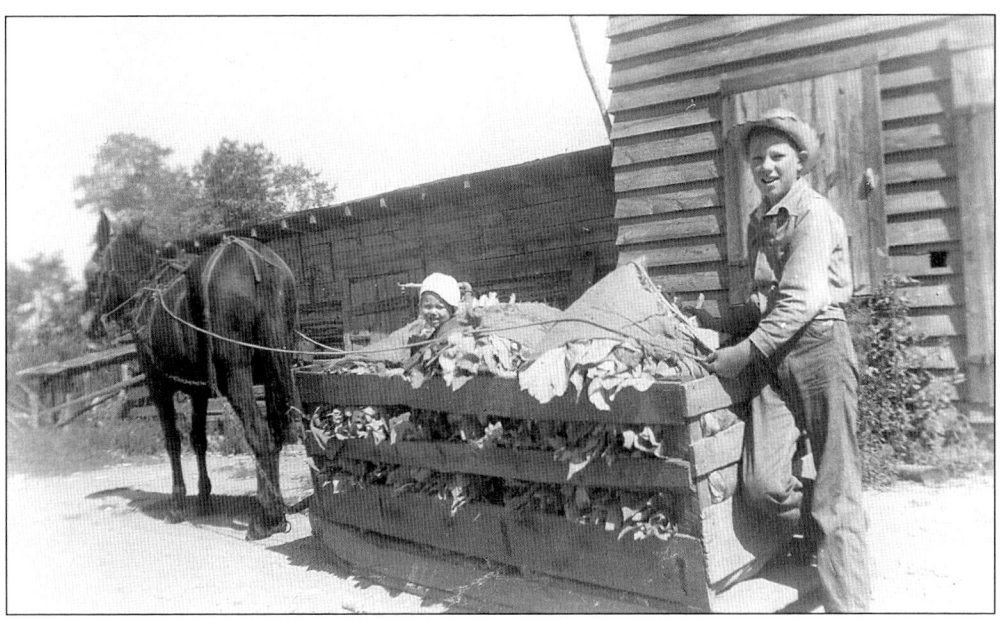

Durwood Bennett and his nephew Steve Cox are shown being pulled in a tobacco sled near Danbury, 1950s. (Courtesy Clara Bennett Nelson.)

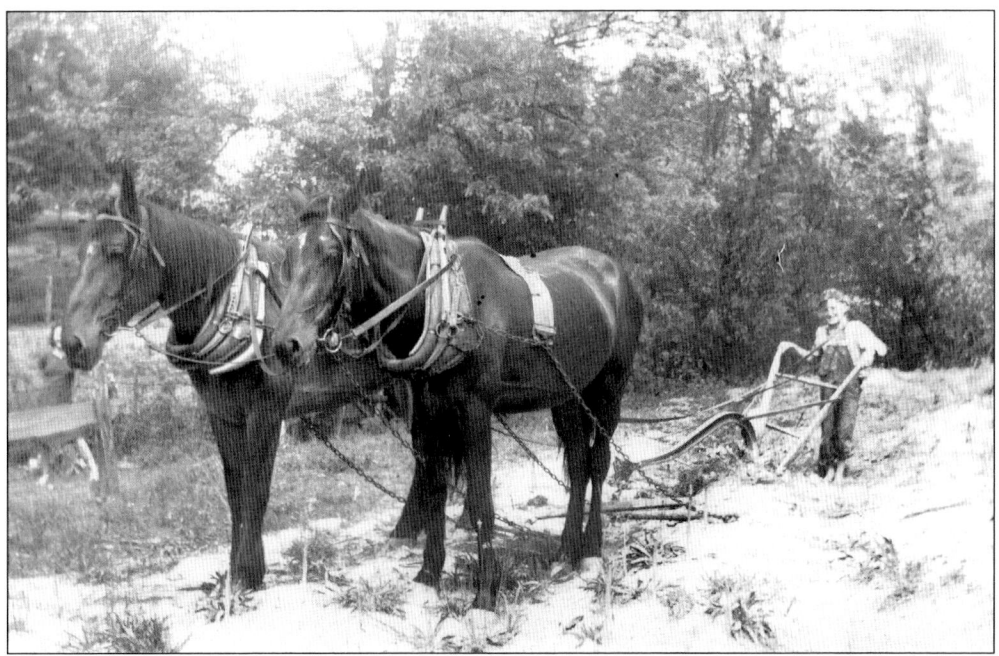

Jeff White, age 10, is seen here steering a plow pulled by Braunie and Maude, near Germanton. Many farmers started using tractors after World War II. (Courtesy Keith White.)

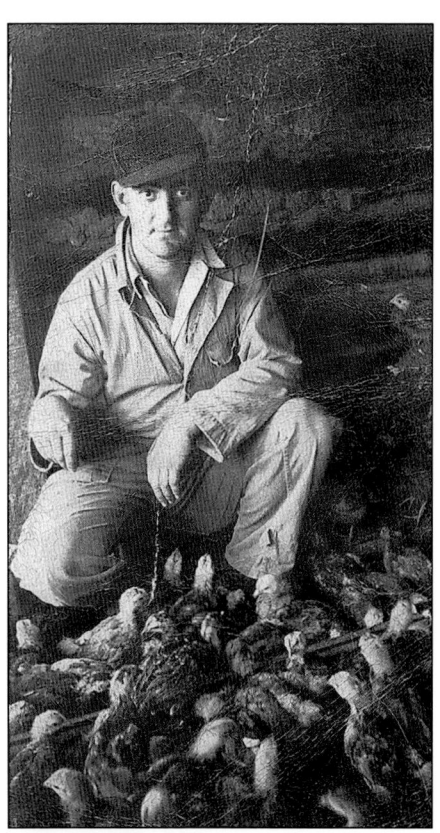

Moir Wood raised chickens on his farm near Danbury, in the late 1940s. (Courtesy the Priddy family.)

In late fall, neighbors would gather to help each other kill their hogs. Before freezers, the hams and shoulders were salted down to preserve and the sausage, ribs, and tenderloins were canned by the women. The families wasted nothing; even the lard was used to make soap. From left to right, Cliff Tucker, Posie Bennett, Ralph Bullins, Fred Bennett, John Rominger, Rufus Mabe, and Gilmer Mabe kill hogs near Danbury, 1940s. (Courtesy Clara Bennett Nelson.)

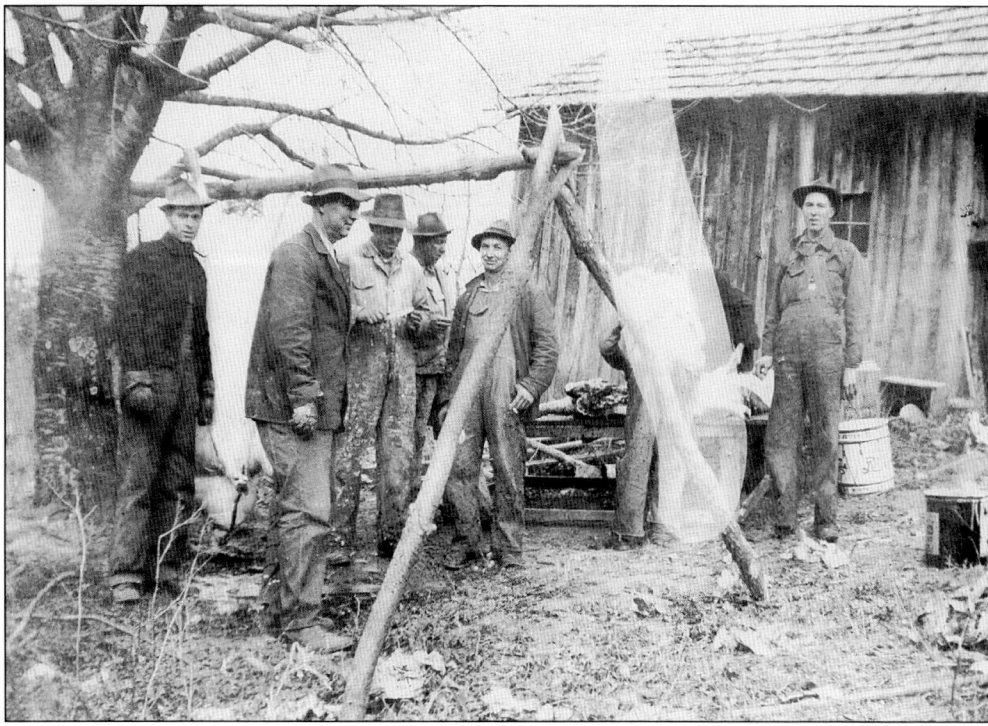

Lillie, Clara, Mary Ann, and Pate Bennett stack the wheat just cut near Danbury, 1940s. The wheat would be used for flour, and the hay used to feed livestock. (Courtesy Clara Bennett Nelson.)

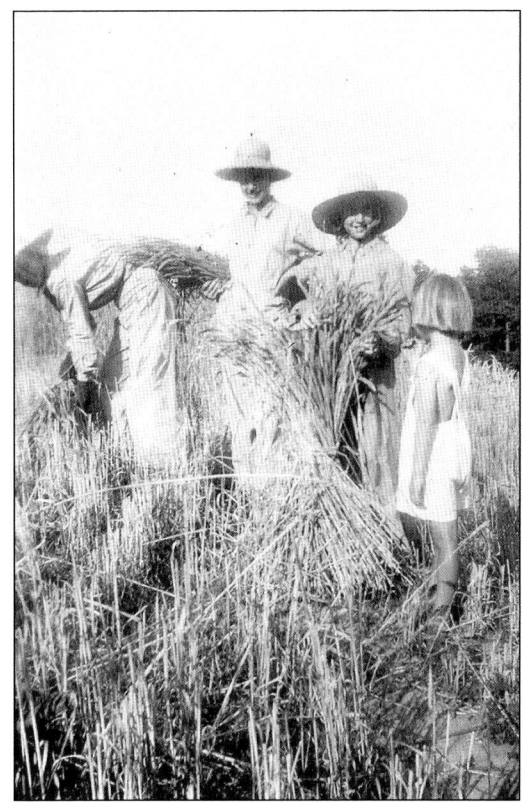

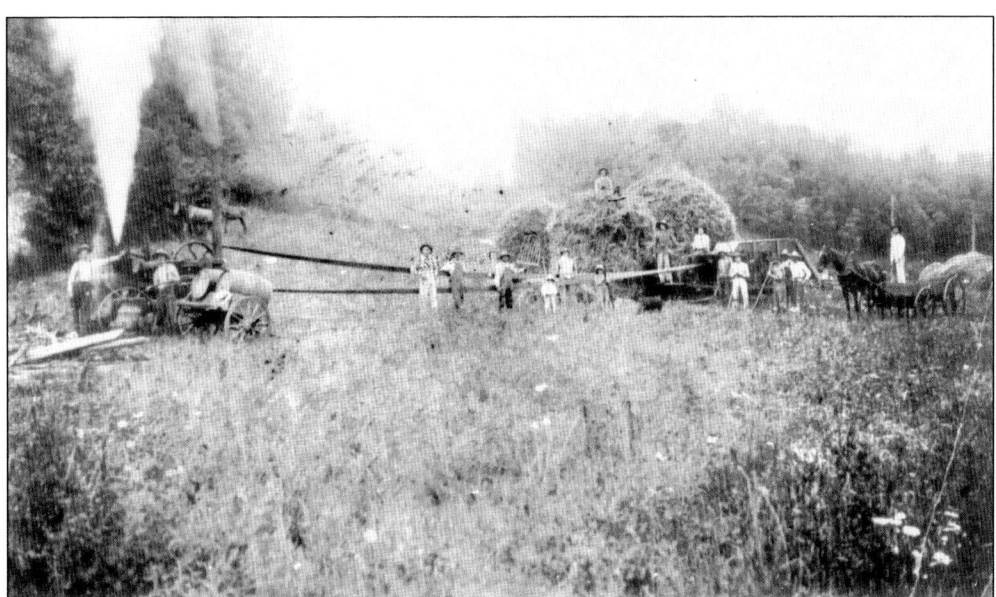

Neighbors came together to help thrash the wheat. Identified are Walter Hill blowing the steam whistle and Charlie Hill standing on the straw stack in Sandy Ridge in the early 1900s. (Courtesy Darrel Lester.)

In the fall neighbors would gather to shuck corn. The corn was used for cornmeal and livestock feed and the shucks were used to feed cattle. At left are Loretta Watts, Roscoe Smith, Elnora Smith, and Hilda Smith, Brook Cove, 1940s. (Courtesy Arnold and Hilda Mabe.)

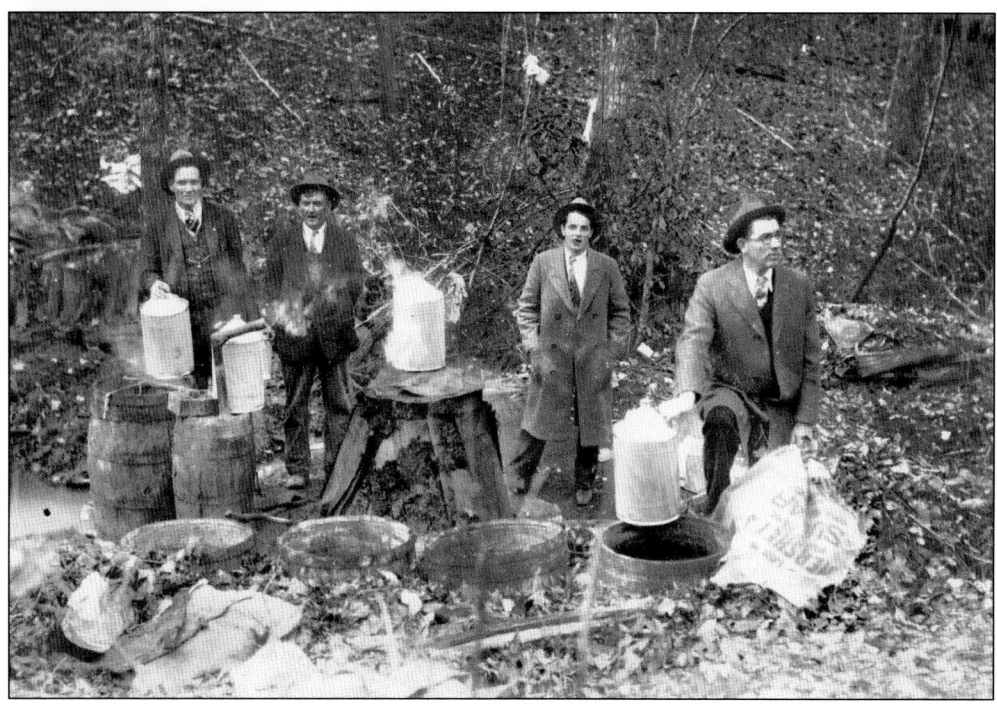

These men are believed to be either "making" or "busting up" moonshine somewhere in Stokes County. The date and people are unknown. (Courtesy the Forsyth County Public Library Photograph Collection.)

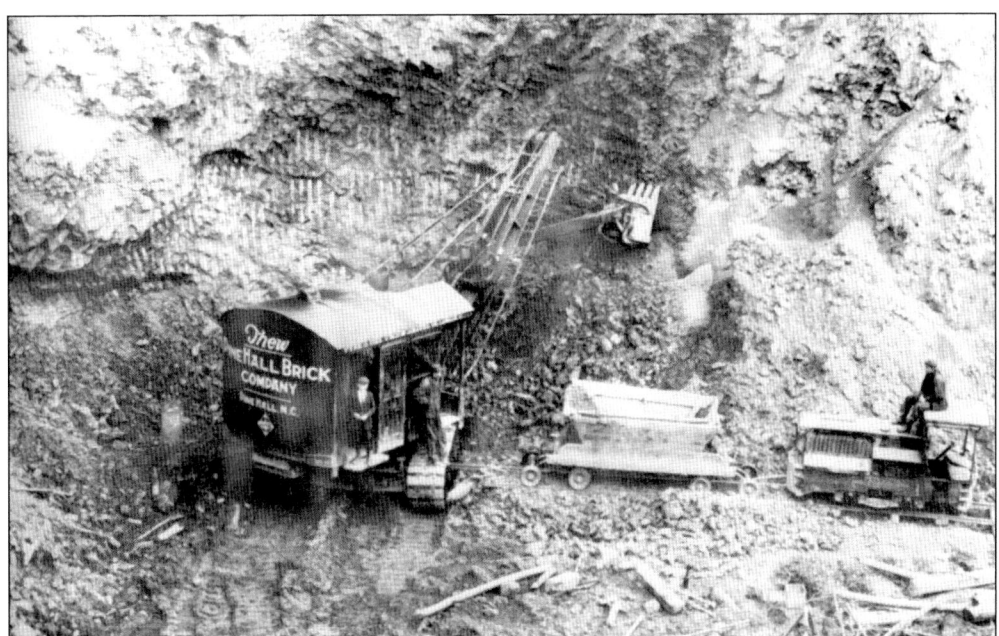

Pine Hall Brick Company workers are digging for clay to make bricks in Pine Hall, 1925. Pine Hall Brick Company began digging for clay in 1923, after buying the land from the Shale Paving Brick and Fire Proofing Company in Pine Hall. (Courtesy Stokes County Historical Society.)

This sawmill operation, in an unknown location in Stokes County, was photographed in 1916. Sawmill operations would travel around to cut wood on site for the construction of a home or farm building. (Courtesy Stokes County Historical Society.)

Luther Madison Smith, seen here holding a string of corn used to feed birds, sold 128 acres of his farm to R.J. Reynolds Tobacco Company. He received $40,000 for the land that would become a part of the company's Brook Cove Tobacco Processing Plant in 1959. (Courtesy Arnold and Hilda Mabe.)

Four

THE HEALING WATERS

We all grew up in Moore's Springs. All the family worked there. I remember when the people would come from far away. They took of it [mineral water] so much and when they left they had to take some of it with them.

—Juanita Moore Marshall, daughter of William Moore,
former owner and operator of Moore's Springs Resort.

The spring water that trickles under the hills and rocky ridges of Stokes County once drew thousands who believed it to hold healing properties. While surveying land, Prof. Samuel Dewey first discovered the mineral water in the early 1800s. By the late 1800s the water, with its sulfuric taste, had given life to the resorts. Moore's Springs, Piedmont Springs, and Vade Mecum Springs had sprung up with enormous hotels and spas that offered royalty living. Visitors from Greensboro and Winston-Salem would travel by train to Rural Hall and Walnut Cove where they would take horse and buggy into the Sauratown Mountains that shadowed the resorts.

Moore's Springs bottled their water to sell, while Vade Mecum shipped out its water in barrels. The Vade Mecum water was sold in drug stores for 15¢ a glass and took the highest honors at the Louisiana Purchase Exposition in 1904.

Before long the water, believed to cure ailments such as stomach disorders and skin diseases, became second thought to the first-class life at the resort. Piedmont Springs Hotel echoed with the sounds of a European orchestra. One of the chefs who served up the high-class dining went on to become a chef at the White House.

The high society that flocked to the summer spas for elegant dining and socializing found new frontiers with the automobile. By the late 1920s the resorts were dying. People could now travel farther into the North Carolinas mountains to seek higher, cooler elevations.

By 1930, both Piedmont Springs and Moore's Springs had burned. Piedmont Springs had burned to the ground before, and was rebuilt. This time, on the edge of the Depression and fewer visitors, many suspected the once-high-society resorts went up in flames for insurance money. Neither Piedmont Springs or Moore's Springs were rebuilt. Two of three hotels built at Vade Mecum Springs burned years before, some believed due to causes such as lightening. Out of all the springs and spa resorts that created a golden era in Stokes County history, only one hotel remains standing at Vade Mecum Springs. Today it is used by the 4-H as an education camp.

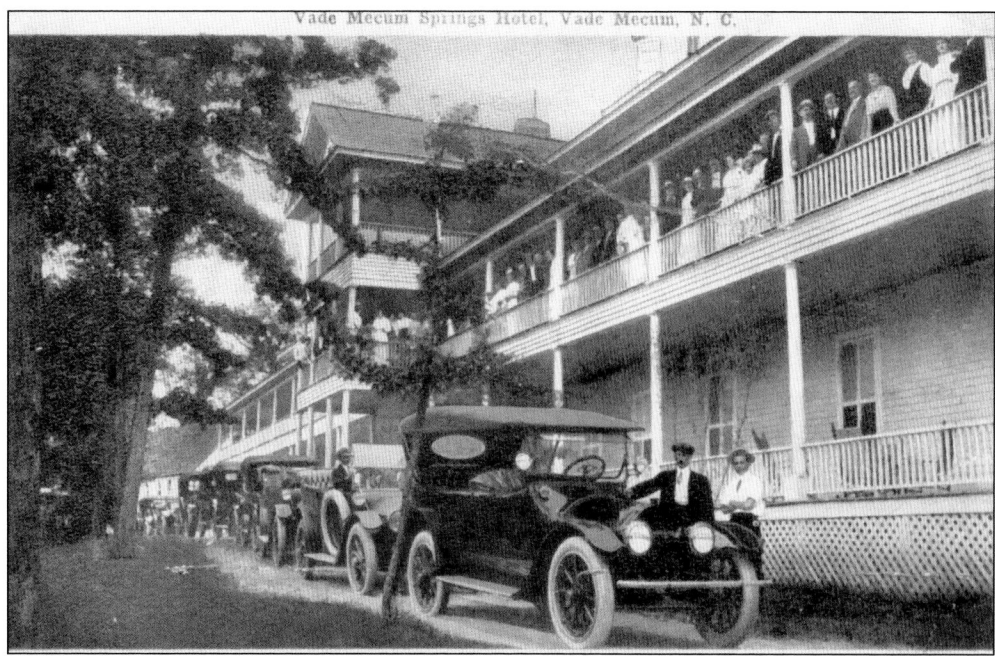

This 1914 postcard is believed to be of the large Vade Mecum Springs Hotel that had a dance hall and was filled with the sounds of a first-class orchestra. It burned in 1920. The hotels at Vade Mecum offered hot and cold mineral baths, acetylene gas lights, telephone, and daily mail. (Courtesy Wayne and Louise Biby.)

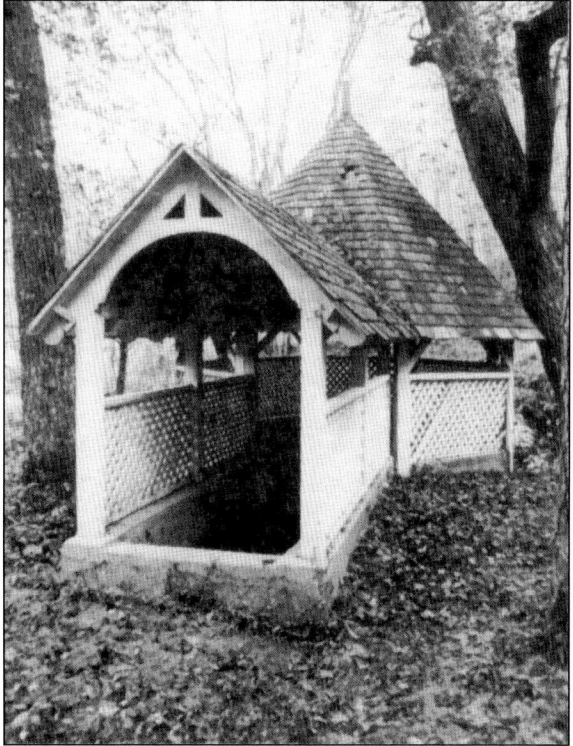

Vade Mecum was the last resort to open and the first to close. Its namesake comes from the surname Vaden. The Vaden family was an early property owner. *Vade mecum* translated from Latin also means "come with me." (Courtesy Evelyn Vaden Nelson.)

Pictured here is the Vade Mecum spring house. (Courtesy Stokes County Historical Society.)

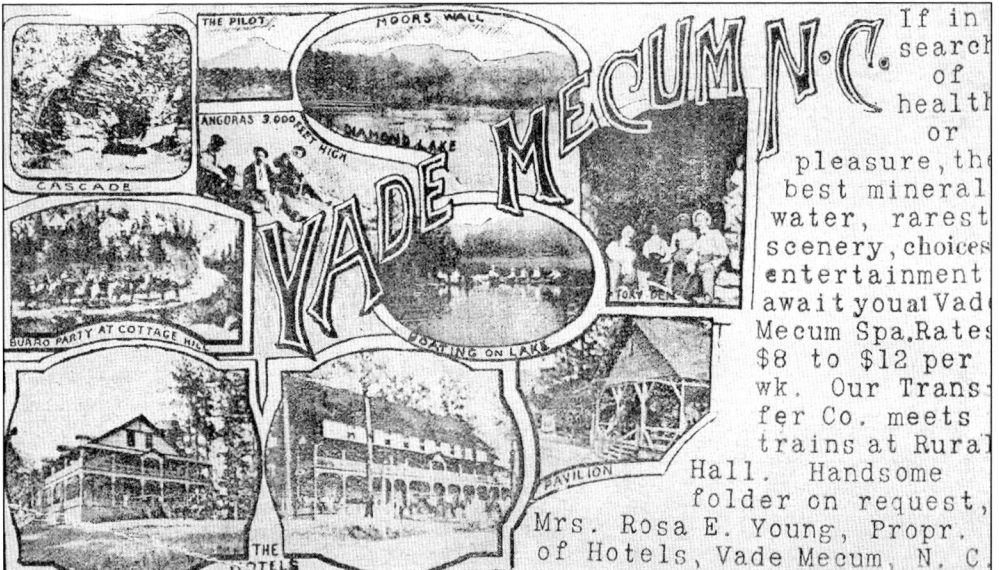

This advertisement was printed in newspapers promoting Vade Mecum Springs. (Courtesy Norman and Shirley Mickey.)

The water from Diamond Lake that turned the power house at Vade Mecum had stopped by May 1938 when this photograph was taken. (Courtesy the Forsyth County Public Library Photograph Collection.)

The spring house at Moore's Springs is shown here c. 1938. (Courtesy the Forsyth County Public Library Photograph Collection.)

At left is Joe Glenn George at the Moore's Springs Spring House, 1945. John and William Moore formed the Moore's Spring Company in the late 1800s. The water was sold in one-gallon glass bottles and fifty-gallon barrels. Its popularity captured attention across the state. The company built a hotel, store, and cottages to accommodate the influx of visitors. The hotel burned in 1921. The land is now owned by North Carolina, who sealed the well at the landmark spring house. (Courtesy Evelyn Vaden Nelson.)

This picture of the Moore's Springs Hotel is c. 1915. (Courtesy Ellen Pepper Tilley Collection.)

Moore's Spring Mill was no longer being used when this picture was taken in 1951. (Courtesy the Forsyth County Public Library Photograph Collection.)

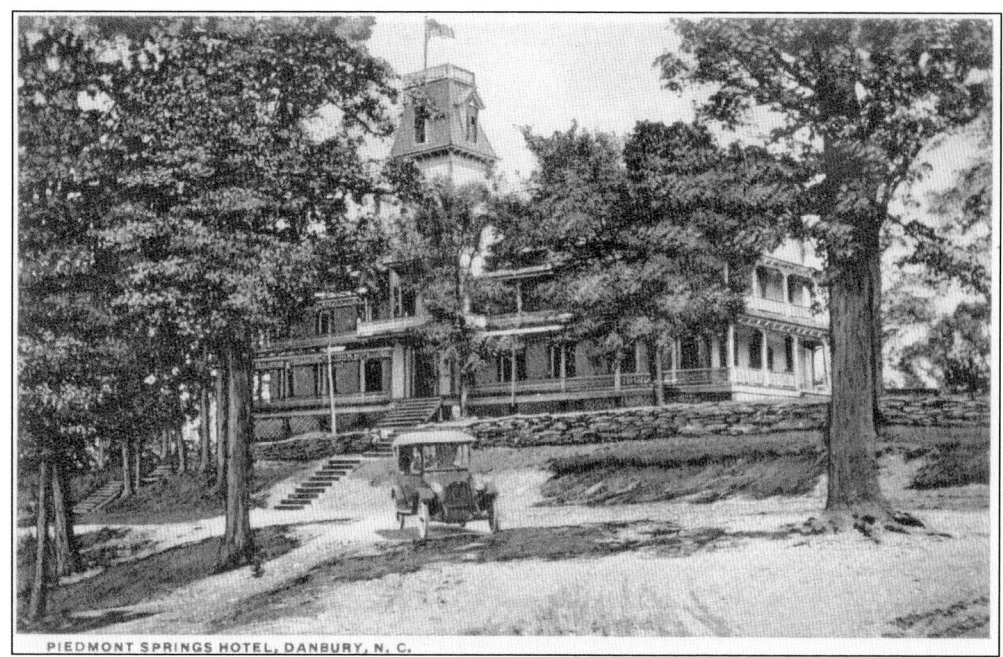

This is a postcard of the third and last Piedmont Springs Hotel to be built in 1889, near Danbury. This 50-room hotel burned in 1930. (Courtesy Ellen Pepper Tilley Collection.)

Unknown summer residents stand on the tennis courts of Piedmont Springs in 1915. (Courtesy Stokes County Historical Society.)

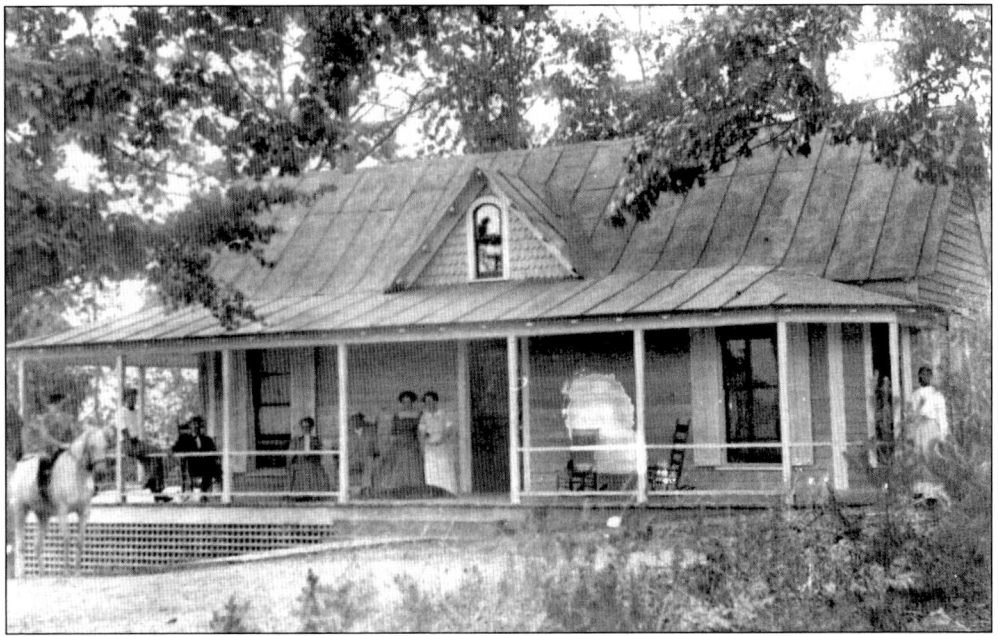

The spring house at Piedmont Springs is seen here at an unknown date. Notice the little girls sitting on the roof. (Courtesy the Forsyth County Public Library Photograph Collection.)

One of the Piedmont Springs Cottages in 1908 was the home of the Prather family (on the front porch), who worked at the resort. From left to right are Will Prather, Charlie Estes, Mr. and Mrs. J.H. Prather, Briggs Prather, Frances Prather, and Matilda Roberts. (Courtesy Ellen Pepper Tilley Collection.)

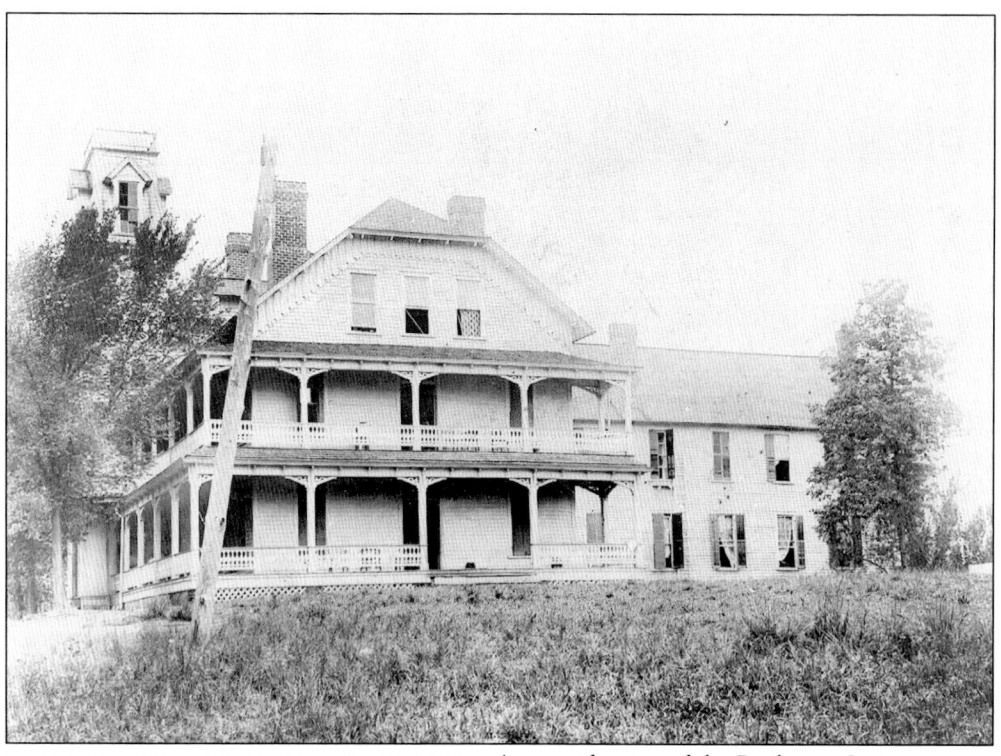

A rare side view of the Piedmont Springs Hotel is captured in this photograph; the date is unknown. (Courtesy the North Carolina State Archives.)

---RATES FOR---

Piedmont Springs Hotel
DANBURY, N. C.

1 Person in corner room, per week................$21.00 Each

1 Person on front hall (not corner room) per week..........$20.00 "

1 Person any other room, per week$18.00 "

2 or more persons in room, rate discounted 10 per cent.

Nurse per week...........$10.00 "

Children from 7 to 12 inclusive, discount 25 per cent.

Children under 7 discounted 50 per cent.

By the Month, 5 Per Cent off Regular Rates.

Cars meets trains at Walnut Cove, N. C.

Shown here is an advertisement for Piedmont Springs that ran in area newspapers. (Courtesy the North Carolina State Archives.)

Five
THE WOMEN OF STOKES

We managed; we got through. I raised a good bunch of children. The children would be put to sleep with the sound of my sewing machine.
—Grace Rierson Edwards, recalling raising her seven children as a widow in the last days of the Great Depression.

They are teachers, nurses, and farmers who spent most of their lives working to better their family and neighbors. They are our mothers, sisters and daughters who for too long had lived in the shadow of others and were sometimes forgotten in local history. With nerves of steel they stood strong and with open arms provided comfort when others were weak. They are the women of Stokes County.

They are the ones who ran the sewing machines into the late hours, and were up before dawn preparing their family for the day. Whether it was raising children, running a business, or turning the soil, women have been the ones planting the seeds but rarely the ones reaping the harvest. This collection of photographs shares that harvest: the pride, dignity, and humor of the everyday Stokes County women. No matter the age, race, or creed, they played an enormous part and sewed an invaluable mark in the fabric of our history. Theirs is a history no pages could give justice.

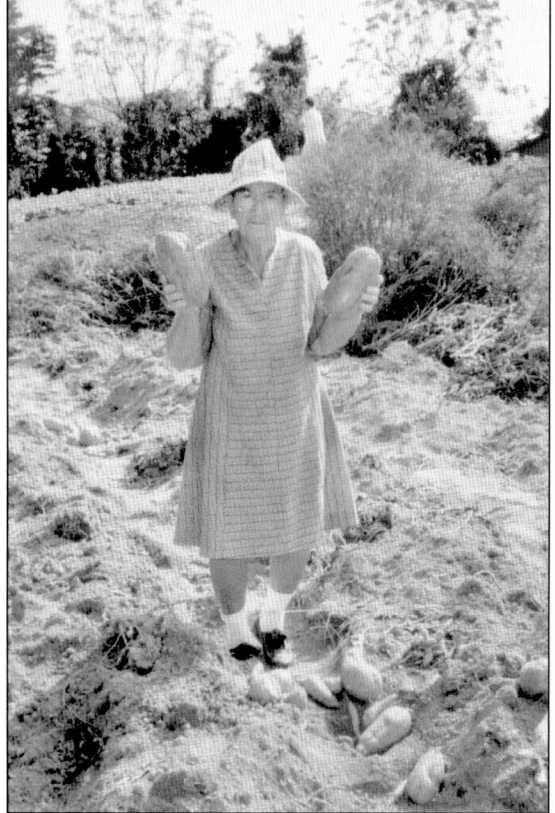

Born in the Dry Springs Community in 1894, Grace Rierson Edwards became a widow very young. During the Great Depression she was left with seven children to raise. She kept the family together by making money sewing for the Works Progress Administration and working at the county home in Stokes County. She died in 1995. (Courtesy Stokes County Arts Council.)

Mary Magdalene (Maggie) Mabe married a Mabe. She and her husband Homie lived on a farm between Lawsonville and Danbury. She never had children. Maggie spent all of her life as a homemaker, farmer, and telling from the size of those sweet potatoes, a successful gardener. (Courtesy Virginia Whitten Mitchell.)

Sara Ann Tuttle is seen at her farm in the 1920s. During the Civil War Sara Ann kept the farm going while her husband, John, fought with the 21st North Carolina Regiment. She would ride her horse to the Germanton post office a few times a year to get letters her husband would write from battle. (Courtesy Keith White.)

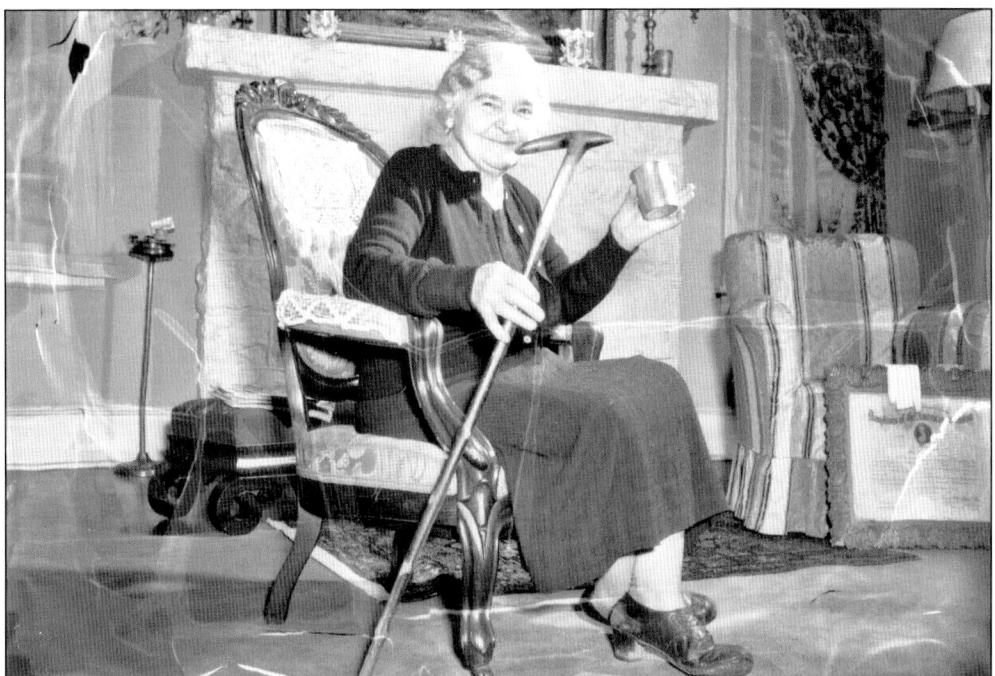

Cabell Redd Mallonee is pictured at her Walnut Cove home in February 1950. She was a great-great granddaughter of Patrick Henry and a 10th-generation descendent of Pocahontas. Here she holds the "Patrick Henry Cup" and the cane used as a gavel at the 1886 meeting that decided to bring the Norfolk and Southern Railroad through Walnut Cove. (Courtesy the Forsyth County Public Library Photograph Collection.)

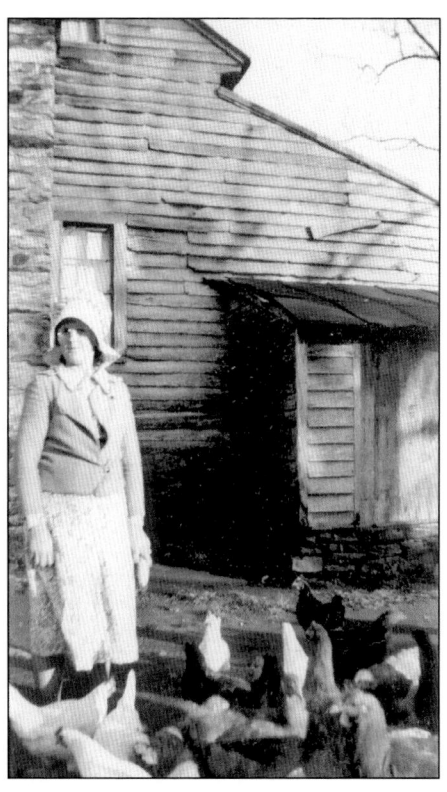

Homemaker and farmer Quincy Irene Amos Joyce is pictured in 1943 outside her pre–Civil War home in Sandy Ridge feeding the chickens. (Courtesy Darrel Lester.)

Sally Gray (sitting) was a homemaker, farmer and civic worker in Walnut Cove's African-American community. She is credited for getting more blacks to the voting polls. Some say "she was not one you told no to" and she sometimes "literally dragged people to the polls" to vote. She also used her stern ways to encourage black students to go to college. Also pictured (standing) is Arlena Hairston. (Courtesy Mabel Johnson.)

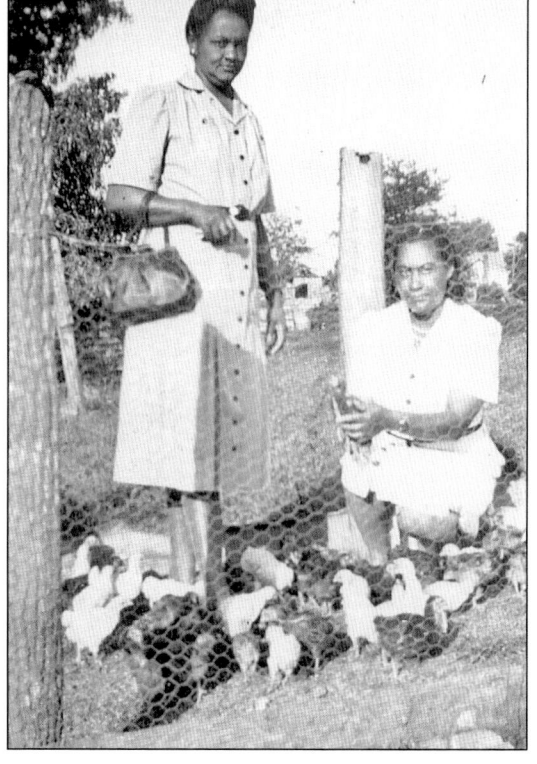

Homemaker and farmer Magdalene Robertson Tilley Compton was born in 1914, the eldest of nine children. She grew up in the Snow Hill community near Lawsonville. Her first husband Eldridge Tilley died in 1963. They had three children. (Courtesy Stokes County Arts Council.)

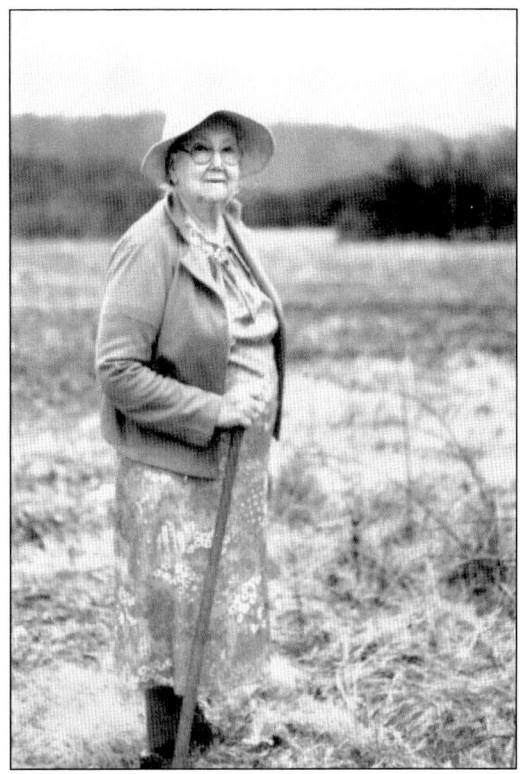

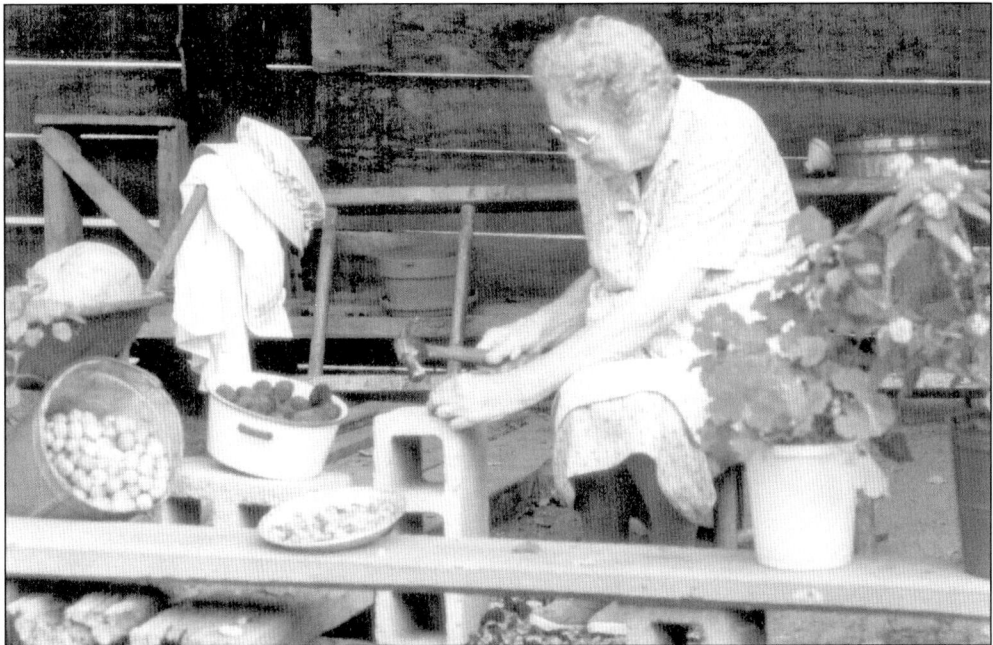

Etta Lawson Whitten is still cracking walnuts. She collected, cracked, and sold walnuts to pay for her wedding dress. A mother of four, she spent her life as a homemaker and farmer. She and her husband Ernest moved from Lawsonville to Germanton in 1948 looking for level farming land. (Courtesy Virginia Whitten Mitchell.)

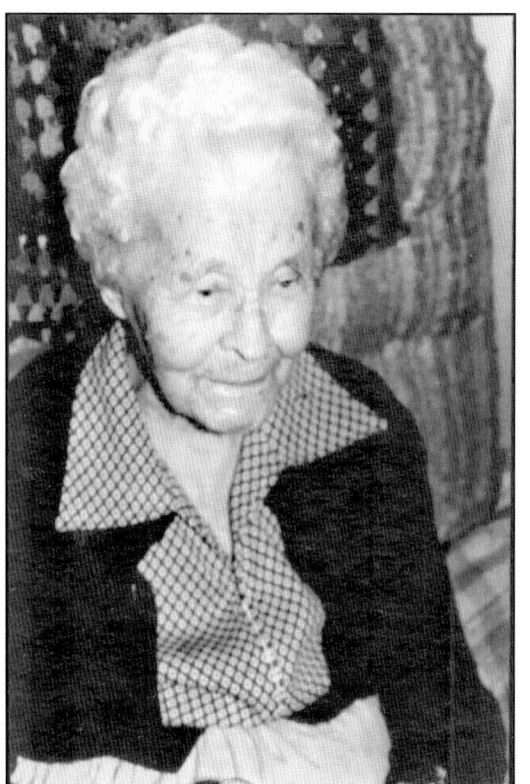

Nevada Jane Hall was born in 1888 in the Brim's Grove Community. She never married and said that was the key to a long and healthy life. She died just weeks before her 105th birthday. (Courtesy Stokes County Arts Council.)

Annie Mae Oakley enjoyed milking her cow and making homemade butter up until the late 20th century. She never married. She spent her life tending to her parents and a disabled sister. (Courtesy Virginia Whitten Mitchell.)

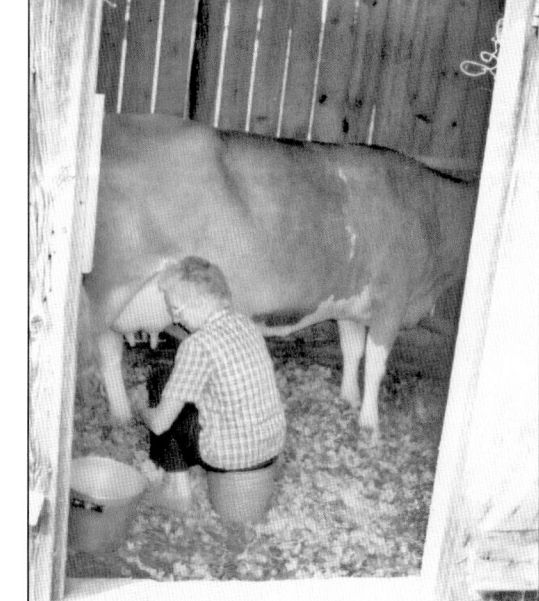

Kate Perry Stone (standing right of an unidentified women) is pictured on her graduation day from nursing school in 1913. Born in 1883, she spent most of her life working as a nurse with her brother, Dr. Grady Stone, and Dr. Rupert Helsabeck at their office in King. She never married and died 1947. (Courtesy Jean Stone Hall.)

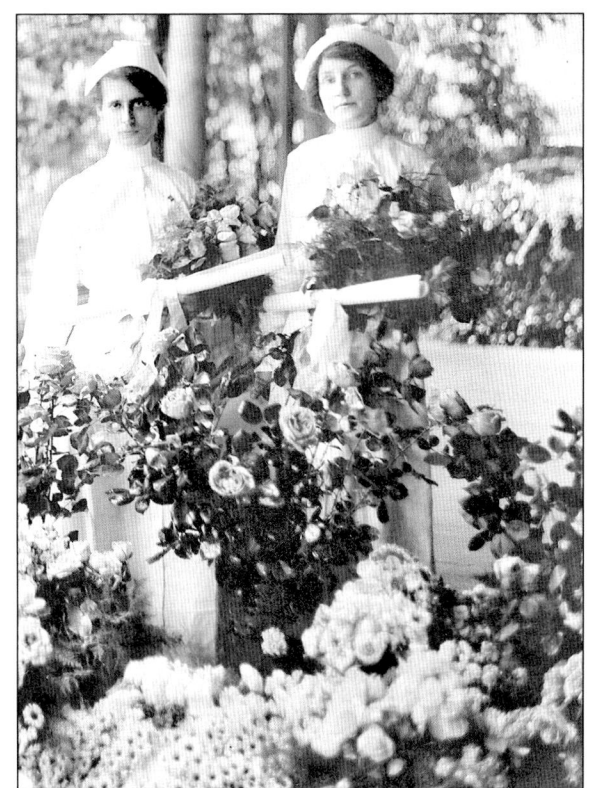

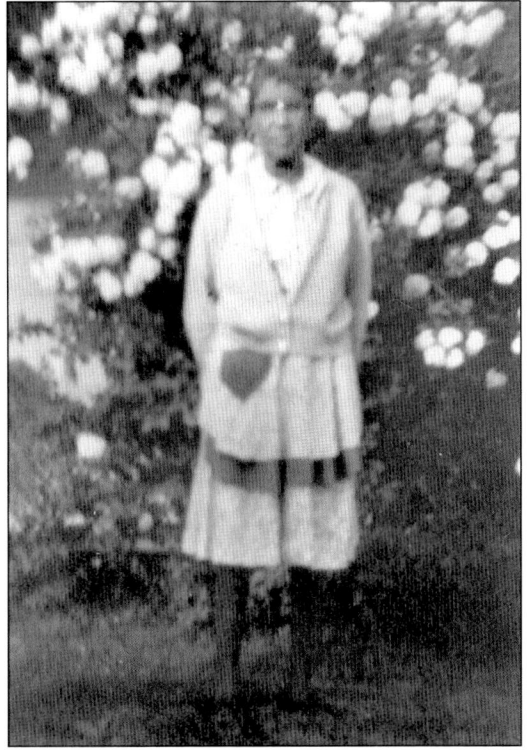

Though her picture may be blurry, her dedication to the mothers of her community is not. Born in 1890, and known in the black community of Walnut Cove as "Aunt Mary," Mary Elizabeth Goolsby Johnson worked her entire life as a midwife until her health failed her. She died in 1975. (Courtesy Mabel Johnson.)

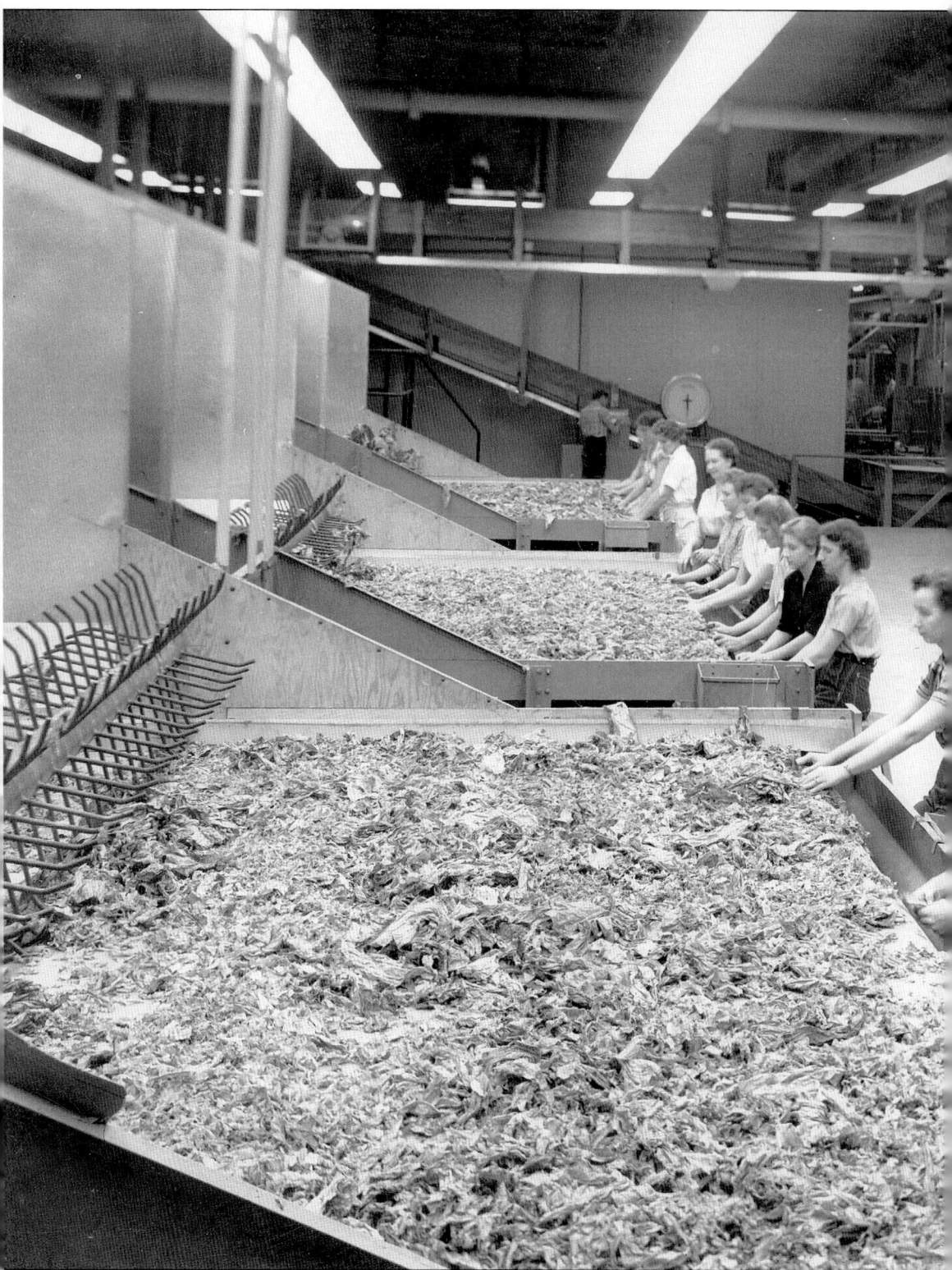

R.J. Reynolds Tobacco Company's Brook Cove Plant is pictured here c. 1960. By the time R.J. Reynolds Tobacco Company opened its Brook Cove Tobacco Processing Plant in 1959, Stokes County women had emerged out of the kitchen, off the farms, and into the public sector. (Courtesy Evelyn Vaden Nelson.)

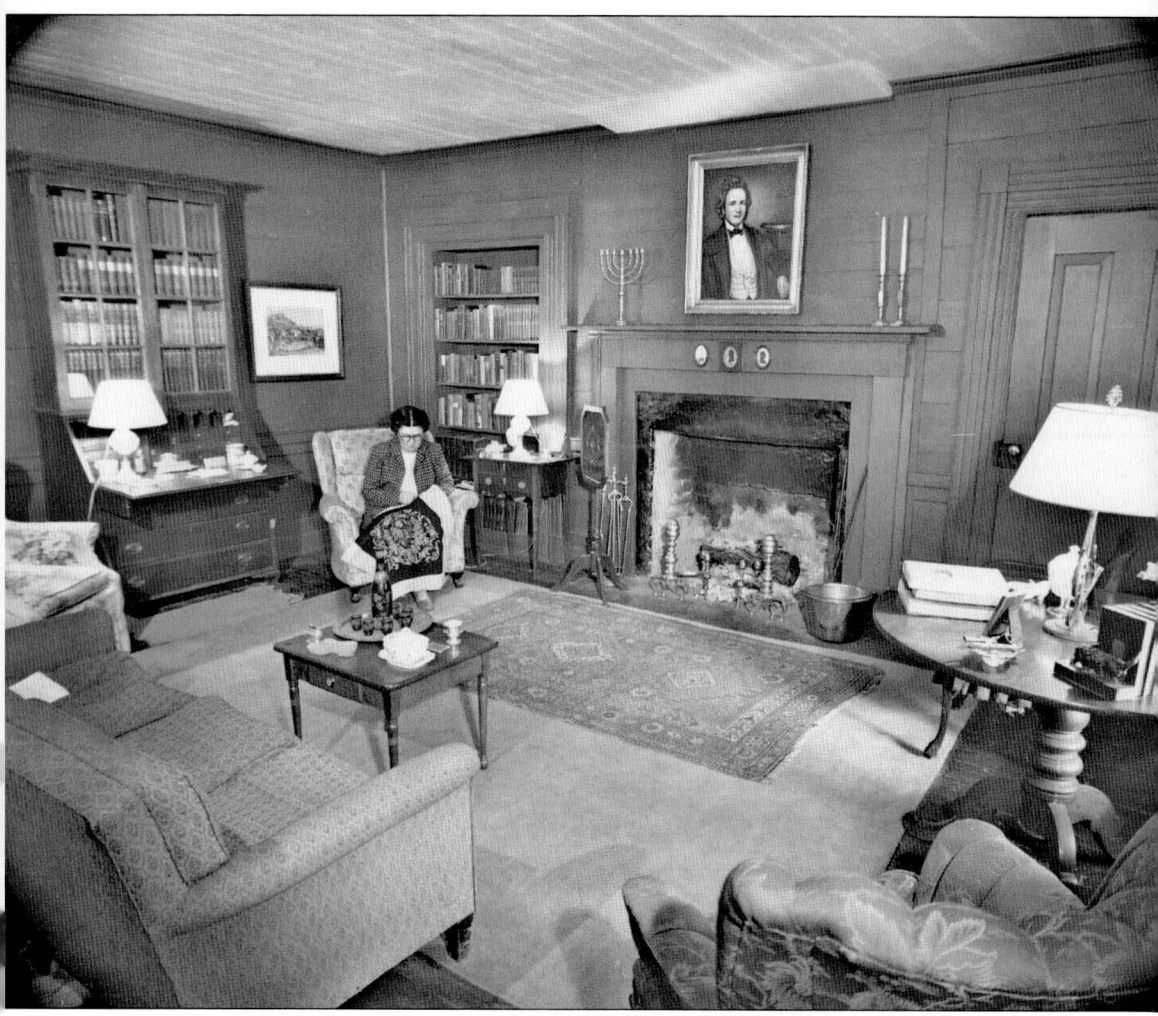

Educator and community leader Grace Pemberton Taylor Rodenbough is seen sitting in the corner of her Library inside the Covington Home near Walnut Cove, 1951. Two years later she would be elected to the North Carolina Legislature, the first woman elected to any public office from Stokes County. She was the only women in that session of the legislature in 1953 and at the time only the 11th in the history of the state. She would be elected to office seven more times. She traveled the state encouraging women to become more involved in businesses and government. She was once quoted saying, "Men have run the affairs of this world a long time. I believe we can help them run it more humanely." In her last term in office she was appointed chairman of a special committee on the status of women. She was also named vice chairman of the House Finance Committee, the first woman to hold a major finance post in the history of the state legislature. She died in January 1967. (Courtesy the Forsyth County Public Library Photograph Collection.)

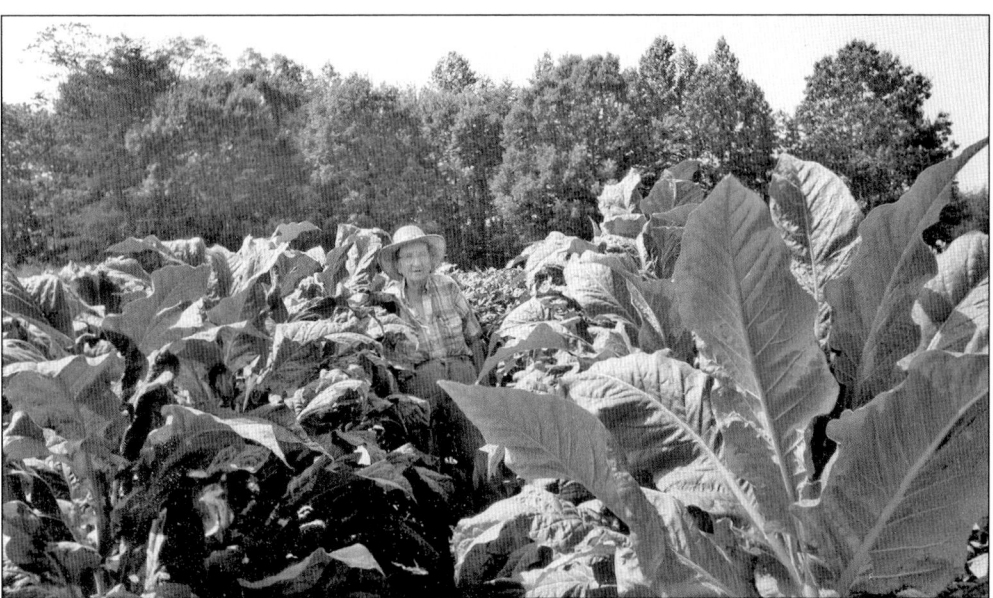

Friends Mabel Coffer, Inez Burwell, Mildred Burwell, and Hattie Mickey are shown berry picking at Vade Mecum, c. 1920. (Courtesy Norman and Shirley Mickey.)

Juanita Gordy is seen here on the tobacco farm she has worked since her childhood. Juanita, a farmer and mother, dedicated her life to her family and her crop. In October of 1990, with the money she made from raising tobacco, she made her last farm payment, buying back her parents' farm. (Courtesy the Gordy family.)

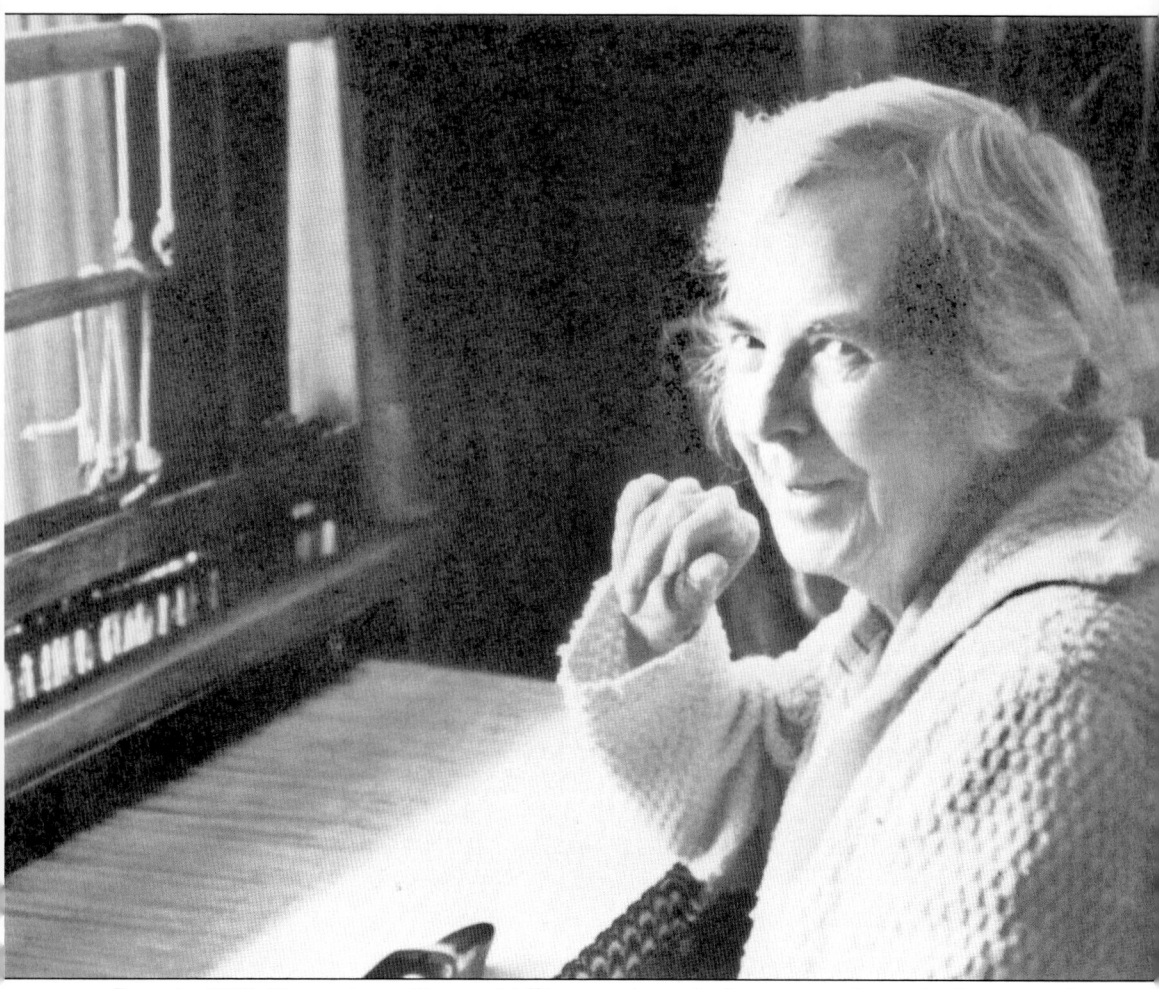

Born in 1900, Gypsy Anne George Hollingsworth worked as a nurse by trade, but it was her life of giving and sharing to the arts and children for which she will forever be remembered. She became involved in the visual arts and children's groups very early, even more so after the death of her husband in 1953. She taught weaving for 20 years at the Sawtooth Center for Visual Design, where she gave her salary back to the arts. She was a founding member of the Piedmont Craftsmen in 1963. A highly educated woman, she taught herself German and in her late seventies began to learn Russian. She continued to teach weaving and share the arts with children up until her death in 1983. Gypsy's coverlets and tapestries hang in the Smithsonian Institute and the Museum of Art in Pasadena, California. (Courtesy Stokes County Arts Council.)

Six

THE MEN OF HANGING ROCK

The CCC was a great thing, I was 16 when I joined. It was hard work; I started using a sledge hammer bustin' rock, then we got a jackhammer, it made things easier but it was still hard work.
—Marion James, at age 81, recalling his years as a
Civilian Conservation Corps worker building
Hanging Rock State Park

It was a hot, humid second day of July in 1935, when 243 men arrived at the edge of more than 2,000 acres of woods and mountainous terrain in Stokes County. It was the Great Depression and the men, out of work, were ready to climb mountains.

With the establishment of President Franklin Roosevelt's New Deal relief agency, the Civilian Conservation Corps (CCC), through land and park preservation, saved thousands of America's greatest acreage and unemployed men.

In April of 1936, the Winston-Salem Foundation and the Stokes County Committee for Hanging Rock sold the land they had acquired from developers to North Carolina for $10. For years, developers from as far away as Florida drew up plans for the land nestled in the Sauratown Mountains. Plans included another springs resort, an idea that washed away when groups started coming forward to protect Hanging Rock.

Though the "CC boys," as they were called, started building their camps and cutting out roads in the summer of 1935, the state did not officially create Hanging Rock State Park until the following year. For seven years they worked, building everything from two dams that created a 12-acre lake to hiking trails. They received $30 a month, a dollar a day, and were only allowed to keep seven of it. The rest of their pay was sent home to help their families trying to survive the Depression.

In 1941, the CCC began to dwindle as men left to prepare for war. Work at Hanging Rock was complete and Congress ended the program in July 1942. Two years later the park officially opened to the public, nine years after the CC boys first arrived. The following is a collection of rarely seen photographs of the men of Hanging Rock.

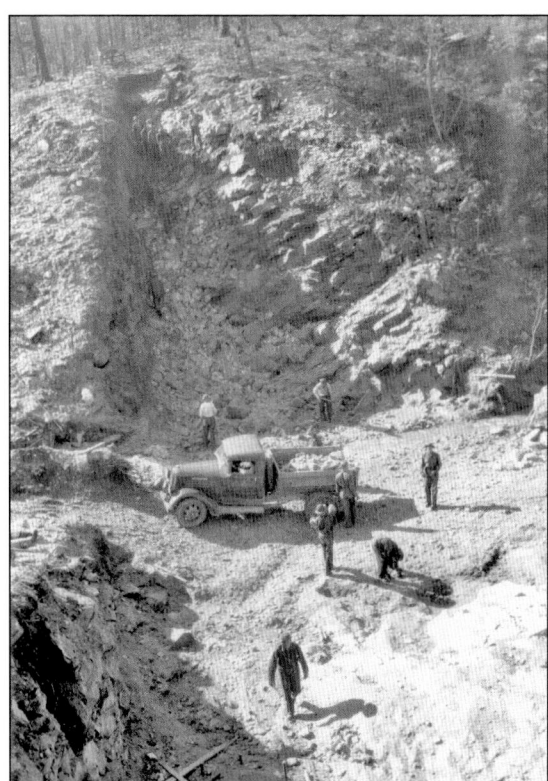

It took two years to build two dams, one concrete and one of earth, that impounded Cascade Creek, creating a 12-acre lake. Both dams were completed in the summer of 1938. The construction of the concrete dam is pictured here. (Courtesy Hanging Rock State Park.)

The dam footing is being excavated in this photograph. (Courtesy Hanging Rock State Park.)

Stone, quarried on-site, was used in the creation of the dams, road retaining walls, picnic shelters, and the bathhouse. After the stone was quarried, workers dammed the pits and the park used it for drinking water until the 1960s. Today the park uses well water. (Courtesy Hanging Rock State Park.)

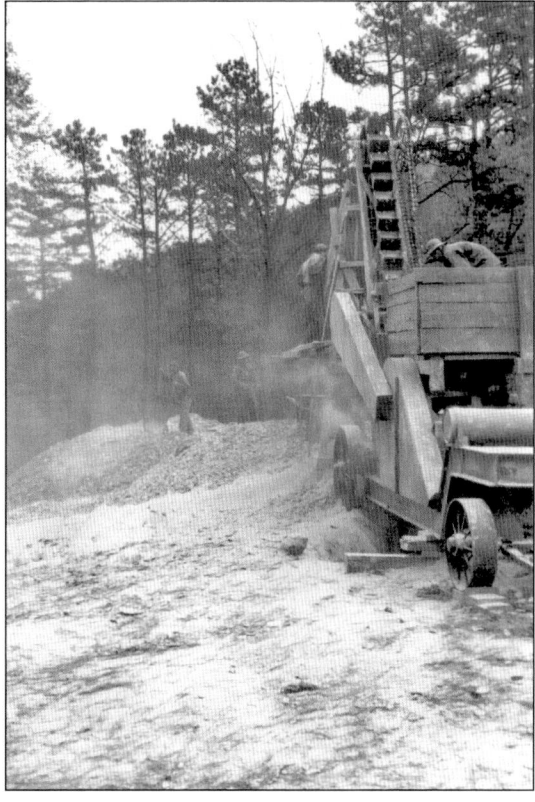

Workers crush rock to use in the making of the concrete dam. (Courtesy Hanging Rock State Park.)

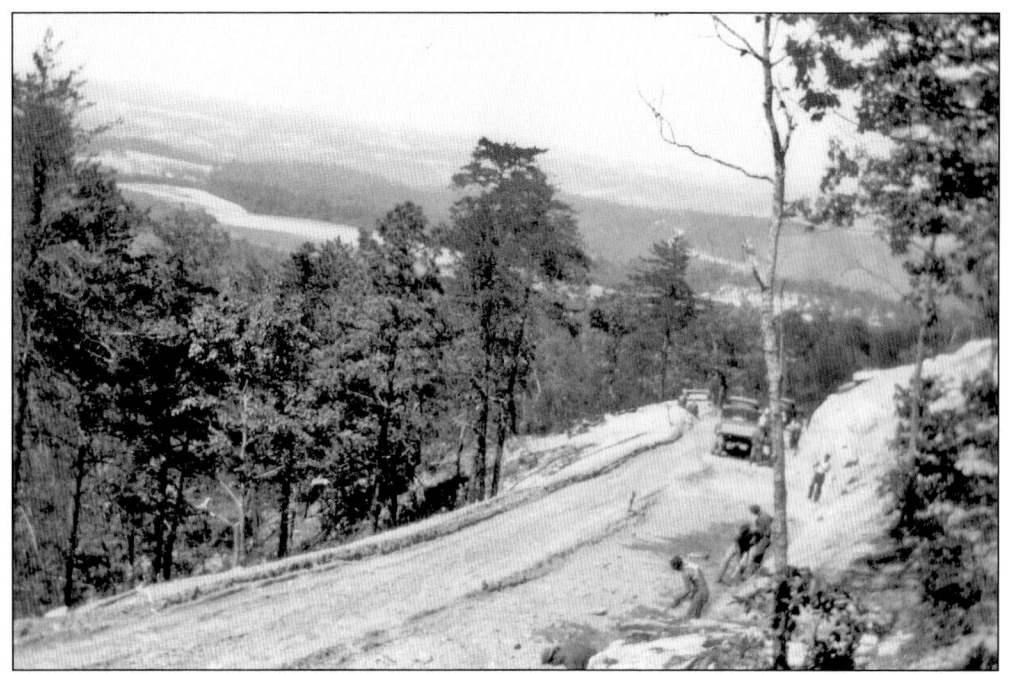
It took nearly a year for workers to carve out a mile-long park road, which workers completed in June 1936. (Courtesy Hanging Rock State Park.)

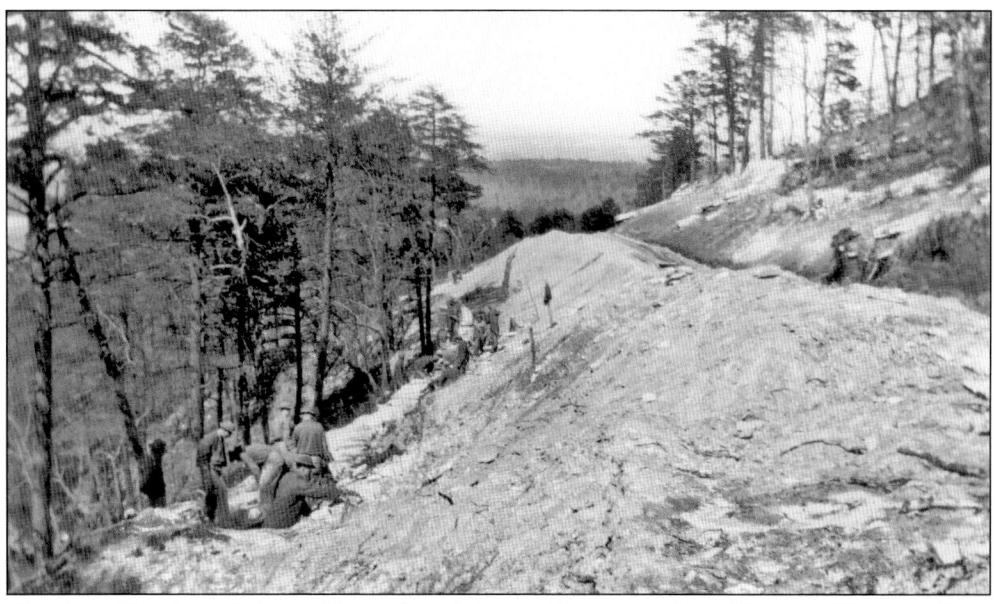
This is a side view of the park's road-retaining wall construction. (Courtesy Hanging Rock State Park.)

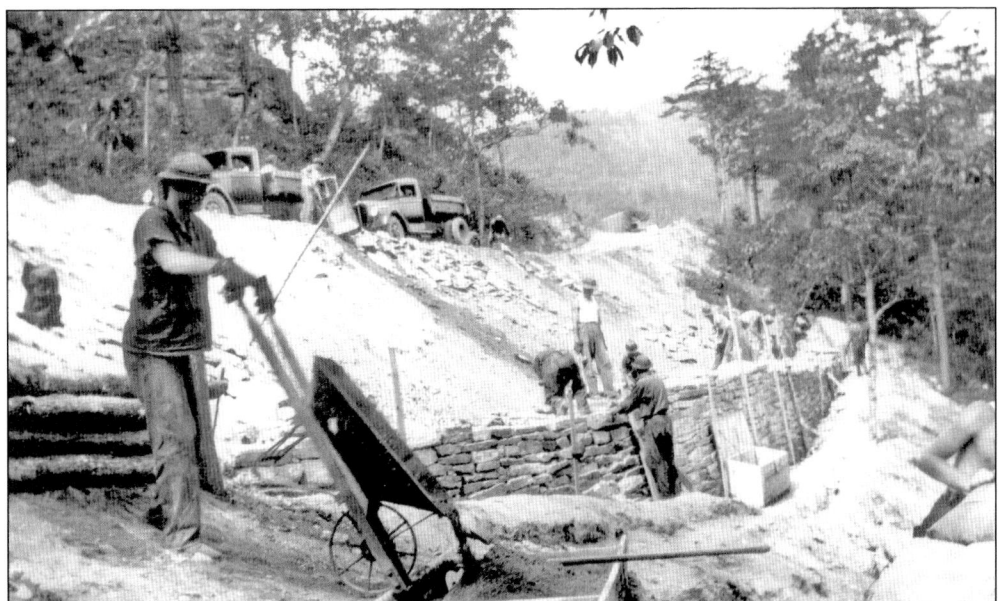

Using bulldozers and wheel barrels, workers moved dirt and laid the park's road-retaining wall by hand with rock quarried out of the park's mountainside. (Courtesy Hanging Rock State Park.)

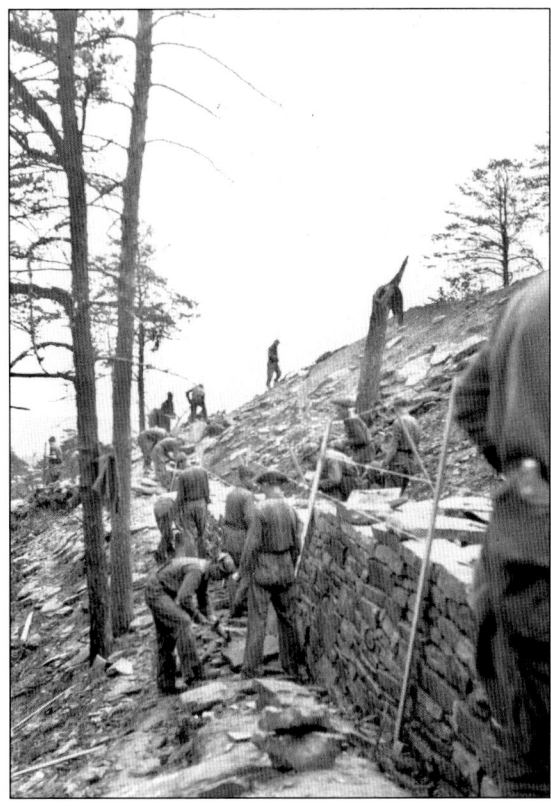

The stonework became a trademark of the parks built by the CCC. (Courtesy Hanging Rock State Park.)

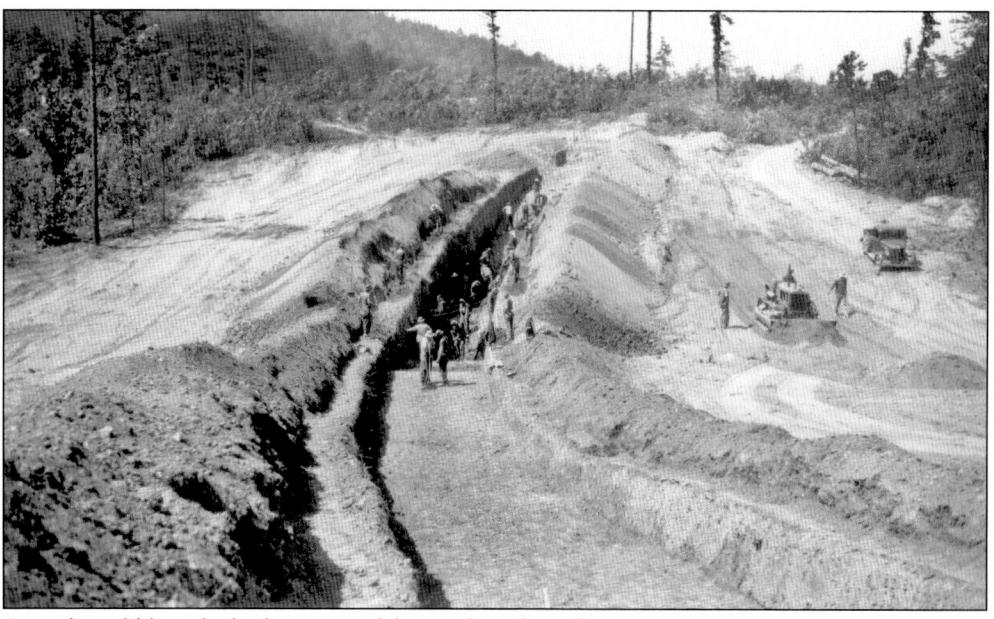

Here is a larger view of the dams under construction. Excess dirt from the dams and park roads was used to create the beach at the park's 12-acre lake, which was filled completely by July 1939. (Courtesy Hanging Rock State Park.)

A road would later be built on top of the earthen dam. (Courtesy Hanging Rock State Park.)

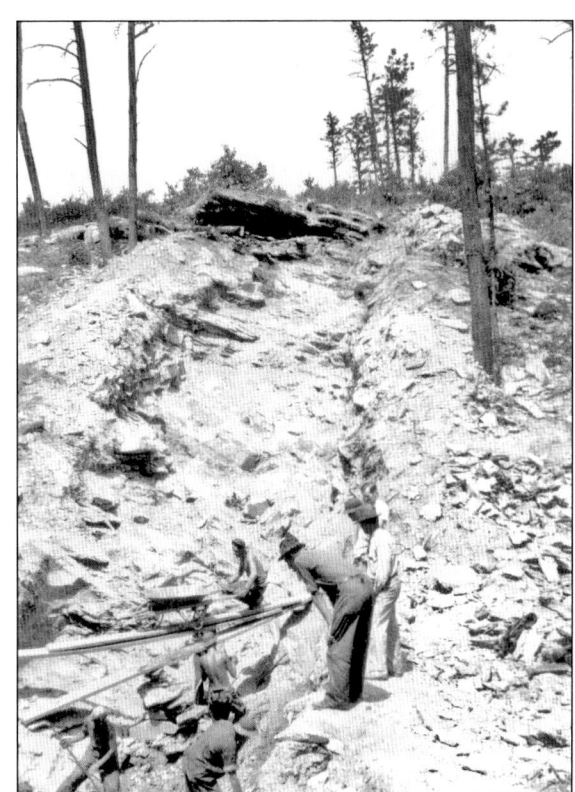

Each stage of the building project had to be inspected. At right, field officers oversee work construction. Below, inspectors look over the dam construction site. (Courtesy Hanging Rock State Park.)

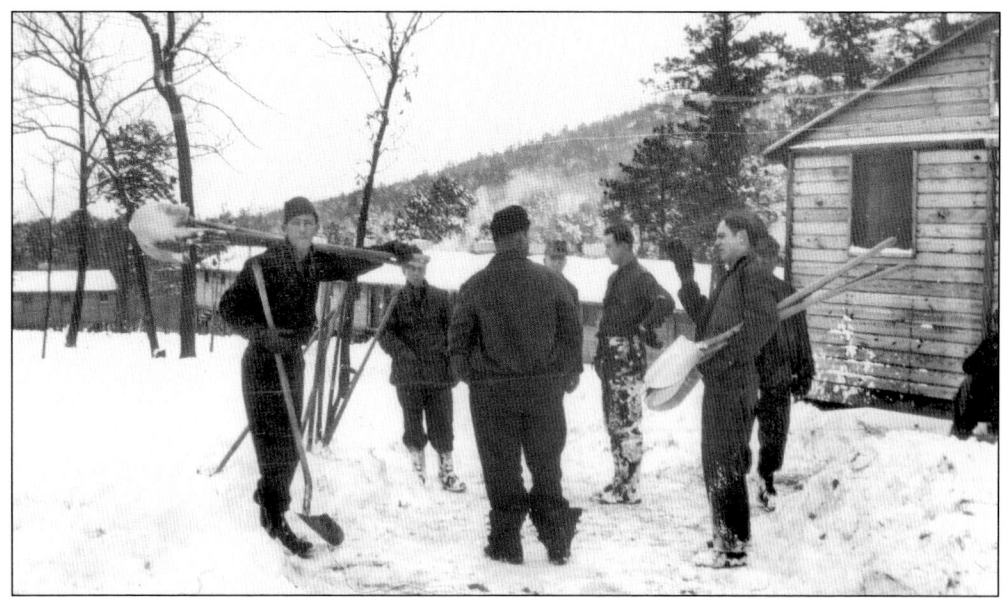

The first workers to arrive slept in tents and bathed in the pool at the Cascades until they built what became known as the "CC Camp" in late summer, 1935. Above, men take a break from shoveling snow at the camp. (Courtesy Hanging Rock State Park.)

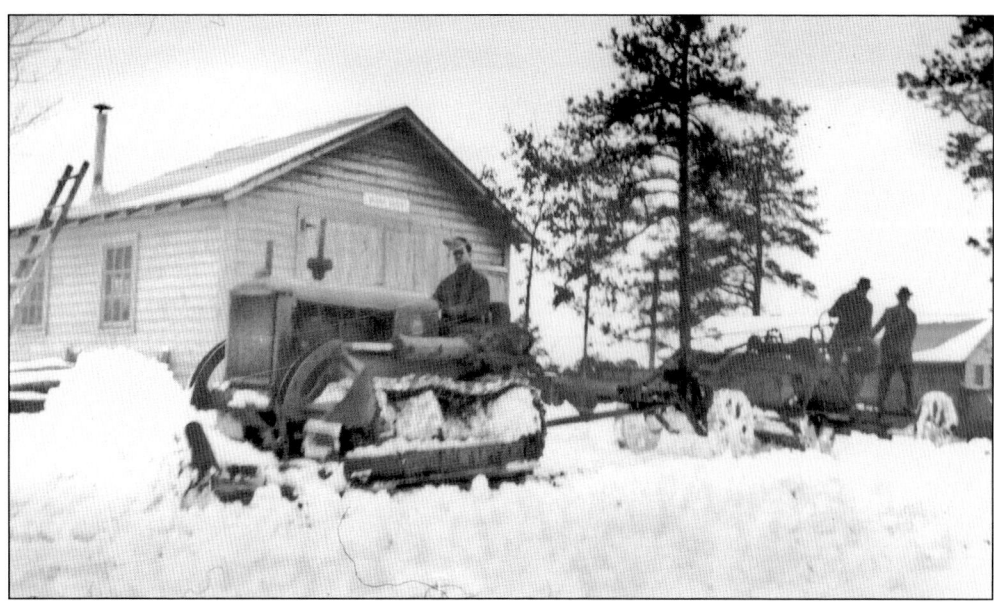

The "CC Camp" was labeled a "first-class town" that included barracks, an infirmary, mess hall, PX, office, and sheds. More than 200 men lived in the camp. (Courtesy Hanging Rock State Park.)

Each barrack housed 52 men, and each was required to work the camp, which was run in military fashion. (Courtesy Hanging Rock State Park.)

In addition to sending part of their pay home, workers were required to learn a trade. Classes were offered in subjects from blueprint making to the Bible. A certificate discovered in the park archives shows that Clindon Howell completed 12 hours of instruction in plumbing at the camp in 1939. (Courtesy Hanging Rock State Park.)

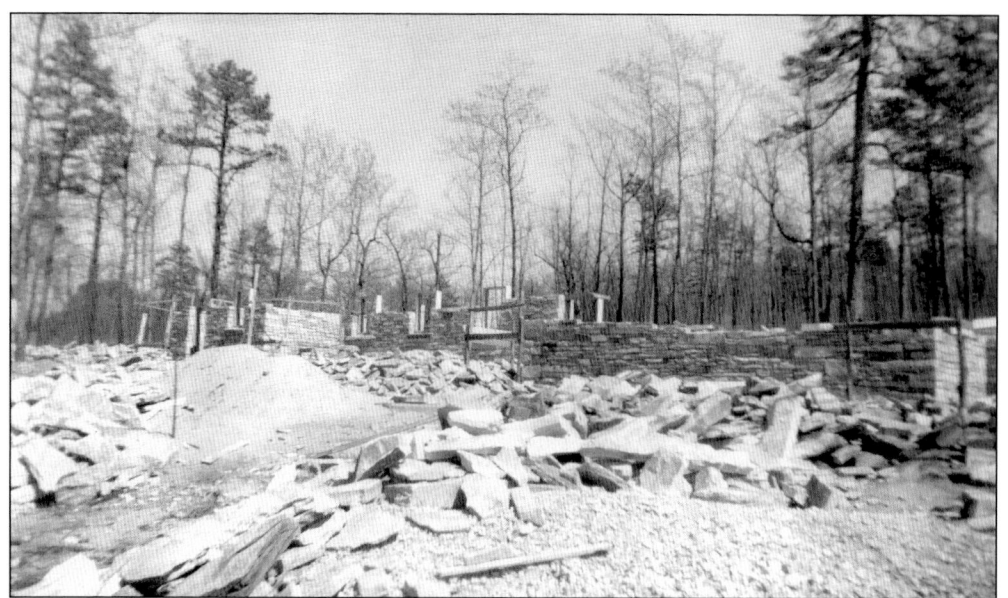

The 150-foot-long stone-and-timber bathhouse was designed by Gaston County native Robert Ormand. Ormand worked as a federal architect for the National Park Service during the Depression. (Courtesy Hanging Rock State Park.)

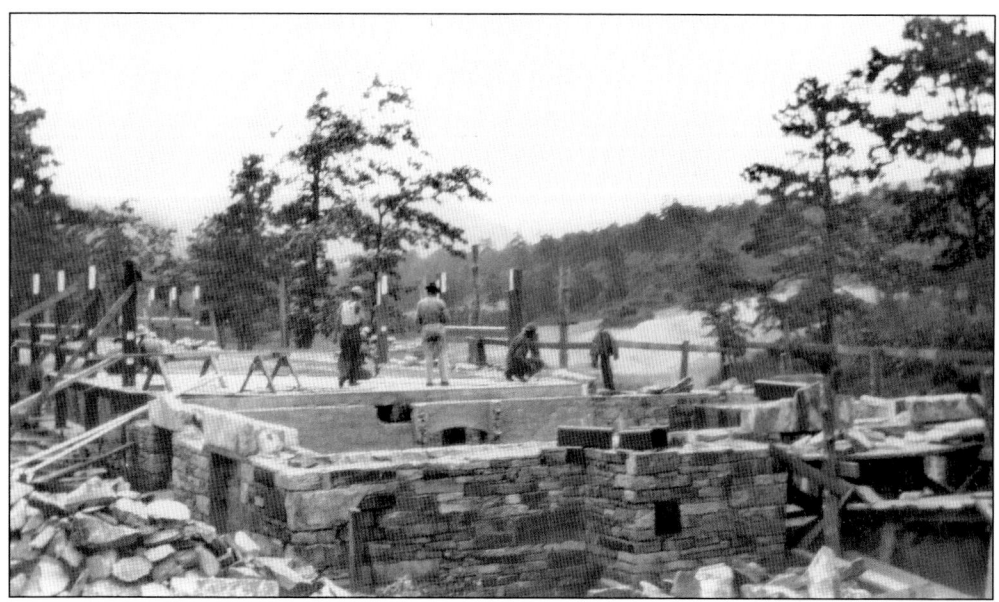

Using stone quarried out of the park, the bathhouse was built to serve 1,000 visitors and was completed in 1939. (Courtesy Hanging Rock State Park.)

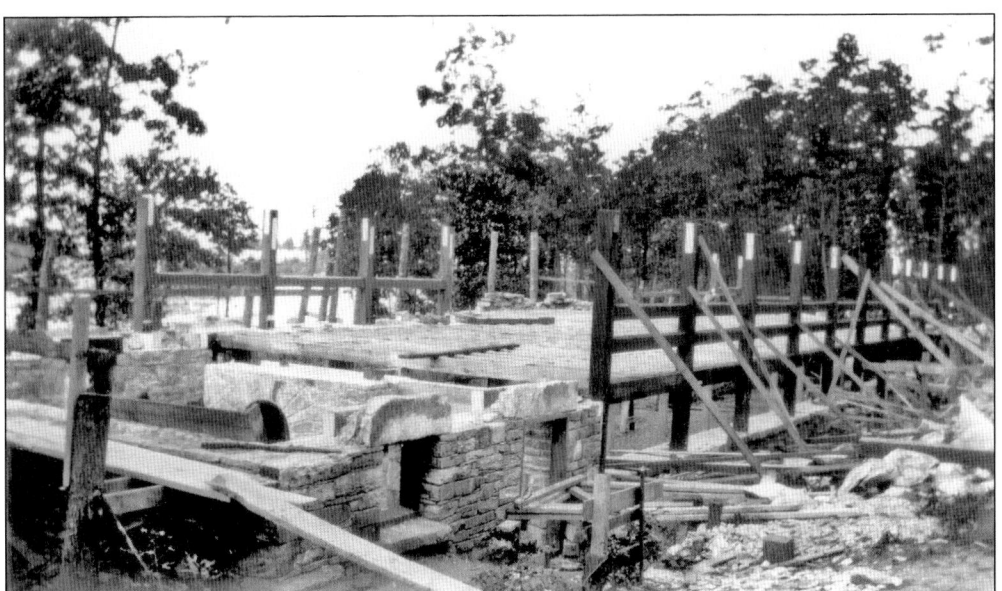

The rock and wood bathhouse has been described as one of the finest built and equipped bathhouses in the Carolinas and has become a landmark of the park. In October 1991 it was placed on the National Register of Historic Places. (Courtesy Hanging Rock State Park.)

State of North Carolina
Department of Cultural Resources
Division of Archives and History

This is to certify that

HANGING ROCK STATE PARK BATHHOUSE
STOKES COUNTY

has been entered in

THE NATIONAL REGISTER OF HISTORIC PLACES

by the

United States Department of the Interior
upon nomination by the State Historic Preservation Officer under
provisions of the National Historic Preservation Act of 1966 (P.L. 89-665).

The National Register is a list of properties "significant in American history, architecture, archaeology, and culture — a comprehensive index of the significant physical evidences of our national patrimony." Properties listed therein deserve to be preserved by their owners as a part of the cultural heritage of our nation.

Director, Division of Archives and History
and
State Historic Preservation Officer

October 24, 1991
Date Entered

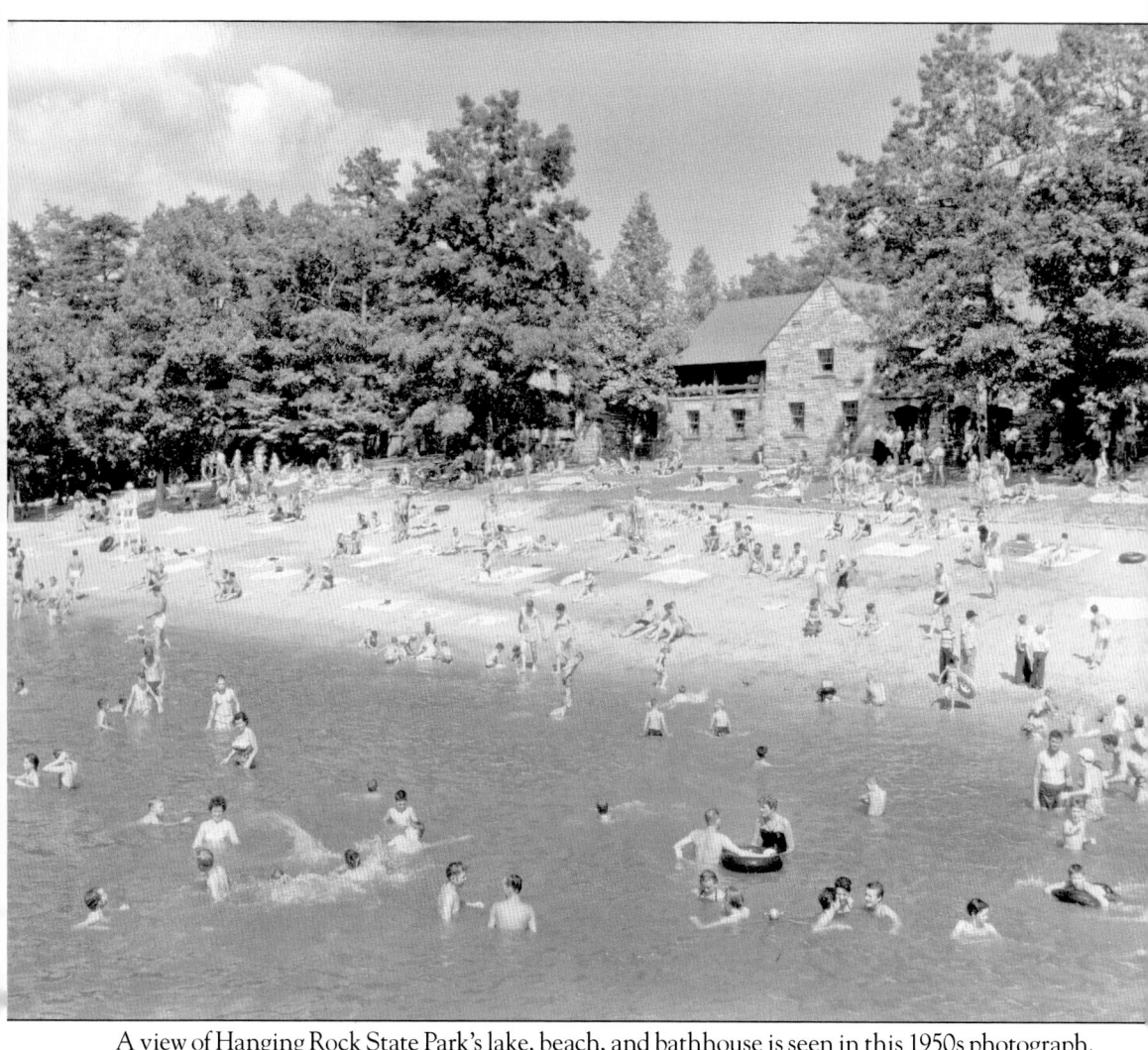

A view of Hanging Rock State Park's lake, beach, and bathhouse is seen in this 1950s photograph. (Courtesy Hanging Rock State Park.)

Seven
SUNDAYS IN STOKES

We looked forward to Sundays; that's when we got the newspaper. We would pass the paper around, taking turns reading. It was the only time we got the paper.
—Clara Bennett Nelson, recalling Sundays growing up near Danbury.

It is the day when things slow down, eternal life is put into perspective, and children become explorers. It is Sunday in Stokes. The day of the week that in a modern, high-speed society still finds its place. Sunday holds a place of comfort in family gatherings and church fellowship. The following photographs from the past capture the images many strive to find, that moment of slower time, simple life, and neighborly care. But the pictures are also lessons in black and white: they show that these things are nothing to strive for, they are already here for the taking.

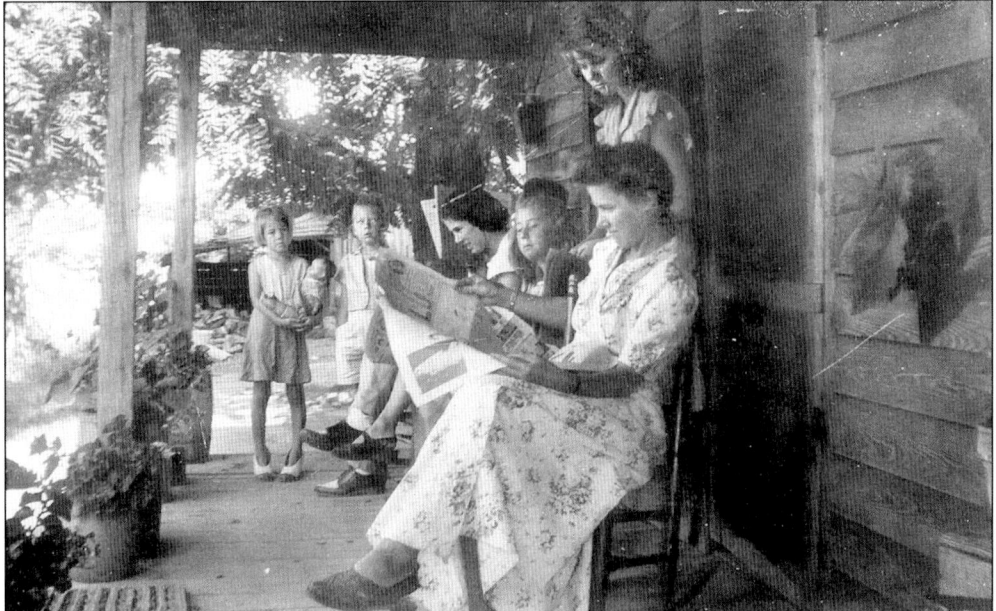

The family of Fred and Essie Bennett are shown taking turns reading the Sunday paper, c. 1947. (Courtesy Clara Bennett Nelson.)

Shown above is the baptism of (from left to right) Cranford Priddy, Curtis Priddy, Nolaska Alley, and Virginia Alley in the Dan River, 1951. The church congregation gathered on the Moratock Park Bridge to watch. Also pictured at far right are elders Coy Mabe and Watt Priddy. (Courtesy Cranford Priddy.)

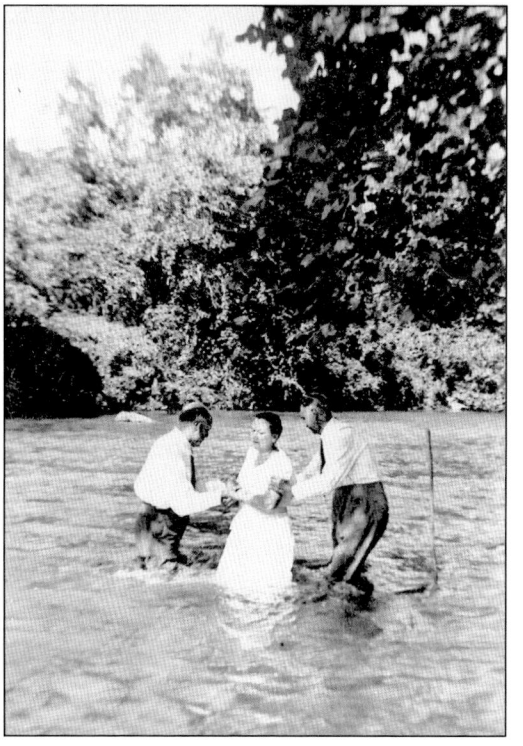

This is the baptism of Nannie Jones Vaden in the Dan River, near Highway 89, 1949. Also pictured are Piney Grove Primitive Baptist Church elders Millard Vaden and W.J. Brown. (Courtesy Evelyn Vaden Nelson.)

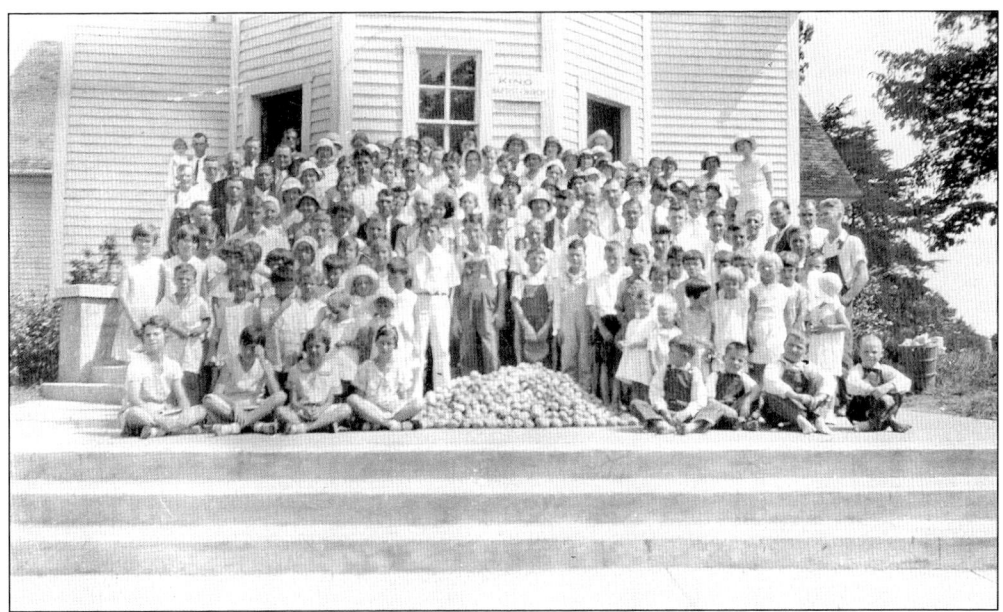

King Baptist Church congregation (today First Baptist Church) is seen here c. 1930. The congregation gathered potatoes to donate to the children's home in Winston-Salem. (Courtesy Becky Rains Moser.)

Members gather for a "footwashing" after services at Piney Grove Primitive Baptist Church, 1920s. (Courtesy Virginia Dare Smith.)

Young folks gathered on a Sunday Afternoon at Quaker Gap in 1915. (Courtesy Virginia Whitten Mitchell.)

J. Harley and Mary Boles White (front seat) and family are out for a Sunday afternoon ride in their Chevrolet, c. 1921. (Courtesy Keith White.)

Pictured here is Northview Primitive Baptist Church's "Dinner on the Ground," which took place in the Hartman Community near Danbury in the early 1940s. In the summer, church congregations would hold "Dinner on the Ground" after Sunday service. It was an event that included lots of food and lemonade. (Courtesy Clara Bennett Nelson.)

The Riley Boyles family hosted a reunion near King in 1918. Riley Boyles (back row, second man from left with wife Mary in front) was the only son out of the seven born to John and Charity Boyles to survive the Civil War. The family is believe to have suffered the most war casualties among any single Stokes County family. Survivor Riley Boyles and his wife Mary were able to keep the family name alive; they had a total of 17 children, all pictured here with their children. (Courtesy Patrick Boyles.)

Sisters Nina, Rachel, Gracie, and Margaret Carter are pictured with their Christmas Dolls. (Courtesy Woodrow Richardson.)

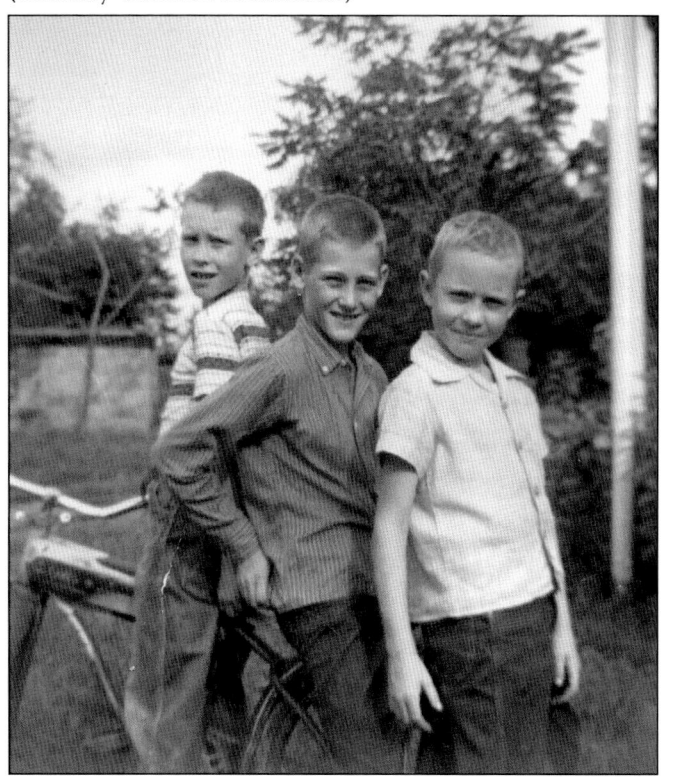

Sundays were filled with play for children. From sisters to cousins they explored the world together, both in their imaginations and in the fields and back roads of Stokes County. At left are David Kiser, Jerry Stanley, and Howard (Bubby) Kiser near Sauratown Mountain, 1959. (Courtesy Stacey Bennett and Julia Vanhoy.)

BIBLIOGRAPHY

BOOKS
Carroll, Robert. *One Hundred Years of King History*. Winston-Salem: Sara Lee Graphics, 1988.
Covington, T.J. *Walnut Cove and Stokes County*. Farm Bureau, 1912.
Duncan, Wade (coordinator) and the Stokes County Historical Society. *The Heritage of Stokes County, North Carolina*. Vol. 2. Charlotte: Delmar Printing and Publishing, 1990.
Hunter, Rixie. *Stokes County, North Carolina*. Winston-Salem: Pepper Printing Company, c. 1960.
Jones, M. Bruce and Smith, Trudy J. *White Christmas, Bloody Christmas*. Trinity, NC: UpWords Publications, 1990.
Phillips, Anne Radford, Taylor Dabney, and the Stokes County Arts Council. *Voices and Reflections of Farm Women: Field, Home and Family*. Winston-Salem: Rainbow Print and Copy, 1998.
Walnut Cove Centennial Committee. *Echoes of Walnut Cove 1889–1989*. Walnut Cove: Town of Walnut Cove, 1989.
Wiencek, Henry. *The Hairstons, An American Family in Black and White*. New York: St. Martin's Press, 1999.
Woodard, John R., ed., and the Stokes County Historical Society. *The Heritage of Stokes County, North Carolina*. Vol. 1. Winston-Salem: Hunter Publishing, 1981.

The use of some quotes and photographs from the guide *Voices and Reflections of Farm Women: Field, Home and Family*, copyrighted 1998, was used with the permission of the Stokes County Arts Council.

INTERVIEWS
Boyles, Patrick. Interviewed by author. Winston-Salem, North Carolina, March 3, 2004.
Carroll, Robert. Interviewed by author. Winston-Salem, North Carolina, February 15, 2004.
Hall, Jean Stone. Interviewed by author. Pinnacle, North Carolina, February 18, 2004.
Johnson, Mabel. Interviewed by author. Walnut Cove, North Carolina, March 15, 2004.
Kiger, Madeline Pulliam. Interviewed by author. Rural Hall, North Carolina, March 29, 2004.
Lester, Darrel. Interviewed by author. Sandy Ridge, North Carolina, March 7, 2004.
Marshall, Juanita Moore. Interviewed by author. Rural Hall, North Carolina, March 11, 2004. Mickey, Norman and Shirley. Interviewed by author. Westfield, North Carolina, March 20, 2004.
Mitchell, Virginia. Interviewed by author. Danbury, North Carolina, March 25, 2004.
Moser, Becky Rains. Interviewed by author. King, North Carolina, March 27, 2004.
Nelson, Clara Bennett. Interviewed by author. Danbury, North Carolina, March 6, 2004.
Spainhour, Sally. Interviewed by author. King, North Carolina, February 26, 2004.
Tilley, William. Interviewed by author. Danbury, North Carolina, March 25, 2004.

NEWSPAPERS
Winston-Salem Journal
Danbury Reporter

INDEX

Alley: Junior, 52; Nolaska, 120; Vance, 16, 52; Virginia, 120
Amostown School, 50
Anderson, Maj. Leonard, 32
Asbury, 55
Baileytown, 80
Beck, Walter, 21
Bennett: Clara, 83; Coy, 6; Durwood, 81; Fred, 82; Lillie, 83; Mary Ann, 83; Pate, 83; Posie, 82; Shirley, 6; Will, 54
Boaz School (second), 51
Bowman, Ida Mae, 57
Boyles: John and Charity, 123; Kermit, 67; Riley and Mary, 123
Brann, Lena Priddy, 52
Brim's Grove, 100
Brook Cove: community, 84; tobacco plant; see R.J. Reynolds Tobacco Company
Brown: H.H., 35; W.J., 120
Bullin, Jim, 73
Bullins: Lim, 16; Ralph, 82
Burwell: Inez, 105; Mildred, 105; Tom, 63
Byrd, William, 40
Calloway, Lee, 2
Campbell, Junior, 73
Campbell Post Office, 31
Camping Island Bridge, see Dan River Bridges
Capella, 58
Carroll, Robert, 9
Carter: Gracie, 124; Margaret, 124; Nina, 124; Rachel, 124
Central Carolina Convalescent Hospital, 48
Chestnut Grove, 58
Civil War, 49, 75, 97–98, 123
Civilian Conservation Corps, see Hanging Rock State Park
Coffer: Mabel, 63, 105; Joe, 63
Cole, Alonzo, 36
Collinstown, 55
Compton, Magdalene Robertson Tilley, 99
Covington Home, 41, 104
Cox: Steve, 81; Wesley, 63

Crawford: see Danbury
Creason School, 50, 58
Cromer, Bryce, 36
Crooked Creek: see Sandy Ridge
Culler: see Pinnacle
Culler, E.W. (Manuel): see Pinnacle
Dan River, 10, 32, 75; Baptism, 120
Dan River Bridges: Danbury, Camping Island Creek, 13; Danbury, Moratock, 13; Pine Hall, Iron Span Bridge, 33
Danbury: Bank, 12; courthouse, 10–11, 20; farming 96, 81–83; high school, 53–54; post office, 15
Danbury Reporter, 15
Dalton: Home, 24; Institute, 24, 51
Dalton, David Nickolas, 24
D.D. Hall Shell Service Station, see King
Depression, Great, 95–96, 107
Dewey, Samuel, 87
Dodd's Mill, 14
Dorsett, Joe Sam, 21
Dry Springs, 58, 96
Dunlap, Dunk, 73
East: Connie, 51; Harden, 51; Juanita, 51; Nellie, 51; Tom, 51
Eaton, Thomas, 67
Edwards, Grace Rierson, 95–96
Estes, Charlie, 93
Fagg: Glenn, 52; Hassell, 47; "Poe," 52
Fagg School, 54
Flat Shoals, 58; School, 55
Flinchum: Edith, 52; Felmore, 54; Stedman, 52
Flynt, Bill, 6
Fontaine, Martha, 32
Forsyth County, 10, 20
Francis Company, see Francisco
Francisco: community, 18; school, 18, 31, 55; post office, 18
Freeman School, 72
Friends Union Friends Church, 65
Friendship, 58
Fulp School, 72
Fulton, George, 41

Gap, 49
Gentry: Jack, 61; Marguerite Slate, 75
George: Joe Glenn, 90; Ray, 67
Germanton: bank, 12; courthouse, 19,72; depot, 18, 21; farming 81, 99; H. McGee & Company General Merchants, 20; Methodist Church, 19; post office, 20, 97; school, 56; W.K. Bowman Grocery, 22
Goins: Carrie, 52; Marie, 52
Gordon: Bobby, 36; Leonord, 36; Norman, 36; Sammy, 36, 67; Vance, 36
Gordy, Juanita, 105
Grabs, V.T., 26
Graham, Ray, 67
Gray, Sally, 98
Great Wagon Road, 19
Greensboro, 87
Hairston: Arlena, 98; James, 43; Joe, 43; John L., 61; Roosevelt, 43
Hall: Johnsia Burwell, 49; Lyman, 52; Myrtle, 63; Nevada Jane, 100; Winfred, 52
Hammet, Ginger "Jenna" Joyce, 52
Hanes, J.L., 32
Hanging Rock State Park: bathhouse, 116–118; bathhouse designer Robert Orman, 116; Civilian Conservation Corps and construction 107–117; park, beach, and lake, 118; tourist, 38
Hartman, 123
Harts Academy, 55
Haw Pond, 58
Heath, Billy, 48
Helsabeck: Joe, 73; Dr. Rupert, 101
Henry, Patrick, 32, 97
High Point, 51
Hill: Byron, 73; Charlie, 83; Ralph, 76; Walter, 83
Hollingsworth, Gypsy Anne George, 106
Hutchison, Jack, 73
James, Marion, 107
Johnson: Mabel, 6; Mary Elizabeth Goolsby, 101

Jones: Frank, 31; Tom, 67
Joyce: H.M. Joyce Store, 15; Quincy Irene Amos, 98
Kallam: Charles, 36; Raymond, 36
Keith, Jim, 17
Kiger, Madeline Pulliam, 6
King: American Legion, 28; bank, 12; (First) Baptist Church, 121; C.S. Newsome's Store, 28; Charles and Francis, 9; Dairi-O, 29; Depot, 25; D.D. Hall Shell Service Station, 30; Drive-In Theater, 29; farming, 76, 78; first county stoplight, 30; Grabs Furniture Manufacturing Co., 26; King's Cabin, 9; Kirby's Grocery, 2; medical doctors, 101; schools, 25, 58–60, 72; Slate Funeral Home, 28; Stone Building, 27
King, Charles and Francis, see King
King, Robert, 52
King's Cabin, see King
Kirby, M., 36
Kiser: David, 124; Ed, 78; Howard, 124
Landreth, Cecil, 43
Lash Family Estate: see Walnut Cove
Lash's Store: see Walnut Cove
Lawson family murders: Arthur, Carrie, Charlie, Fannie, James, Mae Bell, Marie, Mary Lou, Raymond, 23
Lawson, Glenn, 77
Lawsonville: community 31; farming, 77, 96, 99; schools, 31, 54, 61
Lightsey, Sadie May, 51
Little Yadkin River, 75
London School, 61
Mabe: Coy, 120; Ernest, 16; Gilmer, 82; Homie, 54; Mary Magdalene (Maggie), 96; Reid, 16; Rufus, 82; Thurman "Shorty," 16; Weldon, 54
Madison, North Carolina, 40
Mallonee, Cabell Redd, 97
Marshall, Juanita Moore, 87
Martin: Cadelia, 50; Col. Jack, 37; Janie, 52 also see Rock House
Martinsville, Virginia, 80
McCanless, Dr. William, 15
McCanless House, 15
McGee: Gray, 36, 67; Ralph, 36

Meadows: community, 70, 72; school, 8
Mickey's Garage, 38
Mickey: Hattie, 105; Sam, see Mickey's Garage
Mitchell, Mary, 73
Moody, Nathaniel, 15
Moonshine: see Stokes County
Moore: Grant, 31; John, 90; William, 87, 90
Moore's Springs: company, 90; mill 91; resort, 87, 91; road, 38; spring house, 90; water, 87
Moratock Park, 13, 120; also see Danbury
Mount Airy, 24, 51
Mount Olive, 58
Mountain View, 75, 58
Nance, David Bill, 80
Nancy Reynolds School: basketball teams 63; booster club 64; Nancy Jane Cox Reynolds, 63; school, 31, 62
Nelson, Clara Bennett, 119
North Stokes High School, 31
Northview Primitive Baptist Church, 123
Nunn, Orville, 63
Oak Grove, 58
Oakley, Annie Mae, 100
Old Orchard School, 49
Old Pole Bridge School, 65
Overby, A.T., 40
Owen, Lester, 63
Paige, Gladys, 63
Palmetto Theater, 45
Pepper, Paris, 52
Perch School House: see Pinnacle
Petree: Carlyle, 52; Margie, 52
Phillips, Maggie, 21
Piedmont Craftsmen, 106
Piedmont Springs: cottage, 93; hotel, 92, 94; resort, 87; spring house, 93
Pilot Mountain, 34, 40
Pine Hall: Brick Company, 85; community, 9, 32–33, 72; farming, 76; plantation, 32; railroad station, 33; school, 65; Shale Paving Brick and Fire Proofing Company, 85
Pine Log, 58
Piney Grove Primitive Baptist Church, 120, 121
Pinnacle: bank, 35; community, 34, 36, 72; community baseball team, 36; Milling Company, 34; Perch School, 65; school, 66–77; Volunteer School, 66
Pocahontas, 97
Prather: Briggs, 93; Frances, 93; J.H., 93; Will, 93
Prince, Bill, 6
Priddy's General Store, 16
Priddy: Cranford, 120; Curtis, 120; J. Elwood, 16, 52; Jean, 52; Watt, 120
Pulliam: Clarice, 6; Johnny, 6; Junior, 6; Madeline: see Kiger; Marie, 6; Woodrow, 6
Pyrtle: LuElla, 51; Sam, 51
Quaker Gap, 122; farming, 77
Reynolds: Nancy Jane Cox: see Nancy Reynolds School; R.J., 63; Walter R., 63; William Neal, 63
R.J. Reynolds Tobacco Company, 86, 102, 103
Rock House, The, 7, 37
Rodenbough, Stanley and Grace: see Covington Home
Sams, E.R., 36
Sands, Walter, 73
Sandy Ridge: Academy, 68; community, 9, 31, 40; farming, 80, 83; school, 69; Shelton's Furniture Company, 40
Sauratown Mountain, 7, 87, 107, 124
Sauratown Plantation: see Walnut Cove
Sawtooth Center, 106
Scales, Joseph, 40
Sears Roebuck, 70
Shale Paving Brick and Fire Proofing Company: see Pine Hall
Shelton's Furniture Company: see Sandy Ridge
Sheppard, Dr. Marion, 31
Siler City, 21
Slate, J.W., 35
Sleigh, Roberta, 71
Smith: Elkin, 47; Elnora, 84; Hilda, 84; Luther Madison, 86; Roscoe, 84; William, 73
Smith Post Office, 31

Smithsonian Institute, 106
Snow Hill, 99
South Stokes High School, 72
Southern Railroad, 43
Southern, Paul, 8
Spencer Shell Station (Grocery), 39
Spencer, John Lee and Lola, see Spencer Shell Station
Stanley, Jerry, 58, 124
Stevens, Manie, 31, 77
Stewart, Alfred, 70
Stewart's School, 70, 72
Stokes County: banks, 12, 44; courthouse (Danbury), 10; courthouse (Germanton), 19, 20; farming 75; first county stop light: see King; Home for the Elderly and Handicap, 17; jail, 12; moonshine, 83; mineral springs, 87; plantations, 9, 32, 75; schools, 49, 61, 74–75; Teachers Institute, 57
Stone: Dr. Grady, 101; Joe, 67; Kate Perry, 101
Stonemans Raiders, 15
Surry County, 16
Taylor: Angela, 52; Ethel, 63; Mallie Sue, 52; Samuel: see Taylor Hotel; Spottswood, 16
Taylor Hotel, 16

Thompson, Roy, 17
Tilley: Dorothy, 51; Eldridge, 99; Eunice, 51; Sallie, 63
Tobacco, 75–76
Town Fork Creek, 9, 41, 75
Townsend, Virginia, 39
Tucker: Agnes, 61; Cliff, 82
Tuskegee Institute, 70
Tuttle, Sara Ann, 97
Tuttles School, 72
Vade Mecum: berry picking, 105; community, 51; hotel and resort, 87–88; mill, 89
Vaden: Annie, 51; Delise, 51; Elise, 51; Evelyn, 51; Harvey, 51; Herman, 51; Howard, 51; Lucille, 51; Millard, 120; Sandy, 120; Troy, 51
Vaughn Hotel, see Walnut Cove Hotel
Venable, Roy Lee, 52
Volunteer Primitive Baptist Church, 66
Volunteer School: see Pinnacle
Wall: Buck, 73; Lois, 52
Walnut Cove: banks, 12, 44; farming, 80; hotel, 45; Lash family estate, 42, 46; Motor Company, 44; plantation, 9; railroad, 43, 87;

Rotary Club, 48; Sauratown Plantation, 46; schools, 53, 61, 70–73
Washington, Booker T., 70
Watson: G.K., 67; Tom, 35; Wess, 67
Watson General Store, 35
Watts, Loretta, 84
Westfield, 18
White: Ed, 76; Gib, 2; J. Harley, 122; Jeff, 81; Mary Boles, 122
Whitten, Etta Lawson, 99
Williams, Charles, 63
Williamston, Troy, 71
Wilson, Magaline, 52
Winston-Salem, 25, 40, 87; Children's Home, 121; Foundation, 107
Winston-Salem Journal, 4, 17, 41
W.K. Bowman Grocery: see Germanton
Wood, Moir, 16, 82
Woods, Guy, 16
Works Progress Administration, 96
Zell's Tobacco Fertilizer, 78

As a television journalist, Chad Tucker has worked across North Carolina as a news producer, anchor, and reporter, but never drifted far from his Stokes County roots. The King native received his undergraduate and master's degree from East Carolina University where he began his journalism career covering hurricanes. In 1999, Tucker was part of a team of journalists awarded the Edward R. Murrow Award for coverage of Hurricane Floyd and the floods that followed. An advocate of volunteering, he gives of his time to children's literacy and hospice groups. Tucker works as a television journalist for Fox affiliate WGHP/FOX8 and is a lecturer of journalism. (Photo by Chris Tanca.)